£4·50

Great Painters
and Illustrators
of the Old West

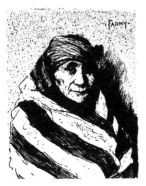

Great Painters and Illustrators of the Old West

by Harold McCracken

DOVER PUBLICATIONS, INC., New York

Published in Canada by General Publishing Company, Ltd.,
30 Lesmill Road, Don Mills, Toronto, Ontario.
Published in the United Kingdom by Constable and Company, Ltd.,
10 Orange Street, London WC2H 7EG.

This Dover edition, first published in 1988, is an unabridged
republication of the work originally published by the McGraw-Hill Book
Company, Inc., New York, in 1952, under the title *Portrait
of the Old West: With a Biographical Check List of Western Artists*.
Thirty-nine illustrations, originally appearing in color, have
been reproduced in black-and-white for the present edition.

Manufactured in the United States of America
Dover Publications, Inc.
31 East 2nd Street
Mineola, N.Y. 11501

Library of Congress Cataloging-in-Publication Data

McCracken, Harold, 1894–
 Great painters and illustrators of the Old West / by Harold
McCracken.
 p. cm.
 Unabridged ed. of: Portrait of the Old West. 1st end. 1952.
 Includes bibliographical references and index.
 ISBN 0-486-25731-2
 1. West (U.S.) in art. 2. Art, American—West (U.S.) 3. Art,
Modern—19th century—West (U.S.) 4. Art, Modern—20th century—
West (U.S.) I. McCracken, Harold, 1894– Portrait of the Old
West. II. Title.
N8214.5.U6M33 1988
758′.9978—dc19 88-6524
 CIP

SPECIAL ACKNOWLEDGMENT is made to the following, without whose co-operation this work would have proved impossible: The New York Public Library, New York Historical Society, Frick Art Reference Library, Smithsonian Institution, Corcoran Gallery of Art, The American Museum of Natural History, Knoedler Art Galleries, David B. Findlay Galleries, City Art Museum of St. Louis, Royal Ontario Museum of Archeology, Public Archives of Canada, British Museum, Yale University Art Gallery, Peabody Museum of Harvard University, Brooklyn Museum, Remington Art Memorial, Metropolitan Museum of Art, Cincinnati Art Museum, Taft Museum, The Richard W. Norton Art Foundation, Walters Art Gallery, Worcester Art Museum, Philbrook Art Center, Berkshire Museum, Public Library of Denver, Old Print Mart, Dr. R. W. G. Vail, William Davidson, Lewis Stark, Elizabeth Roth, Perry T. Rathbone, Dr. Bella Weisner, Mrs. Helen Whiting, Henry M. Sackrider, Mrs. Louise Schreyvogel Feldmann, Mrs. Ruth Schreyvogel Carothers, E. Marie Becker, Mrs. Nancy Douglas Bowditch, Marvin C. Ross, E. Walter Latendorf, Henry Dincalcci, Elizabeth Clare, Bertha L. Heilbron, Dr. F. M. Setzler, Mrs. J. W. Young, and many others. Special credit should also be given for the fine color transparencies and photographs of paintings made especially for this book by Donald Brenwasser, Charles Miller, and Victor Amato.

Preface

THE OLD WEST deserves an important place in American history, and its story takes on increasing significance in our own period of wavering values and uncertain goals. If we look backward in time to examine the firm foundation and solid beginnings of our heritage, we should also look westward in direction to find at least one principal source of our national energy—the vigorous, challenging ethos of the frontier. For such a retrospect, we cannot find a more accurate or inspiring record than the one left us by pioneer artists who devoted their lives to the perpetuation of that colorful era. To bring these men, their work, and their stories into a brighter place in the public domain, is the purpose of this book.

Most of the artists who carried sketchbooks into the West in the early days were graphic historians of what they saw. The documentary value of their work is perhaps more important than the academic. Their records are alive with pioneer zest and the singular virility of the frontier. Life in the West was often as demanding of a painter as it was of a trapper or mountain man. Many of them traveled into the wilderness on horseback, lived alone with the Indians, rode on campaigns with the cavalry, and shot buffalo and other game to survive. They knew the baking-oven canyons and deserts of the Southwest, as well as the freezing blizzards of the Montana Territory. Sometimes their sketches and paintings were traded across a cow-town bar for food or a drink or two—works that were destined to hang in our finest museums and private art galleries. Many of them became National Academicians, although a surprising number were self-taught. They crossed the Mississippi time after time, and some settled permanently in the West. As a whole they have left us a heritage of great value.

This book has certain limitations which must be emphasized. It is neither a monograph nor a critique on Western art. The basic concept has been documentary. It starts at the very beginning of art in America, in the early sixteenth century, and ends with the death of the Old West, as the last century came to a close. Geographically, it is principally restricted to the Great Plains region, stretching westward from the Mississippi to the Rocky Mountains. Even with these prescribed limitations it has been extremely difficult to confine it to a single volume.

The art of California and the Far West could fill a similar book, as could the life and work of any of the individuals presented. It does not include any artist who was born after 1875 and deals only with those who worked from firsthand observation. There has been little attempt to pass academic judgment on the pictures herein, although great care has been exercised regarding their selection and reproduction. As far as possible the artists have been permitted to speak for themselves, in their journals, diaries, and letters, as well as their pictures.

Gathering the material has been a pleasant, though sometimes demanding labor of research, with valuable assistance from many sources: personal journals, family records and correspondence, official government and War Department reports, and such other sources as were deemed reliable. The cooperation of institutions and individuals, many of whom have made special study of particular artists and periods of our Western history, has been most helpful; and assistance in obtaining photographs and permissions to reproduce the desired works in museums and private collections has been very gratifying.

If this book may in some measure contribute toward a better understanding of the Old West and its part in our national development, and provide a greater appreciation of our neglected Western artists, the effort which has gone into its preparation will have been worth while.

HAROLD McCRACKEN

Foreword

THE OLD FORTY-NINERS used to "opine" that there was gold in "them thar hills." Nowadays there is far more of it to be found in the Hollywood studios and on the Bad Lands locations where the modern "westerns" are shot daily. There the driver of the Deadwood coach rides again in clouds of dust and showers of hostile arrows for the delectation of a romantic but uncritical box-office clientele.

Our remote Eastern ancestors, when they were not blasting the unromantic red men out of their native forests with Kentucky rifles or retelling tall tales of Indian captivity for the enjoyment of their backwoods neighbors in the taprooms of a hundred taverns, were attending a turkey shoot, a barn raising, a baptizing, or a hanging. Their amusements were democratic, homemade, vigorous, and a trifle less synthetic than ours in this age of mechanical comforts.

Then our Yankee civilization moved westward over the Alleghenies and we began in earnest to cheat and chase the Indians through their forests and across their plains and to slaughter the buffalo for their hides and meat. We replaced these great shaggy beasts with Texas steers, then with sheep and finally with fenced-in farms which turned from grass to grain and ultimately to gullied dust bowls. Our too eager pioneers became migrants plucking the "grapes of wrath" which their ignorance and greed had planted.

Beginning in the 1830s, it took about three-quarters of a century for this process to carry our civilization from the Mississippi to the Rockies, and it was during this period that the most romantic and best remembered frontier types were swiftly developed and as swiftly disappeared before the railroads, barbed wire, reapers, tractors, Model Ts, gas stations, and hot-dog stands. But they were wonderful while they lasted—the men of our farthest frontier—the Plains Indians on their swift wild ponies, their enemies the cavalrymen, the silent mountain men, the persistent prospectors, the lean and leathery cowboys, and the unromantic sheepherders with their threat of fences. With them came the bad men, and women, crooked gamblers, claim jumpers, prostitutes, horse thieves, road agents, and murderers; the Younger and Jesse James gangs, Yellowstone Kelly, Texas Jack, Billy the Kid, Calamity Jane, and Wild Bill Hickok. These flourished briefly and generally died

with their boots on, in a blaze of gunfire or hanging free of the ground on a twitching rope-end. Less glamorous but more enduring were the hard-featured and courageous pioneer families from back East, the Baptists, Methodists, and Mormons, who followed their dreams of distant, greener fields in their covered wagons along the rutted trails to the gold of California, the Promised Land of Utah, the rich valleys of Oregon. They were farmers for the most part but with a sprinkling of traders, missionaries, mechanics, medicos, lawyers, and newspapermen eagerly going West to grow up with the country. Some left their furniture, their pots and pans, their broken wagons, their dreams, and their very bones along the famous trails; some won through to become the founders of our Western states.

A few of the pioneers kept diaries or remembered to chronicle their adventures when they grew old and reminiscent, and some of these narratives found their way into the publications of our historical societies. There was also an occasional Ned Buntline or Buffalo Bill who sought a larger and more immediate audience and a surer means of perpetuating the adventures of the "virgins, villains and varmints," as Thomas D. Clark calls them. Their bloodcurdling adventures and wild feats of outdoor skill and horsemanship appeared in the dime novels and the crude medicine shows of the period or in the later wild West shows, circuses, and rodeos.

Then came the more or less realistic flickers of silent film days and virtue was again triumphant when backed up by the Colt revolvers of old Bill Hart. So we come to our own time when every Western hero has a hundred thousand miniature replicas, each swaggering in the complete regalia of a Hopalong Cassidy or shouting in childish treble the universal battle cry of "Heigh-ho, Silver!" Ultimately, these two-fisted, hard-riding and hard-fighting heroes—lariat, chaps, six gun, cow pony, and all—have invaded our very homes by way of the television antenna which sprouts from the roof of every shack or mansion.

Where does the present-day movie director get his ideas for the stock types in his wild and woolly western since the originals of these hardy characters were dust before the cinema was born? For the answer we must turn to Frederic Remington, Charles Schreyvogel, Charlie Russell, George Catlin, and some thirty other nearly unknown frontier artists who have left us a vivid and accurate pictorial record of the West as it was in its day of glory.

These artists were varied in their training, ability, and techniques. But if they were deficient in formal art instruction, they had to excel at the arts of Western life, following a trail, building a campfire, stalking an antelope, and riding a cayuse. Because these painters and sketchers actually lived the life of the Western

frontiersman, their accurate, colorful, spirited documentary pictures today supply the motion-picture directors with the inspiration and information which has kept at least a shadow of the Old West alive in our films. But the public deserves more than the shadow; it should be introduced to the original art in which our Old West is so admirably preserved. It is this task of introduction that Harold McCracken has undertaken so successfully.

The work of these almost forgotten pioneer Western artists has been rescued from oblivion in this present handsome volume by an author who has himself lived in the vanished West and among Remington's "men with the bark on." Harold McCracken is particularly suited for the task of selecting the pictures here assembled and telling us about the lives of the artists who made them and the times in which they lived. His is not a book of history or of art criticism, nor is it merely a collection of pictures. Rather it is a skillful blending of the lore and development of the West with the life and work of its finest artists. Author of many a thrilling story of the men and animals of the West and Far North, and recognized biographer and authority on Frederic Remington, this time Mr. McCracken has used the work of some thirty artists to bring back for our delight those stirring days of our memorable past. He has told, frequently for the first time, something of the lives of the determined artists who braved the rough life because they loved the West and were determined to leave a record of it for future generations. All of it is important pictorial history and much of it is also fine native American art of which we can be especially proud, since its inspiration is born of our own soil. We can say of each of these Western artists what Col. Theodore Roosevelt said of Remington: "The soldier, the cowboy and rancher, the Indian, the horses and cattle of the plains, will live in his pictures and bronzes, I verily believe, for all time."

R. W. G. VAIL
Director
New-York Historical Society

Contents

List of Illustrations

*Reproduced in black-and-white in the present edition.

BLACK-AND-WHITE PLATES

ILLUSTRATIONS IN TEXT

THE SILENCED WAR WHOOP Charles Schreyvogel

(Amon G. Carter)

1 *First Views of a New Land*

THREE AND A HALF CENTURIES of exciting adventure have gone into the story of our Old West. From the days of the first conquistadors until the Indian war whoop was permanently silenced, the sprawling land between the Mississippi and the Rockies has produced one of the most dramatic and colorful epochs in history. The *coureur du bois* and *voyageur*, scout, mountain man, squaw man, dragoon, cowboy, and many other rugged types will be long remembered. It is a worthy heritage, one which affords us something healthy and virile to lean back upon. As time passes, it becomes increasingly important that we seek out those things which bring into sharper focus all the characters and characteristics of that whole cavalcade of frontier life.

Unfortunately, we do not have the benefit of extensive archives of photographs or libraries of documentary films which would contribute to the understanding of future generations. Except for the last brief phase of the Old West, we are almost entirely dependent upon the artists for the pictorial record; and even in this respect the material very rapidly decreases, both in quantity and documentary value, as we go further back toward the beginning. Until well into the nineteenth century there was little more than the infrequent drawings of contemporary illustrators, who relied upon secondhand information and their own imaginations, to add graphic realism to the journals of explorers and the works of historians.

The landing in the Bahamas in 1492 of the man the Spanish call Cristóbal Colón and the Italians Cristoforo Colombo was certainly one of the most important events the civilized world ever experienced. This Italian-born navigator, sailing under a Spanish flag, went West to find India and took possession instead, in the name of Isabella of Castile, of Cuba and Haiti. Three times Columbus returned to the New World exploring the West Indies, Trinidad, the mainland of South America, and the south shore of the Gulf of Mexico. As far as is known, he never set foot on the North American continent and of course failed entirely to achieve his original goal —the discovery of a westward route to India. Yet the navigator of the *Santa María*, who sailed from the port of Huelva in Spain to the Canary Islands to the Bahamas

in something like ten weeks, wrought remarkable changes in the history of the world. Unfortunately, there is in existence today no known artistic record of any of his voyages.

It was ninety-eight years after Columbus's first voyage before even an attempt at a pictorial atlas of any part of the New World was published. The first picture on record of the Western Hemisphere is reproduced on page 21. This is a woodcut by an unknown German artist, done about 1505, thirteen years after Columbus landed in the New World. A translation of the explanatory caption which accompanied it reads: "This figure represents to us the people and island which have been discovered by the Christian King of Portugal or his subjects. The people are thus naked, handsome, brown and well shaped in body . . . and they eat each other even those who are slain, and hang the flesh of them in the smoke. They become 150 years old . . . and have no government." Just where the artist got his information is not known, but the picture obviously represents the inhabitants of Brazil, for cannibalism was not practiced in North America.[1]

When Columbus came to this hemisphere, it was far from being an uninhabited wilderness. Central and South America had the well-developed civilizations of the Aztecs and Incas, with cities of 200,000 population or more. Studies of anthropologists indicate that in North America, above the present boundary of Mexico, there were about 1,150,000 Indians,[2] divided into at least 58 linguistic groups and 782 separate tribes.[3] Some 846,000 of these lived within the limits of what is now the United States proper. Throughout the Great Plains of our West the Indians led a nomadic life, dependent almost entirely upon the game they were able to procure with bow and arrow and by driving animals over steep embankments. All hunting was done on foot, and fortunately there was an abundance of game. Authorities estimate there were as many as 125,000,000 buffalo at the beginning of the nineteenth century. They were fairly easy to approach, but difficult and dangerous to kill for a hunter on foot with only a flint-pointed arrow as a weapon. The buffalo in its countless herds answered practically all of the needs of the Plains Indians—food, clothing, tents, war shields, thread and bow strings (the sinew)—but the buffalo migrated at certain seasons, which often made existence precarious for the natives. Their only beast of burden was the dog, and the level of their civilization as we judge such things today was extremely low.

[1] One of the two known original impressions of this picture is in the Stokes Collection of the New York Public Library. The accompanying reproduction is made from this copy. The other impression is in Munich.

[2] *Handbook of American Indians*, Bureau of American Ethnology, Bulletin 30, Smithsonian Institution, Washington, D.C., 1912. Part II, p. 287.

[3] *Ibid.*, Part I, p. 767.

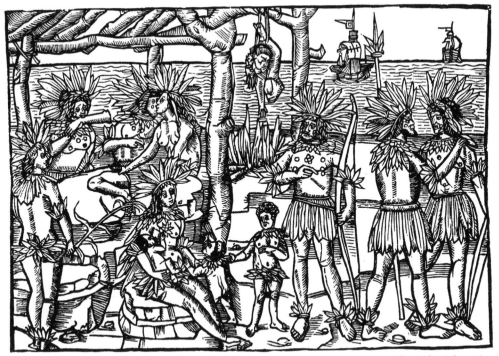

FIRST PICTURE OF AMERICA, *c.* 1505 (New York Public Library)

The Spanish deserve the credit for the exploration of a large part of America, including our own West. As early as 1536 the remnants of one of their expeditions had completed an eight-year overland journey from what is now Florida to the Pacific Coast. That was almost a full century before the *Mayflower* landed the Pilgrims at Plymouth, and more than two and a half centuries before the United States possessed any land rights or had begun exploration in the territory beyond the Mississippi.

It was Alvar Núñez Cabeza de Vaca and three companions who were the first Europeans to visit the West. The others were Castillo Maldonado, Andres Dorantes, and the latter's Moorish Negro slave, Estevan. They were the last survivors of an ill-fated expedition of 600 conquistadors, with eighty horses, that had set out from Spain on June 27, 1527, to explore and conquer all the territory lying north of the Gulf of Mexico, from the Atlantic Coast to the land already controlled by the Spanish in Mexico. After a series of tragic mishaps, a November storm cast the last four half-starved survivors ashore just west of the mouth of the Mississippi ". . . as naked as we had been born . . . having lost everything we possessed. It was bitterly cold . . . every bone in our bodies could easily be counted, and we

looked like death itself." [4] How these men managed to live through the following seven and a half years and complete the journey overland across the continent is one of the most amazing stories in the annals of exploration.

"All the many Indians we saw were archers, and, being very tall and naked, they appear like giants," wrote De Vaca in his unillustrated journal which was published in Spain in 1542 and is the earliest eyewitness account of our Western country. "They are wonderfully built, very gaunt and of great strength and agility. Their bows are thick as an arm, from eleven to twelve spans long [99 to 108 inches], shooting an arrow at 200 paces with unerring aim. . . . Only the women cover part of their bodies with a kind of wool that grows on trees."

Captured and made slaves by the Indians, the four Spaniards escaped death only because the Indians believed they possessed supernatural powers of healing the sick. The Moorish Negro Estevan promoted this subterfuge to such an extent that he assumed the role of a medicine man. Finally escaping their captors, the four followed the Sabine and Brazos rivers, going inland for several hundred miles across the present state of Texas. They traveled virtually naked, lived entirely off the country, and narrowly escaped recapture and death by various tribes of Indians. On this part of the journey they became the first Europeans to see the herds of buffalo on our Western Plains: "Their horns are small, like those of Moorish cattle; and their hair is long, like fine wool . . . some brownish and some black; and to my taste they have better meat than those in Spain. Of the small hides the Indians make blankets . . . and of the taller ones they make shoes and shields. They come from the north, across the country further on . . . and are found all over the land."

The four explorers, after their long ordeal of hardships, finally reached Mexico City on July 24, 1536; the account of their journey begins the story of adventure in our Old West. Cabeza de Vaca and his two gentleman companions returned home to relate their extraordinary experiences in the courts of Spain. But not Estevan, the Negro slave. He persuaded Don Antonio de Mendoza, the Spanish viceroy of Mexico, to buy him from Dorantes and send him back to find the fabulous Seven Cities of Cibola, which became the principal objective of the Coronado expedition a year later. Estevan had not only developed ideas of his own, but he had become a very colorful individual. He is described by a contemporary Spanish historian, Pedro de Castañeda, as "a black man with a beard, wearing things that sounded, rattles, bells, and plumes, on his feet and arms—the regular outfit of a [Indian] medicine man." [5] He traveled with a formidable bodyguard, collected

[4] For a full account of this see *The Journey of Alvar Núñez Cabeza de Vaca* . . . Zamora, 1542. Translated by Fanny Bandelier, New York, 1905.

[5] *The Coronado Expedition,* by George Parker Winship, 14th Annual Report, Bureau of Ethnology, Washington, D.C., 1896, p. 360.

tribute from the Indian villages as he went, and reached the very threshold of his wildest dreams, the outskirts of the first of the cities of Cibola, which was about fifteen miles from the present city of Zuñi, New Mexico. Here Estevan was killed by the Zuñi Indians—not only because of his exorbitant demands of tribute in great quantities of turquoise and native maidens, but because it had become known that he killed the women of his traveling harem as he tired of them or they became too numerous.

Not long afterward came the ill-fated expeditions of Hernando de Soto and Francisco Vázquez Coronado. The former landed at Tampa Bay in May of 1538, and set out overland for Mexico with about 200 horsemen and 560 foot soldiers. De Soto's somewhat depleted force reached the Mississippi at a point near the present city of Memphis in 1541, and spent the following year on the Plains to the west. De Soto died in June, 1542, and was buried in the great river he discovered. The survivors went on across what is now Arkansas, Oklahoma, and Texas to Mexico. The Coronado expedition left Compostela (Mexico) February 22, 1540. The leader rode proudly at its front, arrayed in magnificent gilded armor and plumed helmet, his mount draped in brilliant trappings. According to documents recorded by secretaries of the Spanish viceroy, who was on hand to add his official blessing, "there were more than a thousand horses in the train, besides the mules. . . . Many of the riders were garbed in armor and coats of mail, polished brightly; and they carried great two-handed swords, steel war clubs and metal shields . . . and upwards of a thousand servants and followers, black men and red men, leading spare horses, driving pack animals . . . and thousands of cattle, sheep and

First Picture of the Buffalo, after Gomara—1553 (New York Historical Society)

swine for food." [6] With banners flying, they set out to conquer the legendary Seven Cities of Cibola and all other land and treasure beyond the Rio Grande.

They conquered Cibola, but found no treasure, discovered the Grand Canyon of the Colorado, and for two and a half years wandered over the mountains and the wide buffalo plains, exploring the territory of what is today the states of Arizona, New Mexico, Texas, Oklahoma, Colorado, Kansas, and Nebraska. They were near the present site of the city of Wichita in June, 1541, about the time that De Soto was at Memphis. The sad remnants of the once proud cavalcade finally returned to Mexico City, empty-handed.

These and other early Spanish expeditions resulted in practically no pictorial documentation of any kind, either by eyewitness observers or secondhand illustrations for their journals. This is surprising, for the priests were notable exponents of art and letters, and they played a more than ordinary role in all the undertakings of the conquistadors. Churches were erected along with the forts, elegant cathedrals followed, and virtually all of them became art galleries. Throughout Central and South America the pioneer priests even established schools of art among the natives, which still survive. But their art, like everything else they propounded, was strictly religious, and pictorial documentation did not play even a secondary role. Important history was in the making, but it was not until 1553 that the first actual illustrative picture appeared in any of the books about North America. This is the interesting conception of a buffalo of our Western Plains which is reproduced on page 23; it is the only illustration in the *Historia General de las Indias*, by López de Gómara,[7] a distinguished sixteenth-century scholar. His accompanying description of the buffalo is much more accurate than the illustration.[8]

The first artist of record who visited any part of America and made pictures from personal observation·was Jacques le Moyne de Morgues, who accompanied the French explorer René de Laudonnière to establish the Huguenot colony in Florida in 1564. Le Moyne's specific duties were to portray what he saw of the natives, their mode of life, the geographic characteristics of the new land, and to make maps of the harbors and seacoast. The expedition landed in June, on the east coast of Old Florida. In September of the following year the Spanish overran

[6] *Ibid.*, pp. 378–379.

[7] *Primera y Segunda de la Historia General de las Indias . . .* , by Francisco López de Gómara, Saragossa, Spain, 1553. The woodcut of the buffalo appears on the verso of folio 116 of Part I of this first edition. The reproduction shown herewith is from a copy of this book in the Reserve Division of the New York Public Library.

[8] *Ibid.*, Chapter CCXV.

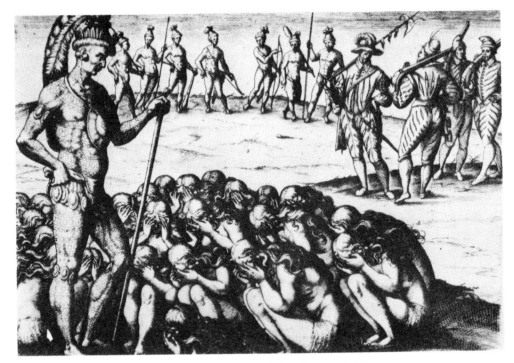

INDIAN WOMEN WHO LOST THEIR HUSBANDS IN THE WAR Jacques le Moyne

the Huguenot colony, killing all but a few. Le Moyne was among those who escaped to a French ship that promptly sailed for home, taking with it the artist and probably some of his sketches and small paintings. After crossing the Atlantic the ship was driven by a bad storm onto the coast of England, and Le Moyne traveled to London, on his way back to France. A chance meeting with a fair lady, however, considerably altered his plans; he married her and settled down in London, to continue his profession. There he wrote a journal to accompany the pictures he had painted of his experiences in America but was unable to find a publisher.

Twenty-one years later, another artist went to America. This was John White, who accompanied Sir Walter Raleigh's historic voyage to Virginia in 1585. White, who was to become the grandfather of the first child born to English parents in America, Virginia Dare of the Roanoke colony, returned to England with Sir Francis Drake, carrying with him a considerable collection of water-color paintings of the American Indians, and flora and fauna of the new land.

Shortly after White's return to London, Theodore de Bry, a prominent German goldsmith and engraver of Frankfurt, came to the English capital to procure the

Le Moyne paintings and narrative for one of a series of illustrated travel books which he was planning to publish. Le Moyne, however, refused, and De Bry arranged to use the John White pictures instead, making the story of the English colony in America the first volume of the series. This was published in Frankfurt in 1590 and contained engravings from twenty-three of the Englishman's water colors. Thus John White became the first known artist to publish pictures of North America and the Indians which had been made from personal observation—ninety-eight years after Columbus's notable voyage. Seventy-five of White's original water colors are today preserved in the British Museum. Two of these are reproduced on page 36.

During the year after De Bry acquired the John White paintings, Jacques le Moyne died, and arrangements were made with his widow for use of his pictures and narrative in Part II, the *Florida* volume of De Bry's *Voyages*. Published in 1591, it contained forty-three engravings made from Le Moyne's paintings, two of which are reproduced herein: *Indian Women Who Lost Their Husbands in the War*, on page 25, and *Indians Hunting Deer*, on page 38.

Only one of Le Moyne's original paintings, of undisputed authenticity, is known to exist today. This earliest known example of American art by a European was discovered in 1901 hanging in the library of the Marquise de Ganay in her Château de Courance near Milly, Seine et Oise, France.[9] It is *René de Laudonnière et le Cacique Satouriova* (1564). The picture shows the Huguenot explorer and some of his soldiers with the Indian chief Satouriova, beside a festooned column adorned with the insignia of France, the royal crown, and a decoration of the Order of Saint Michel. There are offerings at the base of the column and a gallery of Indian men and women worshiping at the shrine. The original painting is a miniature in *gouache* on vellum, measuring 7 by 10⅛ inches. After its loss to the world of art and history for more than three centuries, the discovery of this unique little treasure caused considerable excitement both in Europe and America, and its authenticity was meticulously checked by the best authorities. It was subsequently acquired from the Marquise de Ganay by Mr. James Hazen Hyde, who has recently brought the picture back to America, where it is expected to remain henceforth. It is here reproduced on page 35 in full color for the first time in any book.* Despite its age, it has retained to a remarkable degree its exquisite pastel colors. This highly romanticized portrayal of the primitive inhabitants of our country might be said to mark the beginning of art in America.

[9] For full account of this see article by Dr. E. T. Hamy in Bulletin of the *Academie des Inscriptions et Belles-Lettres*, Paris, France, January–February, 1901.

*Reproduced in black-and-white in the present edition.

2 Four Flags in the West

THE SPANISH contributed little in the way of artistic influence as a result of their conquest of our West. They left behind a style of architecture which still enjoys a popular survival, from Florida to California, although it is a little difficult to establish just how much of this is Spanish and how much is Pueblo Indian. In the fields of graphic and sculptured arts, about the only heritage which they have left is the development of a pleasant sort of folk art among certain of their progeny and converted Indians of the Southwest. These are *santos* (images of the saints), *santos de bulto* (figures of saints in the round), and *santos retablos* (painted panels of the saints), which were made to imitate the religious adornments the Spaniards brought from Mexico to decorate the frontier churches. Many of the original edifices were destroyed by the uprisings of hostile Indians and the natural ravages of time and neglect, and new ones were built by devotees of the faith. Attempts to give ecclesiastic dignity to their altars and to add a Catholic atmosphere to their own homes inspired this native art. The *santos* were fashioned out of local soft woods that could easily be shaped with crude cutting tools, and colored with paints made of local materials, much in the manner that the natives decorate pottery and their own bodies for ceremonies and dances.

The conquistadors left other evidence of their presence deeply implanted in the territory which is now the United States. Many an American city and geographic landmark of today retains the name of a presidio, fort, or mission, or is in some way closely associated with the early Spanish adventurers. They named Texas; Colorado is derived from their reference to it as "ruddy," or "blood-red"; California was so called by Cortez, because it reminded him of the island in an old Spanish story in which a great abundance of precious gems were found; Santa Fe, "holy faith"; El Paso, "the pass"; Las Vegas, "the meadows"; San Antonio, San Francisco, Santa Barbara, and many other cities, mountains, rivers, bays, and lakes.

The most important inheritance which was the outcome of the early Spanish expeditions into our West, fell to the lot of the Indians. Ironically, the explorers were

RETABLO OF SANTA LUCIA
(Santa Barbara Museum of Art)

never to realize the full significance of their magnificent contribution. They put the Indian on horseback—a circumstance which wrought a momentous revolution in the Plains Indians' whole mode of life.

When the Indians first saw the Spaniards ride into their country, some of the red men believed that horse and man were one strange animal. The classical centaur owed its origin to a similar misconception, when the Huns first rode out of the steppes of Central Asia. But the Plains Indians were not long in realizing the advantages which the horse offered. It was only natural that they should come into possession of some of the animals as the spoils of war against the ill-fated expeditions of the invaders. They took to the back of the horse with a natural aptitude that placed them among the finest horsemen on earth; and the buffalo plains provided an ideal home for the horse as the horse was a natural adjunct to the life of the Indian. Some of the animals wandered away or otherwise became free from their Spanish owners. Wild herds spread so quickly that their capture became an important native occupation.

Before the Plains Indian acquired the horse he encumbered himself with only the barest necessities of life. He was nomadic because of his crucial dependence upon the buffalo. Even without surplus accouterment and baggage, he was limited in his range of traveling, and travel was often necessary to find game. The dogs, which were his only beasts of burden, were of little help, and he had to depend mostly upon his own back as a means of transporting supplies. This severely limited his every movement and dictated what he used for clothing, shelter, home furnishings, and articles of personal adornment. For him, or his squaw, to have elaborate buckskin garments heavily decorated with beads and designs or fancy war bonnets with long trains of eagle feathers was unthinkable. If he killed one buffalo, he was faced with a major chore. If he had to travel any distance at all to find game, it was more practicable to take the family along and make his camp beside the supply of food. These inescapable circumstances had kept the Plains Indian in a very primitive state of culture and made his world a very small one.

He did not often come in contact with other tribes and seldom had any knowledge of what life was like two hundred miles from where he was born.

All this was changed with the acquisition of the horse. The Indian was able to travel as far as necessary to find game, and restrictions on the amount of game he could take were lifted. He was able to have a larger and more comfortable tepee in which to live; superior household furnishings and implements; and his squaw could now make all the clothing she wished. The decorative arts, for which the Plains Indians became so notable, were rapidly developed. Intertribal relations began. They had more time for dancing and games, and elaborate ceremonies came into popular practice. The horse brought prosperity to the Plains Indians, and with it the development of the colorful culture with which they are associated today. From a drab and primitive state, they became proud and warlike tribesmen by the early nineteenth century when our own Western conquest began. While the tribes in the south were naturally the first to benefit from use of the horse, its distribution was practically complete among all the tribes as far north as Canada, by the time of Lewis and Clark.

After Spanish rule faded in the Southwest, the Indians remained free from outside interference, throughout nearly all of the Plains territory, for well over two centuries. There can be no doubt that they profited tremendously from the combination of this isolation and the acquisition of the horse. Many of the tribes acquired the horse without knowing of the existence of the white man, a fact strongly supported by Indian legends, handed down through the centuries, regarding the horse's mythical origin.

About the middle of the seventeenth century the French explorers began pushing westward from their little colonial empire along the St. Lawrence. Here again there was the impelling motive of treasure, as well as the broadening of imperial

FIRST OF HIS RACE Frederic Remington

domain. It was the French who first caught the golden vision of the fur trade in the interior of North America. To the natives the pelts were little more than common materials for clothing, often discarded in favor of the flesh for food. This was true even of the lowly skunk. Spurred on by the lucrative fur trading, the French became the pathfinders from the East into the wilderness of the West.

As early as the spring of 1659, Pierre Esprit Radisson and his brother-in-law Médard Chouart Groseillier, after spending the winter on Lake Michigan, pushed on to become the first Europeans on record to look upon the Upper Mississippi, then go westward to the Missouri, and finally to view the Rockies in the territory that is now Montana. Fourteen years later the Upper Mississippi was more officially explored in the name of France by Jacques Marquette and Louis Joliet; and in 1683, René Robert Cavelier de La Salle sailed into the great river from the Gulf of Mexico. Thereafter the French moved down the Mississippi, establishing trading posts and making friends of the Indians, until they controlled the whole valley of the Father of Waters.

Their domain spread westward as well. On December 3, 1738, the French and Indians met in a colorful pageant at the big Mandan village on the banks of the Upper Missouri. Pierre Gaultier de Varennes, Sieur de La Vérendrye, soldier of fortune and explorer extraordinary, entered the big Indian village carrying the flag of France and claiming possession of the territory for King Louis XV. The Mandans offered no resistance as La Vérendrye led a force of fifty Frenchmen and six hundred Assiniboin [1] warriors mounted and in full battle regalia. This explorer had started out seven years and six months before from a little stockade on the St. Lawrence, where Montreal stands today, to find a route to the fabled Western Sea and across it to the riches of China. He built a line of forts and permanent trading posts along the route, to establish the sovereignty of France. He had taken his three teen-aged sons on the expedition, the youngest of whom had died before La Vérendrye reached the Missouri Valley.

The Mandan chiefs and sachems were gathered

Coureur du Bois
Frederic Remington

[1] As a reference for the spellings of Indian tribes and families, the author has used, except where otherwise indicated, *Handbook of American Indians*, Bureau of American Ethnology, Bulletin 30, Smithsonian Institution, Washington, D.C.

together in the big council lodge so that the strange white warrior might question them about the Western Sea. Yes, they had heard about a people who lived in the land of the setting sun— on the shores of a great lake whose waters were too bitter for drinking. They were white warriors, too, and they dressed in glittering armor which an arrow could not pierce. . . . Nothing more than this was known to the Mandans.

Subsequently, La Vérendrye was compelled to return to Montreal to protect his trading domain from seizure by his creditors. His two remaining sons trekked on for another six years across the Northwest as far as the Rocky Mountains, but on New Year's Day, 1743, in a howling blizzard, their Indian guides turned back and the thirteen-year search for the Western Sea came to a landlocked end. Although they failed in their mission, the Vérendryes had claimed a large section of North America for France.

FRENCH-CANADIAN HALF-BREED

It is only natural that we should expect something worth while in the way of art from the French and their occupation of the colonial empire that spread through the great central valley of the Mississippi and Missouri. Although the *voyageurs* and *coureurs du bois* were a rough lot, who mingled freely with the Indians, socially and matrimonially, and could hardly be expected to be proponents of the arts, their leaders had been sent out under the patronage of a cultivated Imperial Court, where the arts and the refinements of the day were strongly encouraged. The seventeenth-century *ateliers* were thriving. The Fontainebleau School was in full bloom and French classicism was boldly competing with the Dutch and Italians, to exert a strong influence on European art. Even the most adventurous of the land *boucaniers* in America had been at least superficially exposed to a nationalistic interest in the arts and might be expected to have an eye for the natural beauties of the land and the picturesque charms of its inhabitants—as well as for the glory of France and profits for themselves.

As in the case of the Spanish, a good many journals of the French explorers came into print, but in the matter of documentary art there is distressingly little. The illustrative pictures which accompany these early accounts are not only few, but as Francis Parkman said, are "in a style which a child of ten might emulate." One of the best of these, which has a bearing on our Old West, is the woolly buffalo

OLD ENGLISH STOCK Frederic Remington

in Louis de Hennepin's journal, which was first published in 1697.[2] This picture, reproduced on page 37, is interesting for reasons which go beyond the artistic. Although the animal is much too woolly in appearance and placed in an almost tropical habitat unnatural to it, the drawing nevertheless shows a noticeable advancement in illustrative realism. It will be recalled that there was a long-lasting dispute over the conflicting claims of Hennepin and La Salle as to which one was the first to explore the mouth and delta of the Mississippi. The background for Hennepin's woolly buffalo is certainly typical of the lower river or delta, which is strong circumstantial evidence that the explorer did visit that area.

The explorers who first saw the buffalo misnamed him, for he is actually a member of the bison family. A true buffalo has no hump (the African buffalo, for instance) and is short-haired. Many of our Western animals were similarly misnamed: our moose is really an elk; our elk is not an elk; and our mountain goat is not a goat. But we can hardly expect our early explorers to have been expert mammalogists. Their errors have done the nation no irreparable harm.

The English followed close on the heels of the French. The "Company of Adventurers of England Trading in Hudson's Bay" was established in 1670 by a charter granted in the name of Charles II to his cousin, the Duke of Cumberland, and seventeen other noblemen and gentlemen. The royal grant was given as an inducement to find the Northwest Passage to the riches of the Far East. But furs proved far more profitable, and there began an intense international rivalry for control of a major portion of North America. It spurred a renewal of interest on the part of Spain and aggravated the French, and the tides of fate flowed back and forth between the three nations, until ultimately the newly born republic of the United States swept across the continent.

[2] *Nouvelle Découverte d'un Très Grand Pays Situé dans L'Amérique*, by R. P. Louis de Hennepin, Paris, 1697, p. 187. The reproduction of the buffalo plate is made from a copy in the New York Historical Society.

There is surprisingly little pictorial material relating to the West until well into the nineteenth century. In fact, Frederic Remington, between 1886 and 1909, produced in retrospect a greater amount of realistic and accurate documentary art of the early Spanish, French, and English colonial periods in the interior of North America than did all the artists of these national groups who lived in the period.

The Louisiana Purchase in 1803 signaled the beginning of the Yankee era in the West, and with it came the steady development of everything from the political, agricultural, and industrial fields to documentary art and the highly skilled crafts. The new acquisition was a vast wilderness sweeping north and west from what is today Louisiana up across the entire middle of the continent to the Canadian border as far west as Montana. Thirteen new states, in whole or in part, were in time organized out of this relatively unexplored country—each almost as large as the combined thirteen original colonies, and embracing one of the richest agricultural areas on earth. It is only natural that such a huge acquisition of territory, coming so abruptly upon the remarkable accomplishment of the Revolutionary War, should have a powerful impact upon our newly found freedom and every aspect of our national ethos.

The historic expedition of Meriwether Lewis, Thomas Jefferson's private secretary, and William Clark, the younger brother of George Rogers Clark, northwestward across the continent from St. Louis in 1804, had a lot to do with stimulating popular interest in pioneering beyond the Mississippi. Jefferson was an enthusiastic advocate of expansion and in 1803 asked Congress for an appropriation of $2500 "to send intelligent officers with ten or twelve men to explore even to the Western Ocean." The appropriation was forthcoming and an expedition of forty-five men, under Lewis and Clark, set out in May of 1804 to find out what sort of real-estate bargain we had made by the Louisiana Purchase. They started from the mouth of the Missouri River, ascended that stream to its source, crossed the "Great Divide," found the upper waters of the Columbia, and followed that river to the Pacific in the summer of 1805. Here they spent the winter, but by November of 1806, fourteen of the original forty-five had returned to St. Louis,

HUDSON'S BAY MAN Frederic Remington

bringing with them a vast amount of valuable data about the Indian tribes and the botany, geology, and zoology of the country. Among other things, they laid claim to territories in the Far Northwest, beyond those purchased from France, which were rapidly being taken over by the British. Lewis and Clark's journal was published, without illustrations, soon after their return, and its wide distribution further stimulated interest in the territory they had explored. As a reward for his services, Lewis received a grant of 1500 acres of land from Congress and in 1807 was appointed governor of the Louisiana Territory, only to die a violent and somewhat mysterious death two years later. William Clark had a longer and just as illustrious career as Superintendent of Indian Affairs of Louisiana Territory, governor of Missouri Territory, and Federal Superintendent of Indian Affairs.

The official reports and published accounts of the Lewis and Clark expedition forcibly brought to the attention of the American public the potentialities of this vast new territory. That is not to say that before the expedition the Louisiana Territory was entirely unknown. On the rivers, the explorers periodically had met shaggy white men dressed in worn buckskins, paddling canoes heavily loaded with furs for the market in St. Louis. But these were silent men from the Platte, the Osage, and the Yellowstone, intent on keeping their trapping grounds and their trade relations with the Indians strictly to themselves. To Lewis and Clark fell the task of informing the East of the thousands of square miles of rich land, the virgin timber, and the vast herds of buffalo. New words and phrases crept into the American vocabulary—Mandans, Blackfeet, grizzly bear, Great Plains, Rocky Mountains. The lure of adventure was reinforced by the promise of great wealth.

Exploring parties began moving out in steadily increasing numbers into the unknown country beyond the Mississippi, probing farther and farther west. A new breed of American was being born—rough, tough, and indomitable—and the permanent conquest of the Western wilderness had begun. Here, also began one of the most significant and colorful eras in our national development and, along with it, an important phase of native American art.

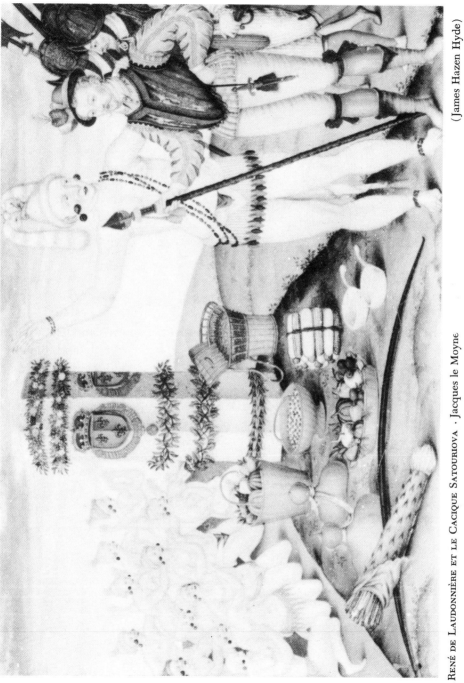

René de Laudonnière et le Cacique Satouriova · Jacques le Moyne

(James Hazen Hyde)

 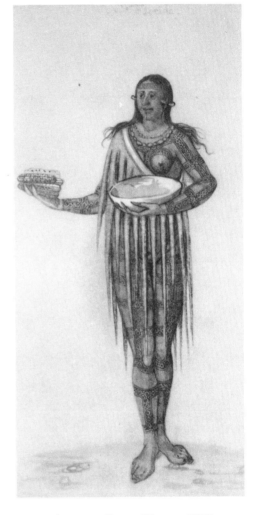

AMERICAN INDIAN WARRIOR—1585 AMERICAN INDIAN WOMAN—1585

(British Museum)

John White

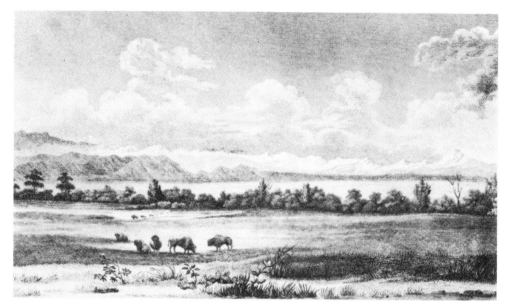

VIEW OF THE ROCKY MOUNTAINS ON THE PLATTE (First picture of the Rocky Mountains)
Samuel Seymour
(New York Public Library)

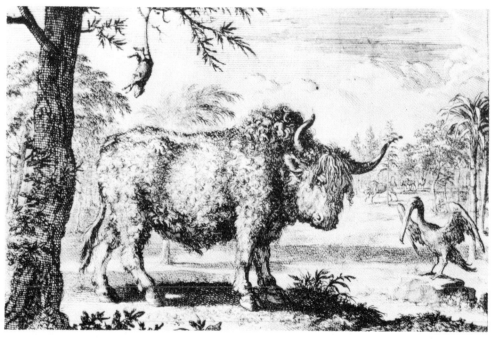

THE BUFFALO—1697 Louis de Hennepin (New York Historical Society)

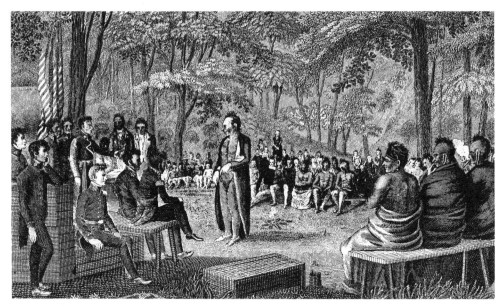

OTO COUNCIL Samuel Seymour

INDIANS HUNTING DEER—1564 Jacques le Moyne (New York Public Library)

CUT-TAA-TAS-TIA, A Fox Chief

WAA-NA-TAA, Chief of the Sioux

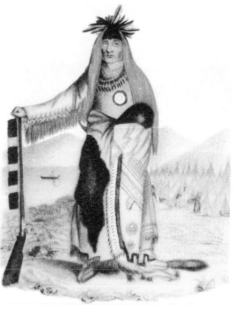

KEE-O-KUCK, Chief of the Sauk

NABU-NAA-KEE-SHICK, A Chippewa Chief

James Otto Lewis

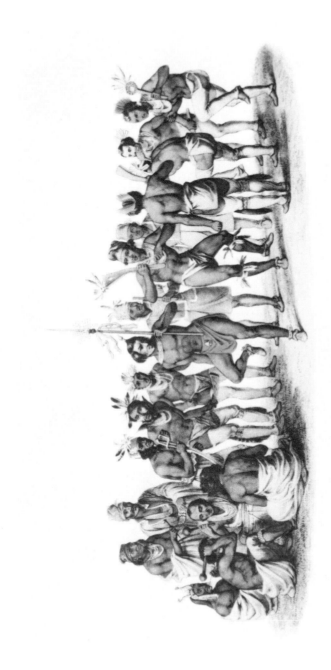

WAR DANCE OF THE SAUKS AND FOXES Peter Rindisbacher

(Litho.—Old Print Mart, N. Y. C.)

Samuel Seymour Peter Rindisbacher James Otto Lewis

3 *All the West a Studio*

IT HAS BEEN CLAIMED that American art is in no way native to America, any more than we ourselves are native to this continent, and that we have never quite been able to free ourselves from European dictatorship in this field of esthetic interest. From the beginning, the hierarchy of our own critics and proponents of art have insisted upon following the teachings of Paris and Düsseldorf, England and Italy. The Old World art schools, from romanticism to modern abstraction, have been so subserviently accepted that many Americans with ideas to the contrary have been ostracized as unworthy or as heretics. If any one group has consistently striven to be free and independent, and suffered the consequences, it has been our Western artists.

The Revolutionary War and its aftermath brought about some profound social changes in the United States. There was a sharp decline in the pomp and ceremony of colonial graces and homespun became more popular than silks and ruffles. But this did not mean that our culture was being neglected. In the field of art, the New York Academy of Fine Arts was founded in 1802, and in Philadelphia in 1805 the Pennsylvania Academy of Fine Arts was fostered by Charles Willson Peale, whose strong artistic taste had inspired him to name his sons Raphael, Rembrandt, Rubens, and Titian. There was a popular vogue for portrait painting, and artists with even a mediocre proficiency fared very well, for nearly everyone who had the means was anxious to have his portrait painted. Indeed, there were numerous important personalities to be perpetuated and most of the artists, even the best of them, did little else besides portraiture. Unfortunately, this was not a very propitious field for the development of new and revolutionary trends in art to parallel our political advances and discoveries, but it must be remembered that this was well before the days of photography, and the artists had the field of portraiture all to themselves. The English pottery maker and scientist Thomas Wedgwood had anticipated only in 1802 the theoretic possibility of producing pictures by the chemical reaction of light on photosensitive materials, and Louis Daguerre, the Frenchman, did not until 1839 accomplish his first crude daguerreotype.

41

The West of the early part of the nineteenth century offered the artist every-
thing he might desire in the way of inspiration and incentive. It afforded scenic
backgrounds for every taste, from rolling plains and arid desert to mountain gran-
deur and giant forests. Millions of shaggy buffalo roamed the Plains in vast herds.
There were scores of Indian tribes with their gaily colored and ornate costumes,
the answer to any artist's wildest dream. There were the warpath and the scalp
dances, the pageantry of migration, the drama of pagan ceremonies, the dignity
of tribal chiefs, the recklessness of unexcelled bareback horsemanship, and the
pursuit of dangerous game. There were numerous council meetings between gov-
ernment representatives and the Indians, and official exploring and military expe-
ditions were sent out into various parts of the new country. Often artists were com-
missioned to accompany expeditions, for more than just verbal descriptions were
needed as documentation for reports. A skillful artist could give a fuller description
of all the new country's aspects, its inhabitants, and the forts being built along
the new routes of travel than could the most competent reporter.

Among the earliest, if not the first artist to whom this unique opportunity was
offered, was Samuel Seymour, "a landscape painter and designer" who resided in
Philadelphia. He was selected to accompany Major Stephen H. Long, United
States Engineers, who in 1819–1820 went out under orders from the Hon. John
C. Calhoun, Secretary of War, "to explore the country between the Mississippi
[River] and the Rocky Mountains . . . and to acquire as thorough and accurate
knowledge as may be practicable, of a portion of our country which is daily be-
coming more interesting, but which is yet imperfectly known." Seymour was to
"furnish sketches of landscapes . . . paint portraits of distinguished Indians, and
groups of savages engaged in celebrating their festivals, or sitting in council. . . ."

The explorers left Pittsburgh early in April, 1819, traveling by river boat to St.
Louis, west up the Missouri to the Yellowstone, thence overland to the headwaters
of the Platte. They covered great stretches of little-known country, passing through
the territory of a large number of Plains Indian tribes. Seymour was the first artist,
whose work we know today, to visit this country. On page 37 is reproduced his
View of the Rocky Mountains on the Platte, which is the earliest known picture of
the Rockies made from firsthand observation. Seymour painted 150 landscape
views and other pictures, of which 60 were finished when he returned to Philadel-
phia. Eight of these, presumably the best, were reproduced in an atlas intended to
accompany the published journal.[1] This was issued in 1822, the year before the

[1] *Account of an Expedition from Pittsburgh to the Rocky Mountains Performed in the Years
1819 and 1820 . . . under the Command of Major Stephen H. Long,* by Edwin James, Phila-
delphia, 1823.

COLONISTS AT RED RIVER (1825) Peter Rindisbacher (Public Archives of Canada)

two-volume text appeared, but the artist's pictures are sadly disappointing both from the standpoint of documentary value and craftsmanship, in spite of their historical importance.

Seymour accompanied another expedition under Major Long in 1823. This was a six months' trip, covering about 4,500 miles into the region around the Lake of the Woods and Lake Winnipeg. The account of this journey was published in London in 1825.[2] It contains only five pictures, not all of which are of a certainty by Seymour, and these also fall far short of inspired art. Aside from their early date, they have but little importance.

Following closely after Seymour came Peter Rindisbacher. He was born in the canton of Bern, Switzerland, in 1806, and his parents brought him to America in 1821. They were among a party of 157 Swiss settlers recruited to join Lord Selkirk's doomed Red River colony in the vicinity of the Hudson's Bay Company's

[2] *Narrative of an Expedition to the Source of St. Peter's River, Lake Winnepeek, Lake of the Wood, etc., Performed in the Year 1823 . . . under the Command of Stephen H. Long, U.S.I.E.,* by William H. Keating, London, 1825.

Fort Douglas, near the present site of Winnipeg, Manitoba. The misinformed emigrants were brought by ship into icy Hudson Bay, whence they had to make a 600-mile journey through the wilderness to their destination. The fifteen-year-old Peter Rindisbacher made an exceptional series of water-color paintings of the whole journey. Forty of these, as well as views of the settlers around the Red River colony, the Indians, and buffalo hunts, are now in the Public Archives of Canada. They are the earliest known paintings of the English settlement of Western Canada, and presumably the first *genre* works of any artist in the interior of North America. One of these is reproduced on page 40.

The Rindisbacher family, like most of the other settlers, did not do very well as agricultural pioneers in the wild new land. They had to go on buffalo hunts to get food to survive, and this necessitated traveling out into the prairies where the Sioux had already taken a fancy to the scalps of the white intruders. All this proved an inspiration to young Rindisbacher, and, although self-taught as an artist, his colorful little paintings were soon being sought after by high-ranking officials of the Hudson's Bay Company, from as far away as England. As early as 1824, when only eighteen, he was receiving as much as £6 for his little water colors.[3]

Tragic winters and starvation conditions were climaxed by the disastrous flood of 1826. The Rindisbachers, together with other settlers, abandoned their pioneer homes and migrated overland to Fort Snelling (Minnesota), a journey of about four hundred miles through hostile Indian country. The following spring the family went down the Mississippi in mackinac boats to settle in present Wisconsin. Still painting his frontier scenes, Peter went to St. Louis in 1829, where he set up a studio and worked successfully until his death in August, 1834, at the early age of twenty-eight. At least ten lithographs of his paintings appeared in the *American Turf and Sporting Magazine*. A portfolio of six others, titled *Views in Hudson's Bay*, was issued in London before his death. Another of his pictures, *War Dance of the Sauks and Foxes*, was selected to be the frontispiece of Volume I of McKenney and Hall's well-known portfolio of *Indian Tribes* (see page 40). In addition to the forty Rindisbacher originals in the Public Archives of Canada, there are eighteen in the Museum at the United States Military Academy at West Point and six in the Peabody Museum at Harvard.

A third artist who enjoyed an unusual opportunity in the early West was James Otto Lewis. During the years 1825 to 1828 he was commissioned by the United States Indian Department "to attend the different Indian Councils, for the pur-

[3] "Peter Rindisbacher—Red River Artist," by Margaret Arnett MacLeod, *The Beaver Magazine*, Winnipeg, December, 1945.

pose of taking portraits of the distinguished chiefs. . . ." The first of these was at Prairie du Chien, Michigan Territory (now Wisconsin) in 1825, when the United States government invited the various Indian tribes to meet and attempt the settlement of feudal differences between them. Another purpose of the conclave was to induce the Sioux to cede to the government all their lands east of the Mississippi, and to bargain for the purchase of some 20,000,000 acres of their rich agricultural land for as much below ten cents an acre as the commissioners could induce the chieftains to accept.

Prairie du Chien was situated on the Upper Mississippi, about five hundred miles above St. Louis. Even in 1825 it had a glamorous background as one of the earliest principal fur trading posts of the French. The Indians had been coming there from long distances farther west for well over a hundred years. It had recently become a United States frontier garrison, although its local residents and transient visitors were still largely the pioneer French and half-breed stock—a hardy and experienced lot, well versed in all the Indian traits and not altogether in sympathy with the new American regime.

The Indians who gathered for this big council meeting provided a wild and colorful spectacle. A vivid description by artist Lewis appears in the text accompanying the 1839 reissue of his *Aboriginal Port-Folio.* He had this to say about the Fox chief CUT-TAA-TAS-TIA (see page 39) who attended the conclave: He "appeared in Council in his war dress, wearing a sword, from the hilt of which hung five human scalps, the terrible trophies of his success and valor in battle. . . . The appearance of the entire tribe was fierce and savage in the extreme and corresponded with the character of their chief."

The principal tribes attending were the Sioux, Potawatomis, Winnebagos, Chippewas, Iowas, Menominees, Sauks, and Foxes. The high commissioners representing the United States government were Governor Lewis Cass of Wisconsin Territory, and William Clark (of Lewis and Clark fame), the governor of Missouri. The most delicate situation which faced the council was an attempt to make peace between the Sioux and the Sauks and Foxes, among whom for a number of years there had been waging a bloody and destructive war. All the invited tribes had assembled and set up their wigwams at different points around the treaty ground, except the Sauks and Foxes, whose appearance was tensely awaited. Some of the braves passed the time indulging in the war dance, others at games of wrestling, foot racing, and the various competitions of strength, stamina, and skill in which every warrior took great pride.

"In the midst of these athletic exercises," wrote Lewis, "a sudden and shattering sound broke upon the ear. The tap of the distant Indian drum intermingled

with reiterated war cries—came booming on the breeze, heralding the approach of other warrior bands. . . . Slowly winding their way around a rocky promontory, forcing their passage against the current of the Mississippi, were to be seen the congregated bands of the Sauks and Foxes, comprising a thousand panoplied and painted warriors. Boldly erect they stood in the majesty of nature, in their canoes, lashed side by side together, indulging in the dance and rendering the river vocal with their war songs. . . . In their seventy canoes . . . the *tout ensemble* was frightfully magnificent.

"Meanwhile the Sioux, who kept in the background on the shore, gazed on their advancing foes with stillness and attention. It was neutral ground, consecrated to peace, and the moment the savage warriors touched the shore, they must bury the tomahawk and stay their murderous strife. Some of the red warriors landed, marshaled in Indian file, and with their chiefs KEE-O-KUCK (see page 39) and CUT-TAA-TAS-TIA at the head, marched to a rising ground, where their friends the Chippewas were in waiting to receive them. . . . The calumet or peace pipe was then tendered and smoked, and a few congratulatory speeches were delivered with vehemence by the savage orators. . . . In the interim the Sioux commanded by their war chief WAA-NA-TAA (see page 39) hurled upon the Sauks and Foxes the fierce proud looks of hatred, rage and defiance. They were, however, restrained from violence and the day departed without any outbreak of hostility."

Of one of the other chiefs, Lewis wrote: "In very early life he visited the carousels of slaughter and delighted to bathe his tomahawk and scalping knife in the blood of his victims. His mercies were those of the grave, and few, if any with whom he entered the death strife, ever escaped the revengeful fury of his arm. . . . He was extravagantly fond of whiskey."

It seems unfortunate that James Otto Lewis did not devote more of his time to writing, particularly when we consider the art work he accomplished. In addition to the treaty meeting at Prairie du Chien, he also attended those at Fond du Lac, Butte des Morts, Fort Wayne, and elsewhere, devoting about fifteen years to attending these councils and otherwise observing the passing parade of Indian pageantry. But his paintings are little more than stilted portraits, such as those reproduced on page 39. Eighty of these were published in *The Aboriginal Portfolio* in 1835. This set of plates in the original edition of separate parts is one of the rarest of pictorial works relating to the American Indians, although there were numerous reissues during the succeeding twenty years.

An examination of the available works of all of these early Western artists is disappointing—both from the standpoint of art and historical documentation. There is but little evidence of the amazing material so profusely thrust upon them.

George Catlin

4 *Dean of Western Artists*

THE FIRST ARTIST of real stature to go into the West for the express purpose of delineating a documentary record of the various Indian tribes was George Catlin. He covered more territory and pictured more different tribes, in greater detail, while they were still in their unspoiled primitive state, than any other artist. After he had made hundreds of his pictures, he set out to acquaint the rest of the world with a realistic knowledge and sympathetic understanding of the American Indians. He devoted his life almost entirely to this high purpose and is indisputably the dean of our Western artists, for reasons that go far beyond the craftsmanship of his profession.

George Catlin was born July 26, 1796, at Wilkes-Barre, Pennsylvania—the fifth of a family of fourteen children. As a boy his two predominating interests were hunting and fishing, and his parents had great difficulty in turning his attention to books. After the limited schooling usual to sons of persons of modest means in the newly created states, he was induced to study law. He was, however, deeply interested in art and gained some local reputation as an amateur portrait painter. After four years of practicing law in the courts of Luzerne County, Pennsylvania, he gave it up and went to Philadelphia in 1823 to try to make art his profession. His promising ability and likable personality quickly won for him the encouragement and warm friendship of Rembrandt Peale, Thomas Sully, and John Neagle. His proficiency as a painter of miniature portraits on ivory gained for him election as an Academician in the Pennsylvania Academy of Fine Arts on February 18, 1824.

Constantly searching for some special field in which he might win distinction, years later he recalled the incident which provided the inspiration for his life's work:

"A delegation of dignified looking Indians from the wilds of the West arrived in the city, arrayed and equipped in all their classic beauty, with shield and helmet, tinted and tasseled off exactly for the painter's palette. . . . In the midst of success I resolved to use my art and so much of the labors of my future as might be

required, in rescuing from oblivion the looks and customs of the vanishing races of the native man in America."

He spent the winter of 1829–1830 in Washington, D. C., where he obtained a letter of introduction to Governor William Clark, Superintendent of Indian Affairs for Missouri, and set out for St. Louis to begin his roaming and painting through the wilds of the West. Governor Clark received him cordially and provided the thirty-four-year-old artist with much valuable information, drawn from his experience as co-leader of the Lewis and Clark expedition and from representing the government in dealing with the various tribes. Catlin spent a great deal of time with the Governor and accompanied him to council meetings in 1830 and 1831, held with the Winnebagos, Menominees, Shawnees, Sauks, and Foxes. It was on these occasions that Catlin began his Indian painting.

Entirely dependent upon financial returns from his art for a livelihood, Catlin pursued the plan of working at routine portrait painting, generally in St. Louis, during the winter months as a means of getting funds for summer trips into the Indian country. He would set up shop in some little house in a promising part of town and outside the improvised studio hang his shingle: "G. CATLIN, *Artist.*" Then he would spread the word that first-class portraits would be painted at reasonable prices. When he had painted all the town dignitaries or others who could afford such a luxury, he would move on to a new location. He would work hard and save all he could, until the rivers were clear of the winter ice; then he would start for the summer's work in Indian country.

After spending the winter of 1831–1832 in St. Louis, Catlin started on his first big trip—a 2000-mile journey up the Missouri to remote Fort Union. The trip upstream was made on the maiden voyage of the American Fur Company's steamboat *Yellow Stone*, the first to navigate the river above Council Bluffs. On the way up he made notes on the Indian villages which seemed to offer the best opportunities for painting, for he planned to make the return trip in a canoe, stopping along the way to make pictures.

The *Yellow Stone* reached Fort Union on June 26, 1832, and Catlin remained there for several weeks. This remote frontier post, which was built in July, 1829, was a popular rendezvous for the Crows, Blackfeet, Assiniboins, and Knisteneux (Cree) Indians, some of the finest types on the whole continent. Realizing that he was one of the first artists to be privileged to paint these Indians, Catlin worked with diligence. Not content with confining his painting to the subject matter around the fort, he made a number of trips by canoe, up and down the rivers and overland to the homes of the tribes. In addition to the large number of sketches and paintings, he took voluminous notes on everything he saw and learned—writ-

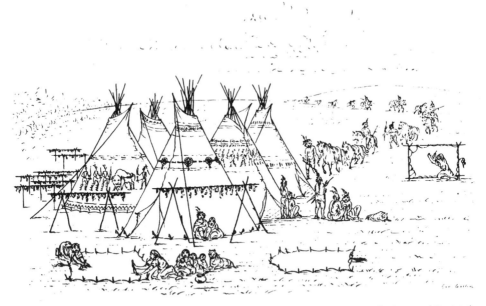

Sioux Buffalo Hunting Camp George Catlin (New York Historical Society)

ten more like the journal of an anthropologist than the memoranda of an artist. Upon his arrival in the West he had also begun sending back to New York City, for publication in the *Daily Commercial Advertiser*, a series of "letters" based on his travels and observations of the various Indian tribes.

This was dangerous Indian country, into which few white men ventured alone for fear of losing their scalps. From the start of his career, however, George Catlin never hesitated to go anywhere alone and he seems always to have won the warm friendship and confidence of the Indians. After a month at Fort Union, he wrote in one of his "letters":

"I am now in full possession and enjoyment of those conditions on which alone I was induced to pursue the art as a profession. . . . I have contemplated the noble red men who are now spread over the trackless forest and boundless prairies, melting away at the approach of civilization; their rights invaded, their morals corrupted, their lands wrested from them, their customs changed, and thenceforth lost to the world, and they at last sunk into the earth and the plowshare turning the sod over their graves; and I have flown to their rescue, not of their lives or of their race (for they are 'doomed' and must perish), but to the rescue of their looks and their modes, at which the acquisitive world may rise from the stain of a painter's palette and live again upon canvas and stand forth for cen-

turies yet to come—the living monuments of a noble race. For this purpose I have designed to visit every tribe of Indians on the continent, if my life shall be spared."

On this one trip in 1832 Catlin made a documentary record of the Plains Indians which has never been surpassed. It includes the Mandans, Crows, Blackfeet, Knisteneux (Cree), Assiniboins, Minnetarees (Hidatsas), Arikaras, Sioux, Poncas, and Iowas. In addition to his pictures he wrote about them in the greatest of detail: their eyes, nose, teeth, why they considered beards a social vulgarity, why they had small families, their childbirth customs, bathing habits, affections, laws, religion, arts, writings, their opinions of white men, and practically every other aspect of their lives. To all this he added a comprehensive word picture of their primeval background "where the buffaloes range with the elk and the fleet-bounding antelope; where wolves are white and bears grizzly; where the rivers are yellow . . . the dogs are all wolves, women are slaves, men all lords . . . where the predominant passions of the savage breast are ferocity and honor. . . ."

After living, traveling, and hunting with the tribes around Fort Union, and painting them all, Catlin began his leisurely 2000-mile journey down the Missouri in a canoe. With him were two trappers, "Ba'tiste and Bogard." They were well supplied with "ammunition in abundance . . . dried buffalo tongues, a dozen or two of beavers' tails and a good supply of pemmican [pounded meat] . . . three tin cups, a coffee pot, one tin plate, a frying pan and a tin kettle . . . ," together with his art materials. They stopped to visit various Indian encampments and to hunt buffalo, elk, antelope, grizzly bear, and mountain sheep. On the seventh day they reached the big Mandan village on the river's bank opposite the present location of Bismarck, North Dakota. Here Catlin stayed for a couple of weeks "in this almost subterranean city, the strangest place in the world, where one sees in the most rapid succession scenes which force him into mirth, to pity and compassion, to admiration, disgust, fear and astonishment."

If Catlin had visited and portrayed no other Indian tribe than the Mandans on the Upper Missouri, the paintings and notes by which he so thoroughly and accurately described these people and their practices and customs, should alone preserve his name in the annals of American art. The importance of this record became greatly increased by the near extermination of the Mandans just five years after his visit, when an epidemic of smallpox took the lives of about 1500 of them, leaving little more than a hundred.

"The lodges are covered with earth" (see page 57), he described the village, "so completely fixed by long use, that men, women and children recline and play upon their tops in pleasant weather. . . . There are several hundred of these houses . . . 40 to 60 feet in diameter, all circular and close together. . . . In the middle is

an open area 150 feet in diameter, in which their public games and festivals are held . . . and over the Medicine Lodge are seen hanging on high poles sacrifices to the Great Spirit . . . sachems, warriors, dogs and horses in motion . . . an air of intractable wildness."

Catlin was the first artist to witness the ceremonial Bull Dance (see page 58),

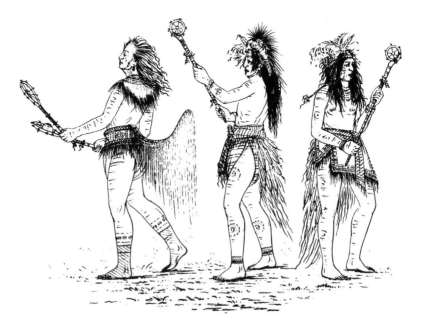

INDIAN BALL PLAYERS George Catlin (New York Historical Society)

and the self-sacrificial ordeal of the Sun Dance or Pohk-Hong (The Cutting Scene) (see page 59), which he drew with the detail of a delicate miniature on ivory. Here is the artist's own description of this most dramatic and excruciating of all the cults of the Plains tribes:

"I entered the medicine-house of these scenes as I have entered a church, and expected to see something extraordinary and strange, yet in the form of worship and devotion; but alas! little did I expect to see the interior of this temple turned into a slaughter-house and its floor strewed with the blood of its fanatic devotees . . . their propitiatory suffering and tortures, surpassing, if possible, the cruelty of the rack or the inquisition . . . a number of the young men are seen reclining and fasting . . . others have been operated upon by the torturers, and taken out of the lodge . . . one is seen sinking whilst the knife and splints are passed through his flesh. One is seen hanging by the splints run through the flesh of his shoulders, and

drawn up by men to the top of the lodge. Another is seen hung up by the pectoral muscles, with four buffalo skulls attached to splints through the flesh on his arms and legs; and each is turned around by another with a pole, till he faints, and then is let down. One is seen as he is lowered to the ground; and another, who has been let down and got strength enough to crawl to the front part of the lodge, where he is offering to the Great Spirit the little finger of his left hand, by laying it on a buffalo skull, where another chops it off with a hatchet . . . whilst all the chiefs and dignitaries of the tribe look on." [1]

Finally returning to St. Louis in the late fall, the artist turned to making finished paintings of his field sketches, and went back to his portrait work to procure funds for another trip. As soon as the ice was out of the rivers in the spring of 1833, he ascended the Platte to the vicinity of Fort Laramie (Wyoming), and "rode to the shores of the Great Salt Lake." [2] During this trip he visited and sketched the Arapahos, Cheyennes, Pawnees, Omahas, and Otos, traveling freely among them. To visit Great Salt Lake, he crossed the Rocky Mountains, although this trip has recently been disputed in a rather academic attempt to prove that Catlin was the third rather than second artist to visit the Rockies.

The following winter he spent in St. Louis, Pensacola (Florida), and New Orleans. During this period he obtained permission from the Secretary of War to accompany the First Regiment of Mounted Dragoons on an expedition to the Pawnee and Comanche country and the Rocky Mountains in a little-known area of the Southwest. The First Regiment had just been organized for frontier service and had been moved from Jefferson Barracks, near St. Louis, to Fort Gibson on the Arkansas, to which place Catlin journeyed upriver by boat. They left Fort Gibson on June 19, 1834, and the hardships of this rigorous expedition are well documented. The official report to the United States Adjutant General's Office of the War Department is contained in Lt. Thompson B. Wheelock's *Journal of the Campaign of the Regiment of Dragoons under Col. Henry Dodge from Fort Gibson to the Rocky Mountains in 1834.*[3] References are made to the artist's accompanying the expedition: "July 4th—Mr. Catlin, portrait painter, is also with us. . . . July 18 . . . six litters [of sick] including Mr. Catlin . . . ," etc. A more detailed account is to be found in *Dragoon Campaign to the Rocky Mountains,* by A Dra-

[1] *The George Catlin Indian Gallery . . . with Memoir and Statistics,* by Thomas Donaldson, Annual Report, Smithsonian Institution, Washington; D. C., July, 1885, p. 362.

[2] *Ibid.,* p. 475.

[3] Public Documents of the U. S. Senate, 2nd Session of the 23d Congress, Vol I., Washington, D. C., 1834.

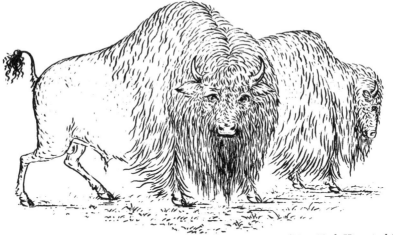

BUFFALO BULL AND COW George Catlin (New York Historical Society)

goon.[4] In this book the author quotes at length some of the letters which George Catlin wrote and sent back East for publication, finding them a better description of the incidents on the expedition than his own words might be.

Serious illness broke out among the dragoons shortly after they left Fort Gibson and took the lives of a large number of the men. Even General Leavenworth, who had planned to accompany them part of the way, died in his tent at the mouth of the False Washita. Although Catlin was so ill he became a "litter case" and could not "hold pen or paintbrush" for several days, he refused to be left in a sick camp established on the way. Finally they reached the big Indian camp at the edge of the Rockies, which was one of their objectives: "The Comanche camp, which was composed of 200 to 300 wigwams . . . is but a short distance away. . . . On the left, in the distance, could dimly be discovered an arm of the Rocky Mountains, the loftiest of whose summit seems to rend the clouds. . . . Our course lay directly across this chain of the mountains." [5] Later the Dragoon's book continues with the account, describing how when they "arrived at the foot of the mountains, we were obliged to dismount and lead our horses. . . ." Catlin himself covers the whole trip with an extensive and detailed account.[6]

The expedition returned to Fort Gibson in the late fall, and although Catlin was still quite ill from the fever, he made the 550-mile overland journey back to St.

[4] *Dragoon Campaign to the Rocky Mountains*, by A Dragoon (James Hildreth), Wiley & Long, New York, 1836.

[5] *Ibid.*, p. 159.

[6] *The George Catlin Indian Gallery* . . . , "Itinerary of 1834," pp. 475–491.

Louis, alone on a horse named "Charley," wandering about in search of new Indian material to sketch and paint.

In the spring of 1835 the artist ascended the Mississippi to the Falls of St. Anthony, spending the season among the Sioux, Ojibways, and other tribes of that area. In 1836 he made a 2100-mile trip by birchbark canoe from Green Bay, via Prairie du Chien, and up the St. Peter's River to the famed prehistoric quarries where the Indians had for centuries procured the red pipestone to make their sacred pipes. Catlin was the first white man the Indians ever permitted to visit this zealously guarded sanctuary. He was also the first to describe the quarries in writing, and the red pipestone material has since been known as "catlinite" in scientific nomenclature, as a lasting tribute to the intrepid artist-explorer.

In the fall of 1836 Catlin transported all his Indian paintings and his large collection of Indian paraphernalia to New York City, and in 1837 his exhibition in several cities of the East brought him international renown. The New York show contained 494 of his colorful paintings. They were not the static portraits of his predecessors, but animated and realistic scenes from the lives of the Western Indians. Successful exhibitions followed in Philadelphia, Washington, and Boston. Then in 1839 he took his "gallery" to London, where he leased Egyptian Hall, Piccadilly, for three years. He also lectured extensively about the American Indians, championing their cause wherever he could find an audience, and in his gallery he demonstrated their dances and ceremonies, first with white actors and later with real Indians.

Catlin had in the meantime made a book manuscript of the "letters" he had written to the *Daily Commercial Advertiser* over a period of almost nine years but was unable to find a publisher, because of the great expense involved in the printing of the many plates which he insisted should go into it. Finally, in London in 1841, he personally underwrote the costs for his *Notes of Eight Years' Travel amongst the North American Indians*, a two-volume work with 400 engravings from his paintings. This venture proved highly successful, going into numerous editions. In 1844 his *North American Indian Portfolio* was also issued in London with twenty-five large tinted lithographs from stone; later editions included thirty-two plates. Subsequently he had other books published on the subject of the Indians.

In 1845 he took the gallery of paintings to Paris, exhibiting in the Salle Valentino, and by command of King Louis Philippe, at the palace of the Tuileries and at the Louvre. But the French uprising and riots in February, 1848, brought sudden disaster to George Catlin. With great difficulty he transported his paintings and his Indian gear back to London, where he opened another exhibition. But the tide of fortune had turned against him. He became the victim of unscrupu-

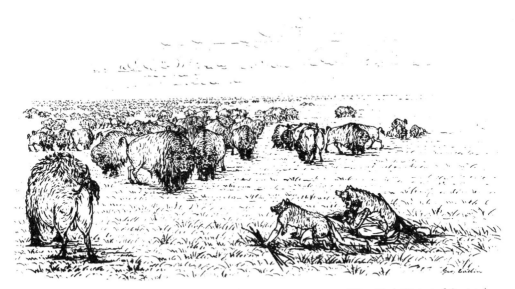

THE ARTIST DISGUISED AS WOLF George Catlin (New York Historical Society)

lous speculators and fell deeply in debt, and in 1852, in a state of bankruptcy, he lost his entire collection to his creditors. An American gentleman, Joseph Harrison, Jr., paid off the artist's debts and took possession of all the paintings and Indian paraphernalia, shipping them to his home in Philadelphia. There they were put in storage and remained completely out of sight and sadly deteriorating for twenty-seven years, until seven years after the artist's death.

Although Catlin was now fifty-six years old, financially ruined, and his life's work swept into oblivion, he bravely set about to remake all his paintings from sketches and memory. He also returned to his travels and between 1852 and 1860 somehow managed to cover even more wild territory than he had previously. He visited native tribes in South America from Tierra del Fuego to the heart of Venezuela and the Upper Amazon, and went clear across that continent from the Atlantic Coast of Brazil to Peru. He also made other extensive trips in the western part of the United States and to Alaska.

George Catlin died on December 23, 1872, in Jersey City, in his seventy-seventh year, after a painful illness. He had painted and repainted pictures of the American Indians, and championed the cause of the red man to the very end of his life. Practically the last words he spoke were: "What will become of my Indian gallery?"

On May 15, 1879, the heirs to the estate of Joseph Harrison, Jr., made a gift of the original Catlin collection "to the people of the United States," and it was promptly removed from storage and transferred to the National Museum, Smithsonian Institution, Washington, D. C. There it was and still is permanently ensconced as a monument to the artist's labors and sacrifice. Unfortunately, Catlin died without knowing that his work would be thus preserved. Today there are 450 oil paintings in this collection. The *Scalp Dance of the Sioux*, on page 58, is reproduced from one of these original works. The American Museum of Natural History in New York has 417 of the oil paintings which he recreated after losing his gallery (see pages 57 and 58), and there are 221 of his drawings, similarly made, in the New York Historical Society (see pages 59 and 60).

George Catlin devoted all his days to the perpetuation on canvas of the Indian way of life. His influence has been tremendous. What shortcomings he may have had in artistic craftsmanship are insignificant in the light of what he accomplished. His stature must always increase, as the dean of all our Indian painters and the interpreter of a culture that has long since and tragically disappeared.

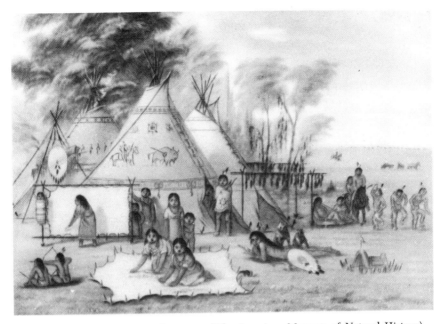

A Sioux Village George Catlin (The American Museum of Natural History)

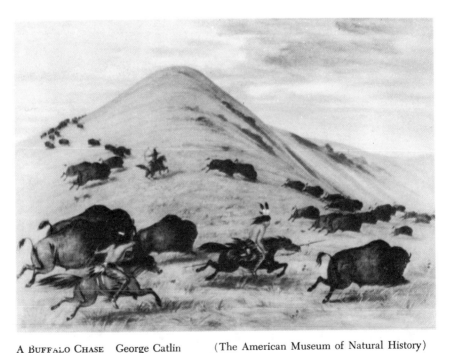

A Buffalo Chase George Catlin (The American Museum of Natural History)

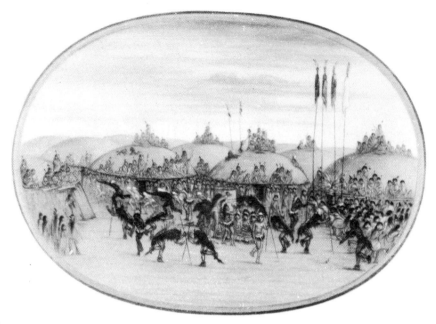

BULL DANCE OF THE MANDANS George Catlin (The American Museum of Natural History)

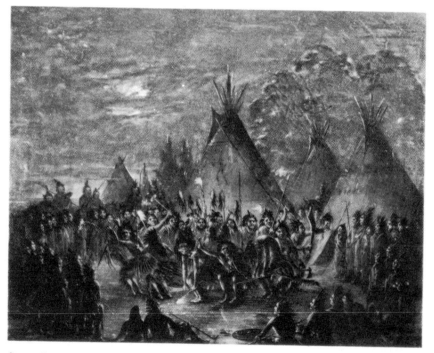

SCALP DANCE OF THE SIOUX George Catlin (Smithsonian Institution)

A Mandan Chief George Catlin (New York Historical Society)

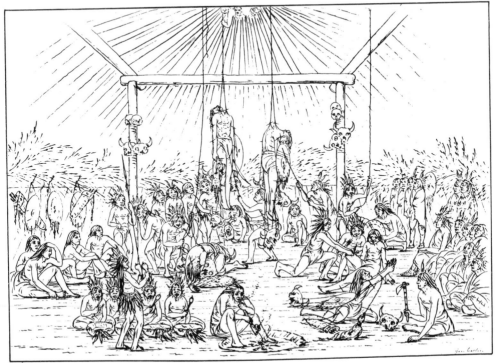

The Ordeal of the Sun Dance George Catlin (New York Historical Society)

CATLIN PAINTING MANDAN CHIEF George Catlin (New York Historical Society)

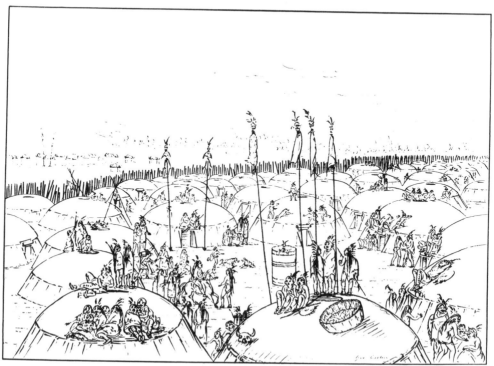

MANDAN VILLAGE George Catlin (New York Historical Society)

THE DEATH WHOOP Seth Eastman

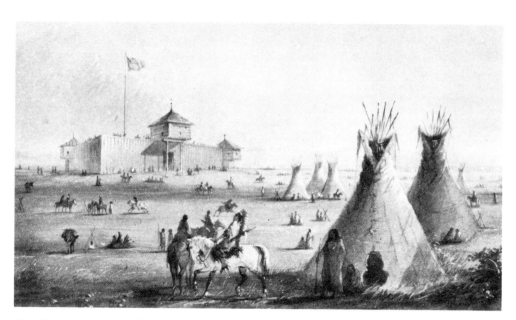

Fᴏʀᴛ Lᴀʀᴀᴍɪᴇ–1837 Alfred Jacob Miller (University of Oklahoma Press)

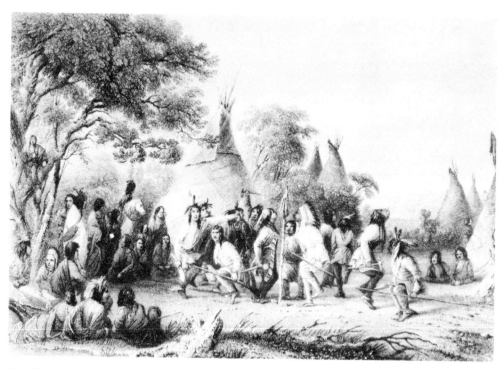

Dᴏɢ Dᴀɴᴄᴇ ᴏғ ᴛʜᴇ Dᴀᴋᴏᴛᴀʜs Seth Eastman

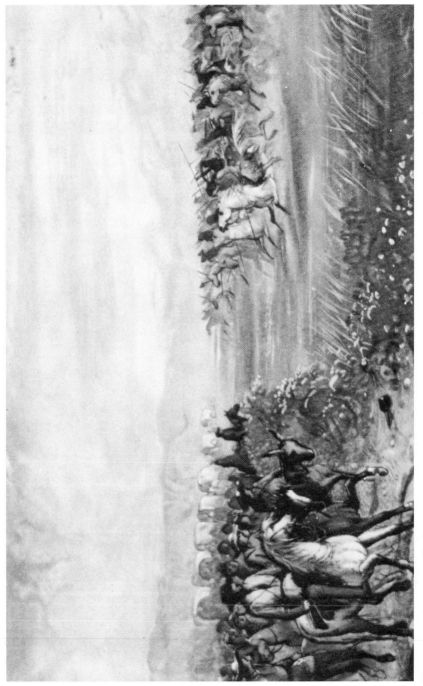

THREATENED ATTACK Alfred Jacob Miller

(Mrs. L. R. Carton)

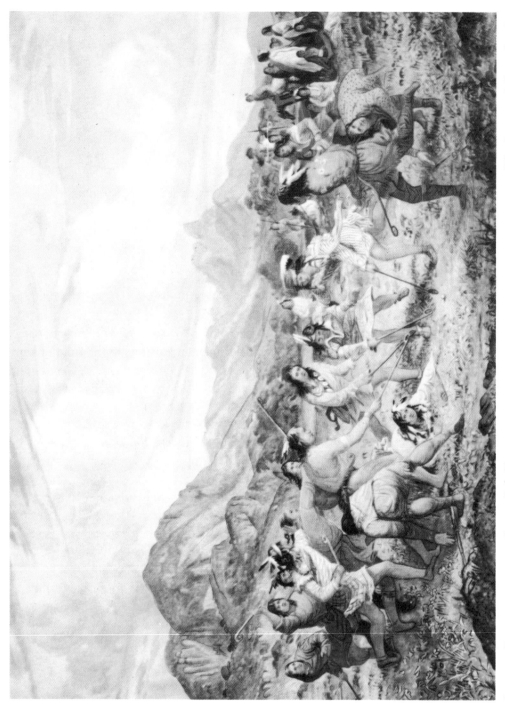

LACROSSE PLAYING AMONG THE SIOUX Seth Eastman

Seth Eastman

5 *Soldier with a Sketchbook*

IT IS AN IRONICAL FACT, particularly in the field of frontier experience, that those who have the most intimate knowledge of the natives are often the least qualified or the least inclined to make their information a matter of permanent record. There was many a shaggy old squaw man, uneducated trapper, and trader in furs who had a vast wealth of knowledge about the early-day Indians, of which we know little or nothing today. There were others who found a strong incentive to become artist or author, in the colorful scenes and dramatic incidents of the frontier. The historical implication was that this strange and colorful way of life would ultimately pass beyond the reach of artists and historians. Many frontiersmen and visitors to the frontier kept journals and made sketches of a crude nature which have played an important part in helping to complete the story of our Old West. Undoubtedly many more are still lying in discard in old trunks and family attics, or have been destroyed because their real value has been hidden in their amateurish shortcomings. Casual personal records and random sketches, attempted merely for albums of recollections, often make important contributions to the historical record.

Army officers who were stationed at the various forts in the Indian country before the days of intensive fighting began had a particularly advantageous opportunity to record the passing scenes around them in sketchbooks and journals. They could not get the insight into the red man's life that was privileged to some of the hardier characters who actually lived in the tepees, for the Indian had a fierce respect for his own ancestral ideas and customs, and much that was held sacred was closely guarded against outside observation. But the army officers were generally of sound education and above-average ability. Their education at West Point included training in sketching, and they had both the time and facilities to take advantage of their opportunities. One of those who persevered until he securely established himself among our Western artists was Seth Eastman. He was fortunate in having a very accomplished wife. Mrs. Mary Henderson Eastman not only collaborated in writing the text for some of the fine books in

which his pictures appeared, but was undoubtedly a guiding influence in his career.

There are no records to show that Seth Eastman manifested any particular abil-
ity along these lines in his boyhood. Born in Brunswick, Maine, January 24, 1808,
he was appointed to the United States Military Academy at West Point on July 1,
1824, and graduated four years later as a second lieutenant, assigned to duty
with the First Infantry at Fort Crawford on the bank of the Mississippi River near
Prairie du Chien, Michigan Territory. He served through 1829 and 1830 in the
environment of the old French-Canadian fur trading rendezvous and important
council meeting place for the Sauks, Foxes, Winnebagos, Sioux, and other tribes.
The young West Point graduate kept no journal of those first days as an officer on
the frontier, but we know that he started sketching the scenes around him very
shortly after he arrived in the Indian country, from one of his pencil drawings
which bears the inscription: "Fort Crawford, Prairie du Chien, 537 miles above
St. Louis, Oct. 1829." That was a year before Catlin arrived in St. Louis to make
his first pictures of the West, and three years before he made his memorable trip
up the Missouri. The Seth Eastman drawings of this period are relatively crude,
although they show an indication of natural talent. Their value is greatly enhanced
by the fact they were strictly documentary in character, and not the stiff and static
portraits made by James Otto Lewis four years before.

Eastman's regiment was moved farther up the Mississippi in 1830 to Fort Snell-
ing, 7 miles below the Falls of St. Anthony—the present location of Minneapolis.
Established in 1819, this big fort was at the time the principal stronghold of
United States military authority in the Northwest, maintained to keep the peace
among the Sioux, Chippewas, Winnebagos, and other tribes, and to protect the
steadily increasing number of pioneers who were beginning to push our national
frontier westward. Fort Snelling had become a great military supply base, and
from its garrison went out columns of well-armed soldiers to roam far across the
new country which was being taken over by the white man. It was to this haven of
protection that the Rindisbacher family had fled from the Red River colony in
1826, and it was to be visited by many other artists in succeeding years.

Eastman spent the better part of a year at Fort Snelling during his first assign-
ment there, and he progressed so well with his drawing that in 1831 he was de-
tailed to topographical reconnaissance work, which for the next two years took
him on extended trips farther out into the West. It was during this time that he
began an extensive series of pictures of our frontier forts, which won for him a
lasting recognition among military men as well as artists. The paintings later made
from these sketches today hang in the Capitol building in Washington. On Janu-
ary 9, 1833, in acknowledgment of his proficiency, he was assigned to the staff of

FORT SNELLING Seth Eastman

the Military Academy at West Point as assistant teacher of drawing, a position he held for seven years. Returned to active duty in 1840, he served a year in the Florida War, after which he was assigned back to Fort Snelling, where he served as a captain for seven years, between 1841 and 1848.

When he returned to his old post on the Upper Missouri, he brought with him a wife, Mary Henderson Eastman, the daughter of the surgeon general of the United States Army, and their two young sons and a daughter. It was during this period at Fort Snelling that he applied himself most seriously to the broader aspects of frontier painting. He was one of the first artists to use photographs as an alternative for field sketches, employing an early model of daguerreotype camera to get pictures of groups of Indians engaged in their dances, games, and daily pursuits, for the purpose of later transposing the scenes into finished paintings.

Eastman enjoyed an exceptional opportunity to observe and paint Indians during his seven years at Fort Snelling. The region was dominated by the Mdewakanton, a tribe of the Dakotas and the largest division of the Siouan linguistic family. Their villages stood on the banks of the Mississippi and the Minnesota (St. Peter's) rivers, easily reached from the fort, and many of their leaders became Eastman's good friends. According to official reports, this tribe numbered about 1,658, of which 484 were warriors. They lived in seven villages composed of bark houses.

Parties of Ojibways, the tribe which occupied the country to the north and east, also visited Fort Snelling, and often members of the two groups, traditional enemies, engaged in combat not far from the fort. For the council meetings, other tribes gathered from long distances around, in all their warrior pomp and proud display. The land itself was a region of virgin forests, lakes, and streams where wild game abounded. Such was the Indian country in which Seth Eastman lived for seven years.

During 1848–1849 a march through Texas on reconnaissance temporarily ended Captain Eastman's active field duty, and he was ordered to Washington, D. C., where he turned his whole attention to making paintings from his sketches, while his wife devoted herself to a literary career. They worked together, and the first book by Mrs. Mary Henderson Eastman was *Dakotah; Life and Legends of the Sioux—around Fort Snelling*, published in New York in 1849, and illustrated by Captain Eastman. The book is an important early contribution to our knowledge of Western Indian character. Its author was apparently a very religious woman and something of a poetess, with a touch of Victorian utopianism and a sensitive appreciation for both the romantic and realistic sides of Indian life. She was a champion of the red man's cause and an exponent of his better qualities, at the same time remaining a realistic chronicler of the more violent of his traditions. Her descriptions of Fort Snelling and the life around it are clear-cut and vivid. She described the fort as "constructed of stone . . . one of strongest forts in the United States . . . placed on a commanding bluff, with somewhat the appearance of an old German castle." Captain Eastman's picture of the fort, which is reproduced on page 67, provided the frontispiece for their first book.

"Between the fort and the Falls of St. Anthony are the 'Little Falls' . . . ," she continues in her description. "The Indians call them '*Mine-hah-hah*' or 'laughing waters.'" Some of the passages in her book are poetically remindful of Longfellow's *The Song of Hiawatha*, published six years afterward, and it is well documented that Mrs. Eastman's book was a principal source of inspiration and information for this epic poem.

Of Capt. Seth Eastman she said: "My husband, before [our] marriage, had been stationed at Fort Snelling and Prairie du Chien. He was fond of hunting and roaming about the prairies; and left many friends among the Indians when he obeyed the order to return to an eastern station. [Captain Eastman spoke their language well.] On going back to the Indian country, he met with a warm welcome from his old acquaintances, who were eager to shake hands with 'Eastman's squaw.' The old men laid their hands upon the heads of my little boys, admired their light hair, said their skin was very white. They brought their wives to see

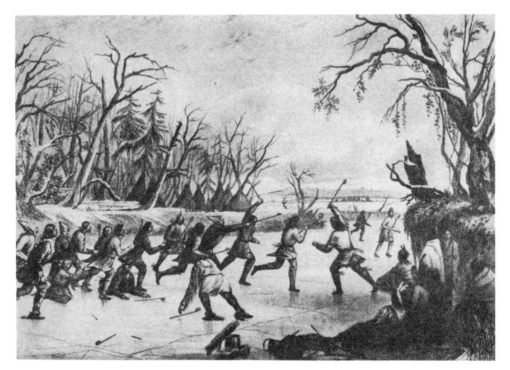

INDIAN BALL PLAY ON ICE Seth Eastman (Litho—New York Public Library)

me. I had been told that Indian women gossiped and stole; that they were filthy and troublesome. Yet I could not despise them; they were wives and mothers— God had implanted the same feelings in their hearts as in mine. . . . When our children were ill with scarlet fever, how grieved they were to witness their suffering. The aged Sioux women, who had crept noiselessly into the chamber—their expressive and subdued countenances full of sorrow. They told me afterward that much water fell from their eyes,' while they thought that my little girl would die."

Captain Eastman was now devoting his entire time to his Washington studio and creating paintings from his abundance of sketches and daguerreotypes made in various parts of the West. The success of their book *Dakotah* had greatly encouraged this team of frontier exponents and inspired in them the ambition to have published a portfolio of Indian pictures and text. In the meantime the Captain was chosen as one of the artists to prepare illustrations for a scholarly and voluminous work on all the Indian tribes of the United States which Henry M. Schoolcraft had been authorized by the United States Congress to compile under

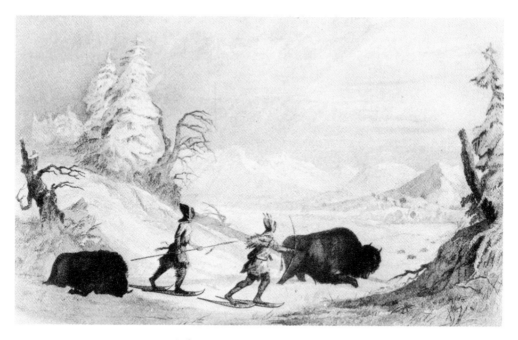

HUNTING BUFFALO IN WINTER Seth Eastman

the supervision of the Bureau of Indian Affairs.[1] This six-volume work was not completed and published for almost ten years, and Eastman's contribution is a lasting monument to his indefatigable perseverance as a self-taught artist. Not only are numerous of his paintings reproduced as full-page plates, but he also made drawings of a great number of Indian artifacts, such as their stone implements, cooking utensils, peace pipes, and other articles which were of daily use in the life of the Indian.

The Romance of Indian Life was published in 1853. This book contained twelve chromolith color plates done from pictures by Captain Eastman and text by Mrs. Eastman. The same year saw the publication of *The Aboriginal Port-Folio*, with twenty-six reproductions from the Captain's paintings and accompanying text by his wife. The *Dog Dance of the Dakotahs*, from this collection, is reproduced on page 62, and on page 61 is *The Death Whoop*, one of the most significant pictures in the portfolio. The engraver must bear the blame for the white man's fea-

[1] *Historical & Statistical Information Respecting the History, Conditions & Prospects of the Indian Tribes of the United States . . . Collected and Prepared under the Direction of the Bureau of Indian Affairs, per Act of Congress of March 3, 1847, by Henry R. Schoolcraft . . . , illustrated by S. Eastman, 6 vols., Philadelphia, 1851–1860.*

tures which have been given to the principal figure, for they do not appear in the original painting which hangs today in a secluded office in the National Capitol building in Washington. By way of explanation, the Captain's rather Victorian lady has the following to say: "It is with a prolonged breath that the Indian warrior shouts the appalling death-cry. It is not the same as the war-cry; it is a sound unlike and far more terrible. The feeling that prompts it is a concentration of all the horrible passions of the human heart. Murder, hatred, revenge, and bloody triumph, unite, in one voice, to sound a victory. The prostrate dead man, with his now useless tomahawk beside him, the arrow in his side, and the blood trickling over his brow, was a moment ago actuated by the same passions; but his form is now quiet forever, and his soul fluttering away to the gloomy regions of the keeper of the souls of the dead. Not so the victor. His blood-stained knife he grasps with one hand, while in the other he holds the crimson scalp . . . and the hills echo again his voice, in the return of the death-whoop."

Mrs. Eastman goes on to explain that "in due time the scalp will be carefully prepared and ornamented . . . stretched upon a hoop, and painted and decorated with feathers. The elated warriors [who have brought back scalps] will cut their hair, paint their faces black, and go into mourning for the enemies they have killed . . . [and will] sing loudly to the music of the medicine man . . . until they are all wearied out. . . ."

Elsewhere in her writings, Mrs. Eastman quotes a chief presiding at a council meeting on the subject of honor: "An Indian who will lie is not worthy to be called a brave. He is not fit to live. If he refuses to sanction what we agreed in council, I will cut his heart out."

As a further indication of the diligence with which Captain and Mrs. Eastman worked together to record the details of their experiences in the Indian country, the following year saw the publication of still another book, *Chicora and Other Regions of the Conquered and the Unconquered*, with twenty-one plates accompanying the extensive text. One of these pictures, *Hunting Buffalo in Winter*, is reproduced on page 70.

At the outbreak of the Civil War, Seth Eastman returned to active duty on September 9, 1861, as a colonel in his old regiment, the First Infantry. Six years later, on December 3, 1867, he retired as a brevet brigadier general, commissioned for bravery. Shortly afterward the United States Congress passed a joint resolution returning him to active duty at full pay "to execute paintings for the rooms of the Committee on Indian Affairs, and on Military Affairs, of the Senate and the House of Representatives. . . ." These paintings still hang in the National Capitol. He died in Washington, D. C., August 31, 1875.

Karl Bodmer

6 *A Barbizon among the Indians*

 BEFORE CATLIN the field of Western art had not taken great strides forward, although many of the earlier expeditions that went into the West for purposes of exploration had brought back volumes of invaluable data. The journal of Lewis and Clark is replete with observations on the country's natural history, anthropology, and agricultural possibilities, and the report of the Long expedition contributed much information of a scientific nature. This is equally true of John Bradbury's travels in the interior in 1809, 1810, and 1811 and H. M. Brackenridge's voyage up the Missouri in 1811 in search of new flora and fauna. Thomas Nuttal made a similar excursion on the Arkansas in 1819, and John K. Townsend made a bird-collecting journey across the Rocky Mountains in 1834. This type of activity is in strong contrast to the lust for treasure of the conquistadors and the quest for profits from fur by the *voyageurs* of France. There were plenty of buckskin brigands among the Yankee frontiersmen, to be sure, and we later sinned unpardonably against all the rights, human and territorial, of the Indians. But there is much that we can be proud of in our early history beyond the Mississippi.

Although it was Catlin, more than any other, who created the popular interest in painting the Indians and frontier life in the West, our native painters did not have a monopoly on Western art. There were several Europeans who came to this continent for the express purpose of painting the wild scenes west of the Mississippi. The first and probably the most accomplished of these foreign artists was Karl Bodmer, a young Swiss who accompanied Alexander Philip Maximilian, Prince of Weid-Neuweid, a small royal house of Rhenish Prussia. These two arrived by ship at Boston on July 4, 1832. The titled leader of the expedition had already established himself as something more than an amateur in the field of scientific exploration by a two-year trip during 1815–1816 into the tropical jungles of Brazil, studying the natives and collecting natural history specimens. Now he had come to the United States on a similar undertaking in our little-known Western country. In order to bring back suitable pictures of the Indians and other

72

scenes to be found along the route, the Prince had brought the twenty-three-year-old Swiss painter, fresh from the art schools of Paris and of promising ability.

Karl Bodmer was born in Riesbach (Tiefenbrunnen), Switzerland, in February of 1809,[1] and became an art student in Paris under the guidance of an uncle, Johann Jakob Mayer. He was described as "tall and handsome," which is easy to believe from his pictures in later life when his neatly trimmed beard gave him a dashing and distinguished appearance.

They did not go directly into the West, for Prince Maximilian spent the first nine months of this trip preparing for the journey by consulting with various scientific men and examining material in our museums in Boston, New York, Philadelphia, and elsewhere in the East. Among those who aided him in this research was the eminent entomologist Thomas Say, who had accompanied Major Long's expedition across the West. During this interim Bodmer made a trip to New Orleans.

The Prince and his young artist arrived at St. Louis on March 24, 1833, to make the best plans possible for a journey into the wild territory beyond. Apparently George Catlin had already left that outpost of civilization for the headwaters of the Platte—although, as Maximilian later wrote, they examined "a great number of the Indian scenes of Catlin . . . in the home of Major Ofallon, in St. Louis."

They left St. Louis at eleven o'clock on April 10, 1833, on the American Fur Company's steamboat *Yellow Stone*, the same boat and the same route which Catlin had taken the previous year. As the boat started on its way "some guns were fired, as a signal . . . and numbers of the inhabitants assembled on the shore. . . . There were about a hundred persons on board, mostly *engagés* and *voyageurs* of the Fur Company—mostly French-Canadians."

Bodmer took advantage of every stop made by the big river boat, finding an increasing number of Indian subjects to sketch as they progressed farther up the Missouri. By the time the *Yellow Stone* reached Fort Pierre it was loaded with buffalo hides and fur and ready to start back to St. Louis. Here Bodmer and Maximilian spent three weeks waiting for another boat to continue their journey. This was in the Sioux country of the Black Hills, and "the Indians, on foot and on horseback, were scattered all over the plains . . . and nearby the Fort were the leather tents of the Sioux Indians, of the branches of Tetons and Yanktons, like a village."

The journey upriver was continued on the *Assiniboin.* There was a brief stop at

[1] The first name Carl is often used, because his pictures in the Maximilian atlas are thus signed—probably because of an attempt on the part of the artist to anglicize his name. In his later work he reverted to the original Karl. The more purely English form of Charles is also sometimes used in referring to him.

Fort Clark, near the big Mandan village, and then on to Fort Union. They went by keelboat to Fort McKenzie, a recently established outpost within about a hundred miles of the high backbone of the Rocky Mountains, and here the artist and his patron remained from August 5 to September 14. The new fort had become a popular gathering place for large numbers of the colorful Blackfeet, of whom there were about 20,000 in the surrounding country, including some 5,000 warriors.

Making serious and detailed paintings of the important personalities among the Indians, arrayed in all their primitive finery of war bonnet and decorated buckskin, often required as much tact as it did artistic skill. Many of the chiefs had a superstitious belief that the artist who put their likeness on canvas took something irreplaceable away from their soul. Others, however, were proud to sit for their portraits. While at Fort McKenzie, Bodmer made a number of fine portraits of the Blackfeet. One chief came eagerly and in full dress, his face painted black and red, clad in a leather jacket elegantly decorated with pieces of ermine and other skins, and carrying a large ceremonial talisman made of the feathers of a bird of prey, woodpecker bills, and red cloth—a remarkably picturesque figure. The sitting was witnessed by another important Blackfoot warrior who was visibly impressed and subsequently dressed up in all his own best paint and finery and presented himself before Bodmer, signifying that he wanted his portrait painted. But this second brave had a very high estimate of his appearance and demanded an extravagant fee for his services. Bodmer's attempt to bargain with the Indian insulted and infuriated him, and it was only after great debate and elaborate compromise that peace was restored and the sitting took place.

Not only was there plenty of material for sketchbooks and drawings, but the Prince and the artist found more excitement than had been anticipated. Trouble had been brewing between the Blackfeet and some of the tribes in the adjacent territory. The other tribes had desired to visit the fort and partake of its trading benefits, but the Blackfeet evidently considered it their private domain. On the morning of August 28 Bodmer and Maximilian were awakened by a sudden turmoil within the compound and outside the walls. A large force of Assiniboins and Crees were attacking the Blackfeet camped around the fort. Here is Prince Maximilian's description:

"When the first information of the vicinity of the enemies was received from the Blackfeet who had escaped, the *engagés* immediately repaired to their posts on the roofs of the buildings, and the fort was seen to be surrounded on every side by the enemy, who had approached very near. They had cut up the tents of the Blackfeet with knives, discharged their guns and arrows at them, and killed or wounded many of the inmates, roused from their sleep by the unexpected attack.

Four women and several children lay dead near the fort, and many others were wounded."

The gates of the fort were opened to permit those Blackfeet who were able, to come inside, and everyone capable of firing a gun rushed to the rooftops and the walls in an effort to repel the superior force of the attackers. Messengers dashed out on horseback to run the gantlet through the enemy lines, in an attempt to reach the main camp of the Blackfeet about ten miles away and bring help. In the meantime the battle raged, with many dead and wounded. If the Assiniboins and Crees had repaired to high ground just across the river, they might have killed everyone inside the fort. But finally the Blackfeet warriors from the main camp came riding onto the scene, hurriedly dressed in war regalia and paint, yelling their tribal war cry, and many an Assiniboin and Cree scalp paid the penalty for the attack. Bodmer's painting commemorating this exciting experience, which was later used as one of the plates in the atlas accompanying Maximilian's published account of his journey through our West,[2] is reproduced on page 81.

Instead of going on through the Rockies, as Maximilian had planned, they went back to Fort Union, and after a month there, continued down the river to Fort Clark, where the Prince and his artist stayed from November 8, 1833, to April 18, 1834. There were no more experiences quite as exciting as the attack on Fort McKenzie, although the nearby Mandan village provided Bodmer a particularly rich source of picture material. Two of the outstanding paintings which resulted from this part of the trip are *Buffalo Dance of the Mandans*, reproduced on page 82, and *Interior of the Hut of a Mandan Chief*, shown on page 83. Another of his fine pictures is *Assiniboin and Yankton Indians*, on page 84. All of these appeared in the Maximilian atlas.

Bodmer and Maximilian got back to St. Louis on May 27, 1834, proceeding to New York, whence they sailed for Europe on July 16. Upon his arrival, the artist returned to his former haunts in Paris and took up permanent residence with the artist colony at Barbizon, in the Fontainebleau forest. Here he worked into finished paintings the eighty-one pictures which were reproduced to form the folio atlas accompanying the two-volume narrative of Maximilian's North American journey. The 1839 full-color edition of these prints is considered the finest of its kind, depicting our Indians of the Old West, and won for Karl Bodmer immediate recognition as an artist of importance. He was not only a master of the best techniques and a superb draftsman, but also very highly accomplished as an etcher and in

[2] *Reise in das innere Nord-America in den Jahren 1832 bis 1834, von Prinz Maximilian Alexander Philip Wied-Neuwied . . . ,* 2 vols. and atlas, Coblenz, J. Hoelscher, 1839–1841.

the various processes of stone lithography, wood-block engraving, and acid etching on copper plates. Many of the Maximilian prints were made entirely by Bodmer's own hands.

Bodmer became one of the best known and most influential of the contemporary Barbizon School. One of his younger protégés was Jean François Millet, later the creator of *The Angelus* and other famous paintings of French peasant life. When Bodmer was at the height of his fame, Millet was a destitute and unknown twenty-year-old with a studio in a barn. One little-known incident with a direct bearing on our Western art cannot be overlooked. An American publisher came to France to induce Bodmer to do a series of pictures to illustrate an elaborate work on the colonial wars. Overburdened with work, Karl induced the needy Millet to do the pictures from sketches Bodmer had made in the United States—and the work was begun under his supervision. Thus Jean François Millet actually painted American Indians! Several were completed, and Bodmer personally transferred five of them to stone and made "probably half a dozen" lithographic prints of each.[3] The publisher learned about the secret arrangement and canceled the agreement, but one of these works of collaboration, *The Capture of Daniel Boone's Daughter by the Indians*, was reproduced a number of times.

As the years passed, the fame and success of Bodmer declined and that of Millet ascended. Finally, the press of unkind circumstances forced Bodmer to sell parts of the fine collection of Millet drawings and paintings he had acquired during their early friendship—including the rare American Indian lithographs. Karl Bodmer's star of destiny continued to dim, until his death at Barbizon on October 30, 1893.

[3] "American Indians—Barbizon Style," by Benjamin Poff Draper, in the magazine *Antiques*, September, 1943.

Alfred Jacob Miller

7 *Many Trails Lead West*

MANY CHANGES were taking place all over the West in the late 1830s. By 1836 some 30,000 farmers, cotton growers, ranchers, and adventurers had swarmed into Texas. On the Mississippi the city of St. Louis was enjoying boom days because of its geographic location at the principal crossroads of travel between North and South, East and West. At the junction of the Mississippi and Missouri rivers, it controlled the bulk of river traffic into the vast Northwest, and the furs and buffalo hides that were brought back. Here also began the land routes over the Santa Fe and Oregon trails. But there was a new pattern of expansion rapidly taking shape. Where the French traders had used canoes to go up the rivers, American frontiersmen put big river boats into service; where a few half-breeds with pack animals had gone out on the overland trails, new generations of settlers came in long wagon trains, escorted by armed guards and columns of soldiers; and where one remote trading post had stood, it now became linked with whole strings of them, and each was made larger and planted deeper in the wilderness.

St. Louis saw more than its share of rough and glamorous individuals who made adventure their business and whose extraordinary adventures engraved their names deeply on the pages of our history. Daniel Boone wandered along its dusty streets in 1795, with his wife and son, probably the first citizens of the United States to settle within the present limits of the state of Missouri. Lewis and Clark, Jedediah Smith, Zebulon Pike, Kit Carson, Jim Bridger, and scores of others had passed through St. Louis on their way West.

One of the most colorful of the foreign adventurers who satisfied his desire for excitement in the wild country beyond St. Louis was Capt. William Drummond Stewart, an eccentric Scotchman and heir apparent to a royal title and sprawling old castles in Perthshire. In the early spring of 1837 he was in St. Louis busily preparing for a trip across the Plains to the Rocky Mountains. This was not his first trip West, nor his last, but from the point of view of art, it was his most important. He was taking along a young artist by the name of Miller, whom he had picked up

on a visit to gay New Orleans. The artist was to do a series of paintings to adorn the Stewart family castle in Scotland, as a vivid reminder of the Captain's experiences beyond the Mississippi.

Alfred Jacob Miller was born in Baltimore on January 2, 1810. This son of a grocer had shown such promising ability in art that in 1833 he was sent to Europe for a year of study. He entered the Ecôle des Beaux Arts in Paris, and his paintings suggest that he was inspired very deeply by the work of Joseph Mallord William Turner, the great English water-colorist, and master of the delicate qualities of light and haze in landscapes.

Upon his return to Baltimore in 1834, Miller hung out his shingle and began looking for commissions to do portraits, while he practiced landscapes in the Turner manner. He did not do so well, and in 1837 went to New Orleans for a change of luck. His meeting with Captain Stewart appears to have been quite by chance,[1] but the opportunity which the titled adventurer offered him must have seemed like a gift from heaven, although there is no indication that Miller had any previous interest in painting Indians or any other phase of Western life.

Shortly after their meeting, Captain Stewart and Miller arrived in St. Louis. The Scot made arrangements for his little party to accompany the annual spring caravan of the American Fur Company that was bound overland along the Oregon Trail to Fort Laramie (Wyoming) and points west. These caravans consisted of big prairie wagons heavily laden with valuable trade goods to be exchanged by the Company agents in the northwest for far more valuable furs. It was almost 800 miles to Laramie and through Indian country where the natives had already cultivated a taste for white man's loot, such as the rich cargo in this long line of prairie wagons. As a countermeasure, the wagon trains were guarded by as formidable an escort of frontiersmen as the Company could hire. It was a colorful baptism for the young Baltimore artist. Miller's patron, because of his military background and previous experience in the West, had been assigned to complete command of the caravan in case of attack by Indians. An incident on this trek to Laramie inspired Miller's painting *Threatened Attack*, reproduced on page 63.

They reached Fort Laramie safely, where the caravan stopped for a short time. Miller's picture of this important frontier fort[2] is reproduced on page 62. The

[1] See *The West of Alfred Jacob Miller*, University of Oklahoma Press, 1951, with an account of the artist by Marvin C. Ross, for the full story of this meeting. Also, *Across the Wide Missouri*, by Bernard De Voto, Houghton Mifflin Company, 1947.

[2] From a photograph of the original painting in the Walters Art Gallery, Baltimore, Maryland, supplied through the courtesy of Marvin C. Ross. A reproduction of this appears on p. 49 of the above-noted book.

wagon train moved on through the South Pass in the Rockies to the colorful fur-trade rendezvous in the valley of the Green River, in Oregon. Here they stayed for about a month. The pictures Miller made of this exciting meeting between white men and red are probably his most important contribution to the record. The rendezvous offered a colorful display of wild and primitive pageantry. About three thousand Indians were gathered, mostly Snakes. There were horse races, ball games, wrestling, gambling, dancing, and carousing that continued deep into the night. The Indians put on a grand parade as a special spectacle for Captain Stewart and his party. As Miller reported: "Some of the dresses worn were magnificent, and although vermilion was worth four dollars per ounce, a lavish use of that article was exhibited on their bodies and faces." [3]

The red man and the white man were at this time still on friendly enough terms to gather together in amicable trade relations. Many of the whites had acquired Indian women, according to the Indian custom and with proper tribal blessing, and they lived compatibly in tepees and raised half-breed families. Contact with the white man had wrought considerable changes in the character of Indian life. Up to this point these influences had been highly beneficial to the Indians. First of all, the white man's invasion gave them the horse. Then came the fur trade, which introduced the Indian to a profitable business with an easily obtainable product which he had previously considered of no particular value. The fur trade gave the Indian many new articles of great benefit—metal to take the place of flint and stone, guns to take the place of bows, arrows, and spears; cloth and household utensils. Thus he became a more successful hunter, a more accomplished warrior, and ultimately a more formidable enemy for his benefactors. He still enjoyed a freedom as yet unrestrained by the white man's farms and fences. The land and everything upon it belonged to every man, and each was judged on his personal prowess as a hunter or a warrior. The white man had not yet planted his seeds of destruction—the plow or the bottle of whisky; the reservation had not been forced upon the Indian. The culture of the Plains Indians was in its golden age. It was to be short-lived, but Miller saw it at its best.

From the rendezvous on Green River the Stewart party moved on to New Fork Lane and the beautiful Wind River Mountain country, which was the Scot's favorite section of the West. They then came back to Green River, and finally returned to St. Louis, whence Miller went back to his studio in New Orleans to begin the task of making finished paintings from his sketches.

Miller's experience in the West was brief and he could have had a sounder back-

[3] *The West of Alfred Jacob Miller*, p. 198.

ground and preparation for the task. Nevertheless he saw a number of Indian tribes, crossed the Plains and the mountains, witnessed the hunting of the buffalo and other types of wild game, enjoyed the exciting experience of traveling with a wagon train, and saw the fur trade in its prime. He also had the privilege of meeting such frontier history makers as Kit Carson and Jim Bridger in their native element. He should have been tremendously inspired by this wealth of material despite his inexperience and ignorance of the country and its inhabitants.

Miller showed the first of his Indian and Western landscape pictures in Baltimore in July, 1838, and in May of the following year eighteen were exhibited at the Apollo Gallery in New York. In 1840 he followed Stewart to Scotland, where he lived in Murthly Castle for over a year while painting the grandiose pictures of the American West to adorn its old walls. The artist returned to Baltimore in 1842, and settled down to the routine of portrait painting and making duplicates of his Western sketches. The results of his trek westward, at least from a documentary standpoint, are disappointing and are commensurate with neither his unusual experience nor his artistic ability. He did a series of small water colors for William T. Walters of Baltimore which are now preserved in The Walters Art Gallery in that city, and 200 of them have recently been reproduced in *The West of Alfred Jacob Miller*.

Miller's work enjoyed its first widespread notice in Bernard De Voto's *Across the Wide Missouri* (1947). A considerable number of the original field sketches, many of them still in the possession of Miller's descendants, are reproduced therein—a collection that lay in oblivion for practically a hundred years.

The work of Alfred Jacob Miller is one of the most extensive records of the Old West that we have. His pictures, however, have certain shortcomings. He overidealized what he saw; his Indian women are too petite and pretty; and there is a general lack of identifiable detail. Perhaps if Miller had exemplified more of Catlin and less of Turner, and had taken full advantage of his unique opportunity and his undeniable talent, he could have become one of the most important of our artists of the Old West.

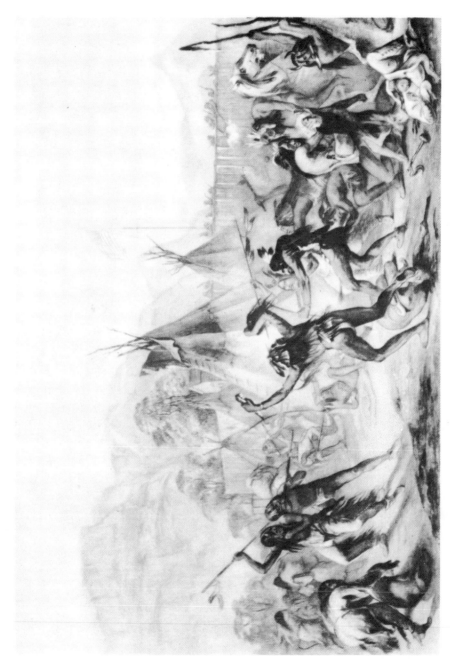

ATTACK ON FORT McKENZIE Karl Bodmer

(Litho.—New York Public Library)

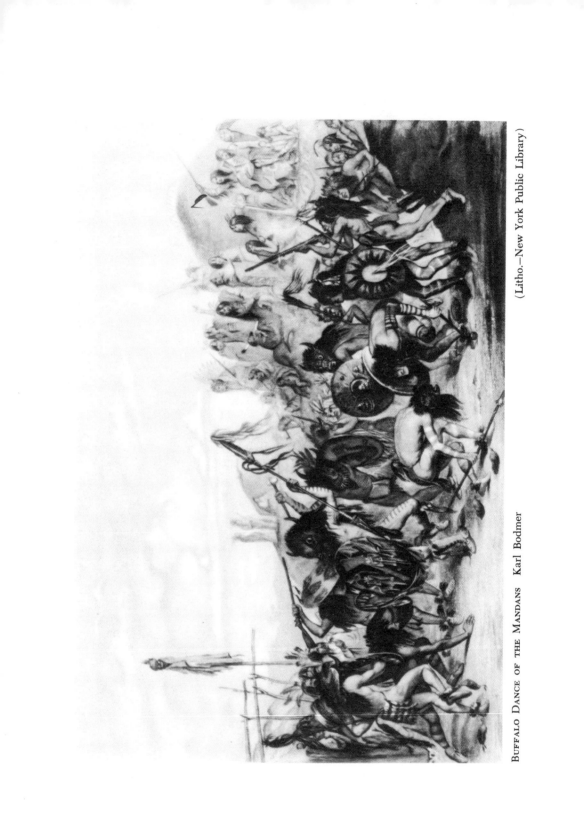

BUFFALO DANCE OF THE MANDANS Karl Bodmer

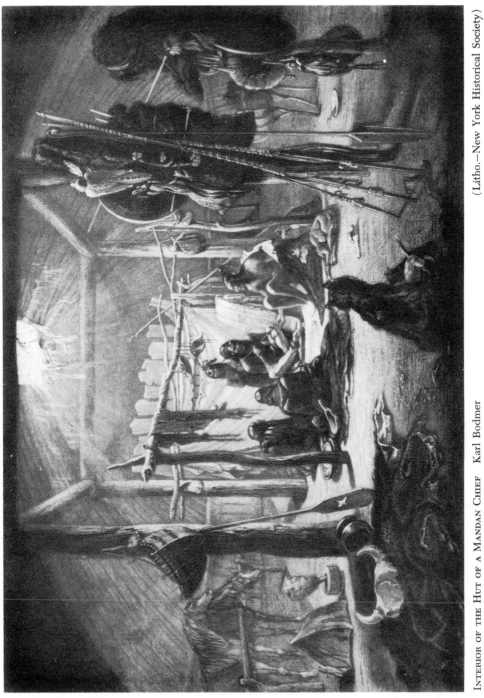

INTERIOR OF THE HUT OF A MANDAN CHIEF Karl Bodmer

(Litho.–New York Historical Society)

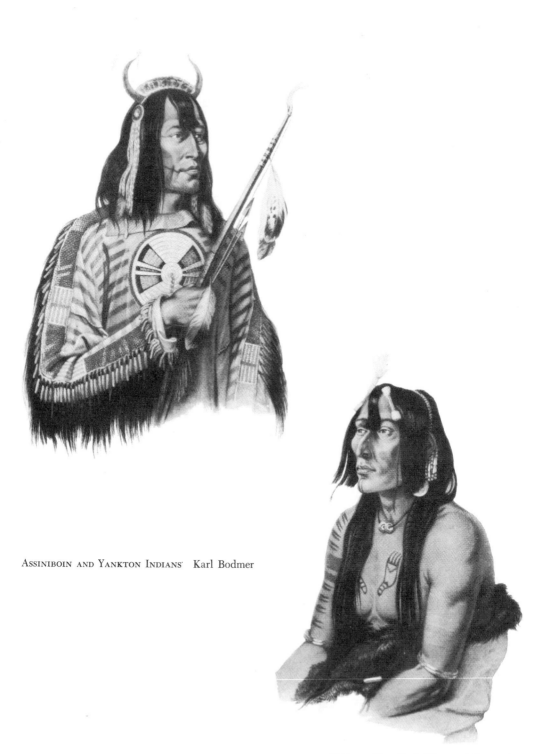

Assiniboin and Yankton Indians· Karl Bodmer

(Lithos.—New York Historical Society)

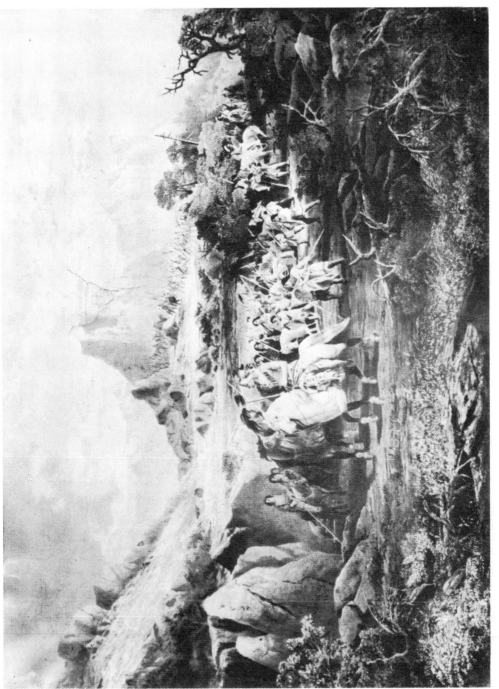

On the Warpath John Mix Stanley

(Litho.—Denver Public Library)

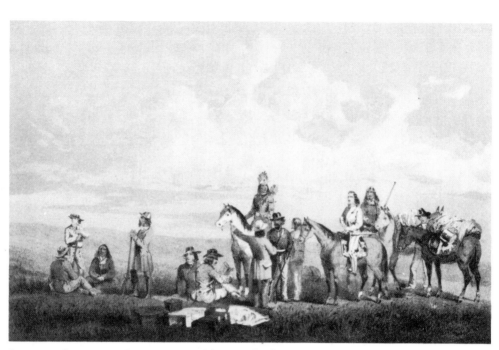

GOVERNOR STEVENS AT FORT BENTON John Mix Stanley

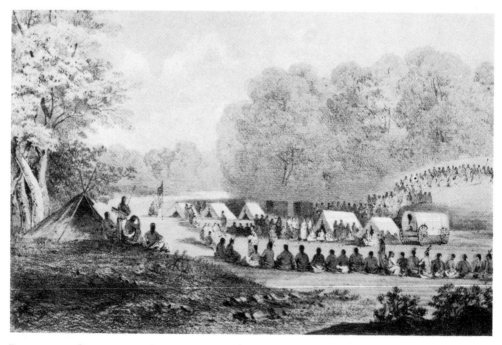

DISTRIBUTING GOODS TO THE GROS VENTRES John Mix Stanley

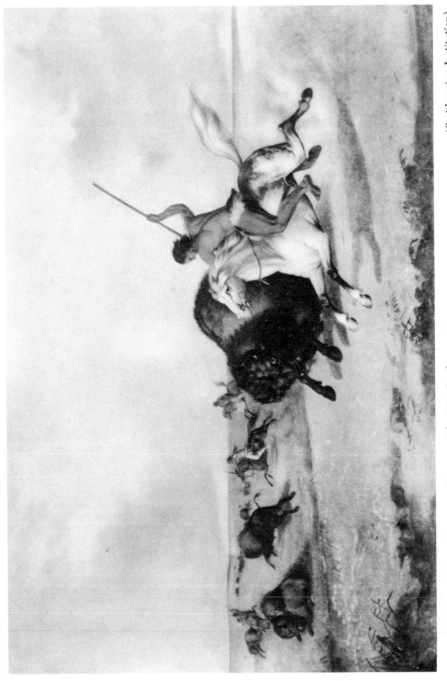

A Buffalo Hunt on the Southern Plains John Mix Stanley

(Smithsonian Institution)

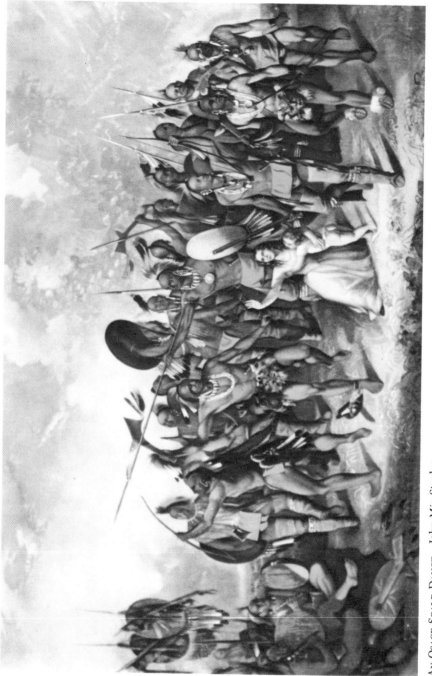

An Osage Scalp Dance John Mix Stanley

(Smithsonian Institution)

John Mix Stanley

8 / *Adventure with Painting*

BACK EAST, the early products of the industrial revolution were suggesting a new era, a new way of life. In 1825, the first boat left Buffalo on the Erie Canal and reached New York City in nine days. The Baltimore and Ohio began the first passenger service on July 4, 1828, with a horse-drawn rail car which traveled over 14 miles of track. Two years later the South Carolina Railroad (now the Southern) put the first steam locomotive into service at Charleston, South Carolina.

In the West the old Indian trails widened under the hoofs of the white men's horses. New trading posts appeared along the overland trails and old posts took on the characteristics of small towns. On November 13, 1835, the Territory of Texas, which for a time had been a Mexican state, proclaimed its independence, and four months later, after eleven terrible days of siege, the garrison of Texans at the Alamo in San Antonio were butchered by the Mexicans. Here the name of Davy Crockett was indelibly engraved on the pages of our history books.

One day in that same year of 1835, a portrait painter by the name of Bowman was walking along the main street in Detroit, and passing the newly established office of the Detroit *Free Press*, he stopped to admire the building and was attracted by the newspaper's newly painted sign. As decorative embellishment, it carried a portrait of Benjamin Franklin, dean of American journalism.[1] Bowman, an accomplished portrait painter himself, who had studied for his profession in Italy and had come from Philadelphia in the hope of finding better business in Detroit, knew a good picture of Ben Franklin when he saw one. After scrutinizing the sign painter's art with a critical eye, he went into the office to find out who had done the work. It was a young man by the name of Stanley, he was informed, a house painter by trade, but a painter of artistic signs by preference. What else did they know about him? He was a nice chap, with a real interest in his work, and seemed to be of very good character. The artist decided to look him up, to offer

[1] This story is taken from an article which appeared in the Detroit *Free Press*, September 28, 1885.

89

encouragement. When they met, Bowman was so impressed by the young man's personality and ambitious attitude that he invited him to visit his studio. Would he like to have some free instruction in the techniques of portrait painting? There was a second sunrise that day for John Mix Stanley, and thus began the career of another of America's important painters of the Western scene.[2]

Stanley was born the son of a local tavern keeper in Canandaigua, in the Finger Lakes country of western New York, January 17, 1814. His mother died when he was five years old. As a boy he became interested in the Indians who regularly came around the tavern which was also his home. Among these was the famous Seneca chief Red Jacket, who, according to family tradition, is reported to have taken a special liking to the motherless boy and often held him on his knee. As Stanley grew older, he spent considerable time drawing pictures of Indians. His artistic tendencies did not impress his father, the tavern keeper, however, for when he was fourteen he was apprenticed to a wagonmaker in the town of Naples, 20 miles south of Canandaigua. In 1834, when twenty years old, he went to Detroit to find a better job.[3]

That Stanley progressed quickly under Bowman's instruction and showed more than ordinary aptitude is evidenced by the fact that he soon gave up his house painting and sign work altogether to spend his time in the studio. The business panic of 1835 made portrait painting an unprofitable profession in Detroit and Stanley and Bowman moved to Chicago, where they opened a studio and gallery, hoping to find better prospects in the larger city. But this venture was short-lived and Stanley started out on his own. He went to Galena, Illinois, where for a time he sought commissions to paint portraits. Then he moved on to Green Bay, Wisconsin, and in 1839 he was at Fort Snelling. There he began seriously painting Indian portraits and scenes from Indian life. The inspiration of his early boyhood returned and he decided to devote his career to this unorthodox field of painting. But paintings of the red men, no matter how beautifully they might be executed, were far more difficult to sell than ordinary paintings of white men back East. It cost money to travel through the West, and Stanley hardly had enough to provide food for himself. Once again he went back East, where he could work at his prosaic profession of portrait painting more satisfactorily in the larger cities—and save money for a trip to the West. After three years in New York, Philadelphia, Balti-

[2] *John Mix Stanley and His Indian Paintings*, by W. Vernon Kinietz, University of Michigan Press, Ann Arbor, 1942.

[3] *John Mix Stanley—Artist—Explorer*, by David I. Bushnell, Jr., Annual Report for 1924, Smithsonian Institution, Washington, D. C. Much of the information in this article is credited to the artist's son, Mr. L. C. Stanley, and it has been drawn upon for this chapter.

more, and Troy, he had saved enough to begin the fulfillment of his real ambition.

Stanley went to St. Louis in 1842 and then on to Fort Gibson, Arkansas. This marked the start of his extensive travels through the West. Unfortunately, he seems to have kept no journal and left but little in the way of autobiographical material. Most of his pictures were accompanied by excellent and often lengthy notes about the individuals portrayed, however, and about the manners and customs of the various tribes. But the personal narrative is sadly missing, and there are long periods about which nothing is known as to even his whereabouts in the West.

From the notes accompanying several of his paintings it is known that in June, 1843, Stanley attended the big council meeting at Tahlequah (eastern Oklahoma), the capital of the Cherokee nation, by special arrangements of P. M. Butler, governor of Arkansas and United States Agent for the district. This big powwow was attended by seventeen different tribes and no less than 10,000 tribesmen, warriors and their families, who gathered to discuss a treaty of peace between the red men and the independent state of Texas, not as yet a part of the United States. Stanley made a number of portraits of the attending Indian dignitaries, and one of his pictures shows all the chiefs sitting together in a meeting. The finished canvases of these scenes were shown in the first exhibition of his paintings, in Cincinnati in 1846. The lengthy note which accompanied the descriptive catalogue ended with the following rather perfunctory bit of information: "During the whole session the utmost good feeling and harmony prevailed; the business was brought to a close at sundown, after which the various tribes joined in dancing, which was usually kept up to a late hour." This prosaic and colorless excerpt is unfortunately typical of the notes accompanying Stanley's paintings.

It is apparent that the artist stayed in the vicinity of Tahlequah for some time, as he acquired commissions to do the portraits of some of the half-breeds and Indian families, which pictures have been preserved by the descendants of the subjects.[4] The catalogue for the Cincinnati exhibition lists eighty-three paintings covering twenty different tribes, with perfunctory notes on each picture. The tribes are the Seminoles (around Fort Gibson), Creeks, Cherokees, Chickasaws, Potowatomies, Osages, Chippewas, Weeachs, Quapaws, Shawnees, Pawnees, Iowas, Texas Delawares, Caddoes, Anandarkoes, Wacoes, Natchitoches, Commanches, Towocconies, and Osages. (Stanley's spellings are used here.)

The artist returned to the West to continue his Indian painting in June, 1846, and joined the Magoffin trading expedition on a trip over the Santa Fe Trail to Santa Fe. Their destination was a notorious rendezvous for the roughest charac-

[4] Kinietz, *op. cit.*

ters of the Southwest, and at the time of their arrival Yankees were not looked on with high favor. The United States had declared war on Mexico on May 13, and Mexico had retaliated ten days later. This was before the Magoffin expedition had started out, but news traveled so slowly in those days that it is doubtful that the party knew of the war until they reached their destination. The Mexicans had already started strong agitation among the preponderantly Spanish population of the district as well as among the Indians in the wild country through which all travel had to pass. Santa Fe's population of between two and four thousand inhabitants were widely known as the poorest people of any town in the province, and even under normal circumstances it was not a particularly safe place for a young fellow alone who wanted to paint pictures of Indians. Stanley's sketch of the bleak-looking town is reproduced on page 93. This drawing was later used as one of the plates in Lt. Col. H. W. Emory's official report on *A Military Reconnaissance from Fort Leavenworth, in Missouri, to San Diego, in California.*

In mid-August a large military expedition arrived from Fort Leavenworth, Missouri. Part of this contingent was under orders to proceed on an exploratory expedition across the mountains to San Diego, another hot spot in the war with Mexico. This advance guard of the Army of the West was under the command of the above-mentioned H. W. Emory, then a brevet major, and Stanley got himself attached to it as "draftsman." [5] They left Santa Fe on September 26, with that most famous of all scouts, Kit Carson, as guide.

In Major Emory's terse, abbreviated military report on this notable expedition,[6] printed by Congress in 1848, Stanley's name occasionally appears in connection with various incidents. True to military form, there are no embellishments, but the following brief excerpts give some inkling as to the adventures and hardships that were encountered: "Oct. 3: At town of Pulvidera we arrived day after Apaches had attacked and looted the place. . . . Oct. 14: We parted with our wagons and continued [over the mountains] by mules. . . . Nov. 23: Warner, Stanley, and myself, saddled up to visit the junction of the Gila and Colorado, which we found due north of our camp. . . ." They crossed the Colorado River, the desert, and finally entered the "beautiful valley of the Agua Caliente." Shortly afterward they ran into stiff armed resistance by the Mexicans, and a sharp fight resulted "in which we found ourselves engaged in a hand to hand conflict with a largely

[5] *Notes of a Military Reconnaissance, from Fort Leavenworth, in Missouri, to San Diego, California . . . , by W. H. Emory, Lieutenant Colonel, Corps of Topographical Engineers, Made in 1846–47, with the Advance Guard of the "Army of the West,"* Washington, D. C., 1848.

[6] *Ibid.*

SANTA FE—1846 John Mix Stanley

superior force . . . and . . . as day dawned, the smoke cleared away, and we commenced collecting our dead and wounded. We found eighteen of our officers and men were killed on the field and thirteen wounded." One of the young officers, who had been shot through the head, had been married only a few days before he left Fort Leavenworth.

The report continues: "Dec. 7: Day dawned on the most tattered and ill-fed detachment of men that ever the United States mustered under colors. The enemies' pickets and a portion of his force were seen in front [ready for another engagement]. . . . Arranging our wounded and the packs in the center we marched on. . . . The enemy retired as we advanced. . . . Dec. 8: We bored holes for water, and killed the fattest of our mules for meat. . . . Dec. 10: The enemy attacked our camp again, driving before them a band of wild horses, with which they hoped to produce a stampede. . . . Two were killed in the charge . . . and in the shape of gravy-soup were found an agreeable substitute for the poor steaks of our own worn down brutes, on which we had been feeding for a number of days." At this juncture the intrepid Kit Carson, with a young officer for a companion, made a dash through the enemy lines to summon aid from the American garrison which they hoped to find at San Diego. In due time a column of 180 mounted United States Marines and sailors, sent out by Commodore Stockton, came to the rescue, and escorted the dilapidated exploring party to its destination. Shortly thereafter Stanley continued on to San Francisco, where he worked into finished paintings many of the sketches he had made on the eventful journey from Santa Fe when

he was not shooting Mexicans. A number of these were used as plates with Major Emory's report, the first of the artist's work to be reproduced.

This did not by any means end Stanley's adventures in the Far West. During another encounter with the Mexicans at San Pasquale, the painter lost nearly all of his personal belongings, but was able to save what to him was most important, his sketches, paint, and canvas.[7] Afterward, deciding to continue his Indian painting among the tribes of the Northwest, he went to Oregon in July of 1847. There he made a thousand-mile trip by canoe down the Columbia River, and by a matter of a few hours escaped being a victim of the Indian massacre at Waiilatpu, which took the lives of the famous pioneer missionary, Dr. Marcus Whitman, his wife, and ten others who were with them at the time. From Oregon he went to the Hawaiian Islands, losing his large collection of fine Indian paraphernalia which he had acquired in the Northwest, in a shipwreck. In Honolulu he painted the portraits of King Kamehameha III and his queen, improvising canvas from a folded tablecloth. These pictures now hang in the Government Museum, formerly the Royal Palace.

Stanley was in the Eastern United States by 1850 and began exhibiting his paintings in New York and some of the New England states. In 1852 the collection of 152 pictures was placed on exhibition in the Smithsonian Institution in Washington. The seventy-six-page catalogue of *Portraits of North American Indians, with Sketches of Scenery, etc., by John Mix Stanley* (1852), was prepared by the artist and states in the preface that it contains "accurate portraits painted from life of forty-three different tribes of Indians, obtained at the cost, hazard and inconvenience of a ten years' tour through the southwestern prairies, New Mexico, California and Oregon." At this time Stanley began negotiations to get the government to purchase his collection of paintings and make it a permanent display in the Smithsonian Institution.

The following spring the artist was on his way West again. The government had ordered an extensive survey to determine the most practicable route for a railroad to the Pacific Coast. Isaac I. Stevens, governor of the Washington Territory, was placed in charge of exploring the northern routes in the vicinity of the forty-seventh and forty-eighth parallels. Stanley procured an appointment as artist of this expedition, on which "all officers detailed on the survey . . . will in the field receive one dollar per day." [8]

[7] "John Mix Stanley, Indian Painter," by Nellier B. Pepes, *The Oregon Historical Quarterly*, September, 1932.

[8] *Report of Explorations & Surveys to Ascertain the Most Practicable Route for a Railroad from the Mississippi to the Pacific Ocean—1853–54*, Senate Executive Document No. 78, Washington, D. C., 1855.

One of the rare personal accounts of the artist's experiences is contained in his brief official report on a "Visit to the Piegan [Blackfeet] Camp, at Cypress Mountain," [9] on September 14, 1853, to "bring them into council at Fort Benton. . . . We reached the divide between Milk and Bow rivers. From this divide . . . I discovered with my glasses a band of horses, five miles to the westward, which directed me to the Indians I was in pursuit of. I descended a steep valley. . . . Here was the Piegan camp, of 90 lodges, under their chief Low Horn. . . . Little Dog conducted me to his lodge, and immediately the chiefs and braves collected in the Council Lodge, to receive my message. . . . The usual ceremony of smoking being conducted, I delivered my 'talk,' which was responded to by the chief saying, 'the whole camp would move at an early hour the following morning to council with the chief sent by the Great Father.' . . . The day was then spent in feasting with the several chiefs, all seeming anxious to extend their hospitality; and while feasting with one, another had his messenger at the door of the lodge to conduct me to another feast. . . .

"Sept. 15: At an early hour a town crier announced the intention of the chief to move camp. The horses were immediately brought in . . . and in less than an hour the whole encampment was drawn out in two parallel lines, forming one of the most picturesque scenes I have ever witnessed. . . . The poles of the lodges, from 20 to 35 feet in length, are divided, the small ends being lashed together and secured to the shoulders of the horse, allowing the butt-ends to drag on either side; just behind the horse are secured two cross-pieces, to keep the poles apart; and upon which are placed the lodge and domestic furniture. This also serves for transportation of the children and infirm. . . . The horses dragging this burden— often of 300 pounds— are also ridden by the squaws, with a child astride behind, and one in arms, embracing a favorite young pup. The dogs are also used in transporting their effects in the same manner as the horses. . . . This heterogeneous caravan, comprised of 1,000 souls, with twice that number of horses and at least 300 dogs, fell into line and trotted quickly until night, while the chiefs and braves rode in front, flank, or rear, ever ready for the chase or defense against a foe. . . . During my sojourn among them I was treated with the greatest kindness and hospitality, my property guarded with vigilance, so that I did not lose the most trifling article." This experience may have given the artist the general idea for his painting *On the Warpath* (reproduced on page 85). Two of the pictures made to accompany the Government Report on this expedition are reproduced on page 86.

Stanley returned to Washington, D. C., in 1854, where in that year he married

[9] *Ibid.*, Vol. I, pp. 447–449.

Miss Alice C. English and settled down to a very conventional existence of more painting and less adventure. During the years he had spent in continuous traveling beyond the Mississippi, he had covered more territory and visited more different tribes, before either was spoiled by civilization, than any other artist with the exception of George Catlin. He painted some tribes not visited by the latter although the scope of his work and the information which he recorded is in no way comparable to that of Catlin.

The paintings which John Mix Stanley had made at such a great personal sacrifice were still deposited in the Smithsonian Institution when the artist took up permanent residence in the East, and he resumed his efforts to get Congress to purchase his Indian gallery. This was just twenty-five years before the Smithsonian acquired the Catlin collection. But Stanley, like Catlin, was doomed to bitter disappointment. From year to year Congress had the purchase under consideration, but it took no definite action on the matter before the afternoon of January 24, 1865, when a disastrous fire consumed the section of the Smithsonian containing the Stanley collection. All the pictures were destroyed except five that had previously been removed to another part of the building. Among those saved was a 40- by 60-inch canvas, *An Osage Scalp Dance*, painted in 1845 and reproduced on page 88, and also *A Buffalo Hunt on the Southern Plains*, reproduced on page 87. Both of these now hang in the Smithsonian Institution.

Shortly after the fire John Mix Stanley left Washington for Buffalo. There he continued painting Indian subjects and built up a remunerative business doing less exciting portraits. One of his finest Indian pictures, *The Trial of Red Jacket*, a canvas 70 by 100 inches, was done in 1868 and now hangs in the Buffalo Historical Society. He continued his work until overtaken by a serious illness which led to his death in Detroit on April 10, 1872, at the age of fifty-eight. Although the tragic fire wiped out most of John Mix Stanley's life's work, the canvases that exist today permanently establish him in the front rank of our early Western artists.

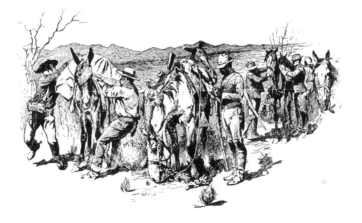

Charles Deas

9 *Lost in the Passing of Time*

ARTISTS OF THE WEST in the 1840s had to be men of a variety of talents—handy with a gun, at home in a saddle, and knowledgeable in the ways of the Indian. To live the rugged life, men of undeniable talent left the East and the security of a life of portrait painting to pursue a career they considered more worth while. Unfortunately these sacrifices often were in vain, at least in the historical sense, for much of their work has faded into oblivion. Just such a man was Charles Deas, who in the 1840s was one of the most highly regarded of our Western artists, but is today virtually unknown. Of the many pictures he produced in about seven years in the West, barely half a dozen can now be located.[1]

Charles Deas was born in Philadelphia, December 22, 1818. He was of a distinguished family, the grandson of Ralph Izard, the Revolutionary patriot. His first ideas of art were fostered by copies of the old masters belonging to his father, and at an early age he became interested in making art his life's work. His parents had other ideas, it seems. and he prepared to enter the United States Military Academy at West Point. He failed to get into the Academy, however, and subsequently turned his whole attention to becoming an artist, studying first under the auspices of the National Academy of Design in New York City.

On a visit to his home in Philadelphia during the winter of 1837–1838, he studied an exhibition of George Catlin's Indian paintings, and this incident proved important in the shaping of his career. For the little we know about Charles Deas we are indebted to Henry T. Tuckerman,[2] the authoritative biographer of artists of this period, whose evaluation of Deas and his work was based on personal acquaintance: "To visit the scenes whence Catlin drew these unique specimens of art; to study the picturesque forms, costumes, attitudes, and groupings of Nature's

[1] "Charles Deas: Painter of the Frontier," by John Francis McDermott, *The Art Quarterly*, autumn, 1950.

[2] *Book of the Artists*, by Henry T. Tuckerman, New York, 1867 (revised and enlarged edition of original 1847 edition, which is titled *Artist-Life*).

own children; to share the grateful repast of the hunter and to taste the wild ex-
citement of frontier life, in the very heart of the noblest scenery of the land, was
a prospect calculated to stir the blood." The deep interest which the young Deas
had for hunting and life in the woods further stirred him to investigate the life,
land, and people so vividly portrayed in Catlin's paintings.

Although hardly out of his teens, Deas was making notable strides in his art. He
earned a popular reputation with his *Turkey Shoot*, which was hung in the exhi-
bition of the National Academy in 1838 and became a well-known lithograph of
the period. During the next two years he had eleven paintings exhibited in the
National Academy, an unusual accomplishment for so young an artist. In the
spring of 1840, having been duly elected an Associate National Academician, he
left New York and headed West for Indian country.

At Fort Crawford (Prairie du Chien), Deas met his brother, a young officer in
the Fifth Infantry. He settled down at the fort and accompanied military and
American Fur Company parties on missions into the surrounding territory. He was
on hand when Keokuck, the great chief and orator of the Sauks and Foxes, brought
his tribesmen to Fort Crawford to hold council with their enemies, the Winne-
bagos. Tuckerman reports the artist's own description: "The costume of the ven-
erable chief was superb—a tiara of panther and raven skins adorning his head . . .
and there was all the primitive panoply for which these haughty council meetings
were noted, spiced with the tense excitement of impending trouble."

During the first winter the artist made several trips to Fort Winnebago, at the
Fox-Wisconsin portage, to visit the Winnebagos in their own setting, and in the
summer of 1841 he went up the Mississippi to Fort Snelling to become acquainted
with the Sioux. In addition he visited the Chippewas and Pawnees. "The scenes
witnessed would require a volume to do them justice. . . ," Tuckerman wrote. "In
passing from lodge to lodge, the most extraordinary incidents presented them-
selves, and in the stillness of the moonlight nights, the echoes of the Indian's lute
blent with the battle-chant, or the maiden's shrill song." During those first two
years "he was able to collect enough sketches of Indians, frontier scenery, etc.,
for a life's painting." In the fall of 1841 he went to St. Louis, where he established
a permanent studio which was to serve as headquarters through the years to come.

In the spring of 1844 Deas accompanied Major Wharton's military expedition
from Fort Leavenworth to the Pawnee villages on the Upper Platte River. An
account of this undertaking was published just one hundred years afterward, from
the journal kept by Lt. J. Henry Carlton.[3] According to this chronicler, the soldiers

[3] *The Prairie Logbooks, Dragoon Campaigns to the Pawnee Villages in 1844 . . .* , Louis
Pelzer, editor, The Paxton Club, 1943.

nicknamed their artist companion "Rocky Mountain," because he "wore a broad white hat; a loose dress; and sundry traps, and truck hanging about his saddle, like a fur-hunter. Besides, he had a Rocky Mountain way of getting along; for, being under no military restraint, he could go where he pleased, and come back when he had a mind to." What is possibly a self-portrait of the artist while in the West is in the Garvan Collection in the Yale University Art Gallery (see page 107) and was reproduced as a lithograph entitled *Long Jakes.*

There are other interesting references in Carlton's journal to Deas and his experiences while sketching the Pawnees, including the following amusing sidelight on his character: "Mr. Deas seemed to possess the whole secret of winning the good graces of the Indians. Whenever he entered a lodge it was with a grand flourish and a mock bow that would put even an Ottoman in ecstasies. . . . He always gave his salutations in French [these Indians did not understand English] and with a tone and gestures so irresistibly comic [he spoke French very badly] that, generally, the whole lodge would burst out into a roar of laughter, though not a shadow of a smile could be seen on his face."

Deas followed the practice of most of his contemporaries by getting such commissions as he could for local portrait painting, but his principal interest remained the Indian country and its inhabitants. His style was somewhat different from that of most of his fellow artists, more romantic and less documentary. Because as a young man he had achieved a reputation in the East, his frontier works received considerable attention. Between 1838 and 1849, Deas had eighteen of his paintings hung in exhibitions in the National Academy in New York, and in December, 1844, some of his large oil paintings of the West were exhibited at the American Art Union in New York. They were accorded high praise by the press and one critic wrote in appropriate vernacular of *The Prairie Fire*, "If you want to see a horse with a hide on, go and see this picture." It now hangs in the Brooklyn Museum of Art and is reproduced on page 106.

Charles Deas continued to make his home and studio in St. Louis and to make periodic sketching trips into the West until his death in 1867. Of a lifetime's labor, only a handful of canvases have survived, and we have been able to learn distressingly little about this important artist.

Paul Kane

10 *Across the Broad Northwest*

THE WEST which lies north of the Canadian border was not pioneered as rapidly as the areas farther south. The long winters of drifting snow and bitter cold were a strong barrier, particularly when there were inviting green hills and wide plains to explore in friendlier latitudes. At a very early date the French and the English pushed spearheads of exploration across the Northern wilderness and established outposts to reap the rich rewards of the fur trade. However, these trading posts in the bleak North did not grow quickly into villages as was the case farther south. Until 1846, young Peter Rindisbacher was the only notable artist to portray the pioneer scene on the Canadian frontier, and the scope of his work was limited by his early death. There may have been others who have been lost in the passing of time, but the name of Paul Kane stands out boldly as the first artist to depict this broad expanse of land in a professional manner.

There was much in the boyhood experience of Paul Kane to lead him toward his ultimate career. Born in the village of Mallow, county Cork, Ireland, September 3, 1810,[1] he was brought to Canada at the age of eight, when his father emigrated and settled in York, the original name of the present city of Toronto. In those early days, York was frequented by many Missisauga Indians and was a principal rendezvous of the picturesque French-Canadian half-breeds and *voyageurs*. The Irish lad found their stories of exploration and adventure far more to his liking than the dry routine of the classroom or the prospect of succeeding his father as a wine and spirits merchant. As he grew to manhood his desire to go West and paint frontier scenes took on a serious aspect; but first he longed to go to Europe and study under some great teacher. Instead, circumstances forced him to go to work in a shop

[1] Introduction by Lawrence J. Burpee, in the reprint of *Wanderings of an Artist among the Indians of North America*, by Paul Kane (London, 1859), The Raddison Society of Canada, Toronto, 1925. According to evidence established by Burpee, Kane was born in Mallow, county Cork, Ireland, and not at York, Ontario, as frequently recorded in references to this artist.

100

where household furniture was made, and decorating cheap chairs and chests of drawers was the nearest he could come to artistic expression. But he never lost sight of his goal. At the age of twenty-six he left Canada for the United States, determined to make art his profession and to get together enough money to study in Europe.[2]

After five years of wandering all the way from Detroit to New Orleans, working at odd jobs and saving his money, Kane sailed for Europe in June of 1841. Without sufficient funds to afford a teacher, he made his way from city to city, again working at odd jobs and devoting all the time he could to copying and studying paintings of the old masters in the museums of Paris, Rome, Venice, Milan, and London. After four years of this self-education, he returned to Toronto determined to fulfill his lifelong ambition of going West to paint Indian life.

Paul Kane's first frontier sketching trip was in June, 1845 ". . . with no companions save my portfolio and a box of paints, my gun and a stock of ammunition. I possessed neither influence nor means for such an undertaking . . . yet it was with a light heart that I made the few preparations for my future proceedings." [3] He spent the summer wandering, alone, among the Ojibways, Hurons, and Ottawas around Lake Huron. It was not a very pretentious trip, but the sketches he made were put to good use. He arranged to show them to Sir George Simpson, governor of the Hudson's Bay Company, as a means of getting permission to accompany the next spring's brigade of Company river boats into the Far West. So well did Kane sell himself that he not only succeeded in his mission but also was ordered to paint twelve pictures for the Governor. Furthermore he found a liberal patron in the person of George William Allan of Toronto, who commissioned him to make 100 Indian paintings for his private collection.

The following spring he missed the Company brigade at Sault Ste. Marie, but set out in a light canoe and overtook the party on one of the long portages. The men who manned the big flotilla of fur boats were a hard-bitten lot, and traveling with them was in itself an amazing experience. Kane filled his sketchbooks with the interesting scenes along the way. One of the paintings he later made of the brigade under full sail is reproduced on page 108.

They crossed the province of Ontario and sailed down Rainey River to Lake of the Woods, then down the Winnipeg River to Fort Alexander, near the river's mouth on Lake Winnipeg. Here, halfway across the continent, the artist left the boat brigade to join a party of Indians bound for Fort Gary on the famous Red

[2] Dr. (afterward Sir) Daniel Wilson, in the *Canadian Journal*, 2d series, Vol. 13, 1871. Dr. Wilson is responsible for most of the information regarding the artist's early life.

[3] Kane, *op. cit.*, Chap. I.

River. Kane slept in the tepees and grew to enjoy the pungent odor of smoked buckskin and roasting moose meat. After a short stay on the Red, he cast his lot with a large party of half-breeds on their annual buffalo hunt farther to the westward. He was the only white man in the big caravan that moved out across the rolling Plains, with hunters on horseback and the big-wheeled Red River carts carrying families, tepee coverings, and all the necessities of the hunting camp. Kane's painting of this colorful caravan is reproduced on page 108. En route, they were attacked by a band of hostile Sioux, and in the sharp fight that ensued eight of the half-breeds were killed.

As they neared the buffalo country, scouts rode off in search of game, sometimes not returning until long after the caravan had camped for the night. There were quarrels and fights, and false alarms of Indian attacks. But the buffalo were finally located. The artist was with the scouting party that first sighted the herd, stretching over the plain as far as the eye could see. Word was quickly carried to the other hunters and within an hour about 130 were gathered to begin the chase. Every man loaded his gun, checked his priming, made sure that his saddle girth was well secured. Each crammed his mouth with balls to drop into his muzzle-loader while riding at full gallop. Then the signal was given and the hunt was on.

"In twenty minutes we were in their midst," wrote Paul Kane in his journal. "There could not have been less than four or five thousand buffaloes in our immediate vicinity, all bulls. . . . The scene became one of intense excitement; the huge bulls thundering over the plain in headlong confusion, whilst the fearless hunters rode recklessly in their midst, keeping up an incessant fire at but a few yards distance. . . . Upon the fall of each buffalo the hunter merely threw some article of his apparel—to denote his own prey; and then rushed on to kill another. . . . My horse was suddenly confronted by a large bull that made his appearance from behind a knoll, and thus taken by surprise the horse sprung to one side, and getting his foot into a badger hole, he fell at once, and I was thrown over his head with such violence that I was completely stunned. Some of the men caught my horse, and I was speedily remounted."

He galloped on and soon put a bullet into another animal of enormous size, at which point his career as an artist almost came to an abrupt and bloody conclusion. "He did not fall, however, but stopped and faced me, pawing the earth, bellowing and glaring savagely at me. The position was so fine I could not resist the desire to make a sketch. I accordingly dismounted, and had just commenced, when he suddenly made a dash for me. I hardly had time to spring onto my horse and get away, leaving my gun and everything else behind. He turned over the articles, pawing fiercely as he tossed them about, and then retreated toward the

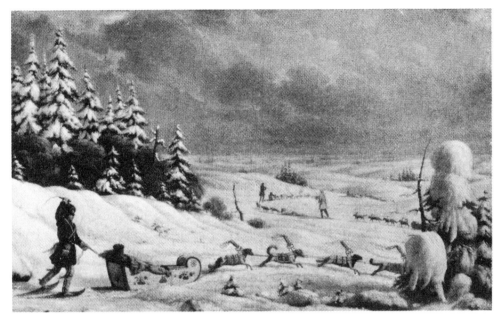

WINTER TRAVELING BY DOG SLEDS NEAR EDMONTON Paul Kane
(Royal Ontario Museum of Archeology)

herd. I recovered my gun and soon planted another shot in him. This time he remained on his legs long enough for me to make a sketch.

"The chase continued only about an hour, during which time about 500 buffalo were killed. Next day the hunt was continued, and the women began cutting the meat into slices and hanging them on the racks to dry in the sun. At night the stillness of the plains was made noisy by the howling and fighting of innumerable wolves and half-wild dogs that roamed about where the buffalo had been slain."

Upon his return to Fort Gary the artist went by small sailing sloop up the length of Lake Winnipeg to the Hudson's Bay Company's Norway House, where in mid-August he joined the Company's brigade and continued westward with them. Ascending the Saskatchewan River to Carlton House, they left the river boats and proceeded overland on horseback to Edmonton (central Alberta). Continuing westward, they entered the Rocky Mountains, at what is now Jasper Park, and early in November ran into such heavy snow that the horses had to be abandoned and the journey over the pass continued on snowshoes. The brigade finally reached Fort Vancouver on the Pacific Coast, December 8, 1846.

After spending the winter around Vancouver Island, where he made sketches for a series of paintings of the West Coast Indians, the long journey back across

the continent was begun on July 1, 1847. It took the party more than five months of continuous struggle against dense forest, rocky canyons, and high passes, to get across the Rockies. They reached Fort Edmonton on December 5, and Kane remained there for the balance of the winter. Although well north in the Canadian Rockies, and in the bitter cold of winter, the artist found an abundance of game and Indians in the area. "The buffaloes range in thousands close to the fort," Kane wrote in his journal; ". . . as for seeing aborigines, no place can be more advantageous. Seven of the most warlike tribes on the continent are in constant communication . . . Crees, Assiniboines, Blackfeet, Sar-cees, Gros-vents, Paygans, and Blood Indians." He joined in a midwinter buffalo hunt, a thrilling encounter with a herd "probably numbering nearly 10,000" which almost cost the life of the chief factor of the fort. He made a number of other, more extensive trips by dog team. As soon as the spring weather permitted, he continued eastward, arriving back in Toronto in early October, 1848, thus ending as strenuous a twenty-nine months in the wilderness as any of his artist contemporaries had ever experienced.

Upon his return Paul Kane buckled down to the studio task of making finished canvases. The 100 paintings delivered to George William Allan were subsequently purchased by Sir Edmund Osler and presented to the University of Toronto. They are now in the Royal Ontario Museum of Archeology.[4] There is no record of what has happened to the twelve which he delivered to Governor Simpson, his original benefactor. Many other Kane paintings can be found today in museums and collections both in Canada and the United States. One of these is reproduced in full color on page 105.*

About 1860 his eyesight began to fail and he was compelled to abandon his art entirely, an unfortunate circumstance which saddened his remaining years. He died in Toronto, February 20, 1871, securely established as the pioneer of Canada's Western artists.

[4] For a complete catalogue see Kane, *op. cit.*, Toronto reprint, 1925, pp. xxxviii *et seq.*

*Reproduced in black-and-white in the present edition.

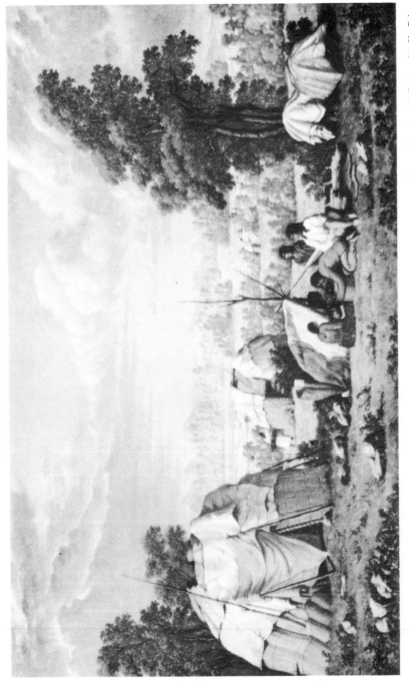

WHITE MUD PORTAGE, WINNIPEC RIVER Paul Kane

(Knoedler Art Galleries, N. Y. C.)

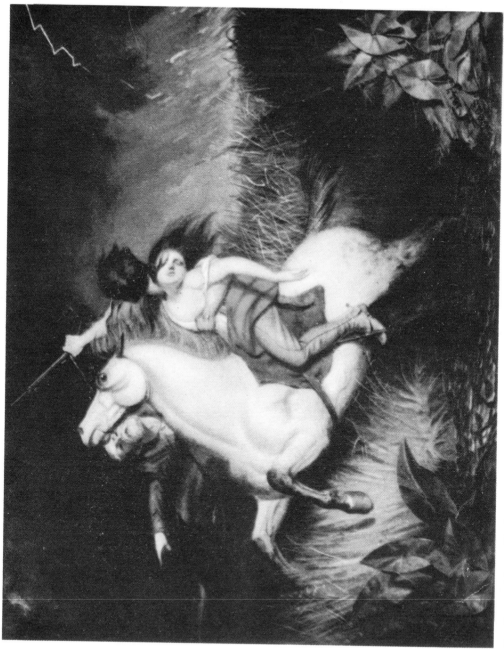

THE PRAIRIE FIRE Charles Deas (Brooklyn Museum of Fine Art)

THE TRAPPER (LONG JAKES) Charles Deas (Yale University Art Gallery)

HALF-BREEDS TRAVELING Paul Kane (Royal Ontario Museum of Archeology)

THE BRIGADE OF BOATS Paul Kane (Royal Ontario Museum of Archeology)

AN IOWA MAIDEN (Probably the artist's wife) Sketchbook drawing by Friedrich Kurz
(Bernisches Historisches Museum)

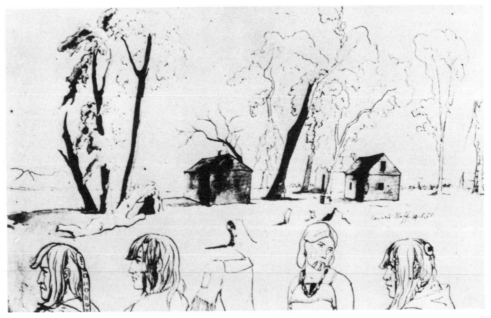

COUNCIL BLUFFS—May 19, 1851 Sketchbook drawing by Friedrich Kurz
(Bernisches Historisches Museum)

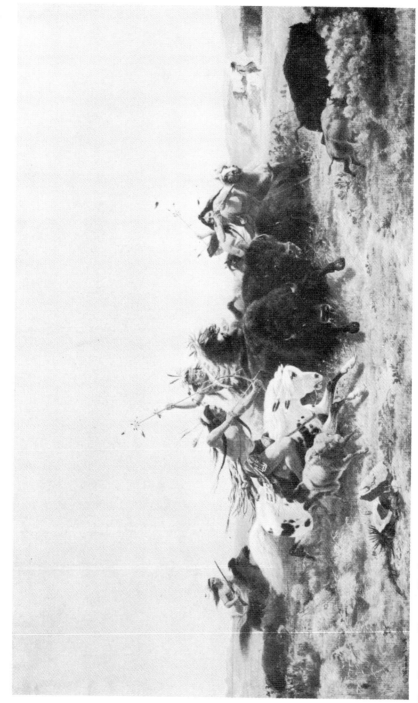

THE BUFFALO HUNT Charles Wimar

(Washington University of St. Louis)

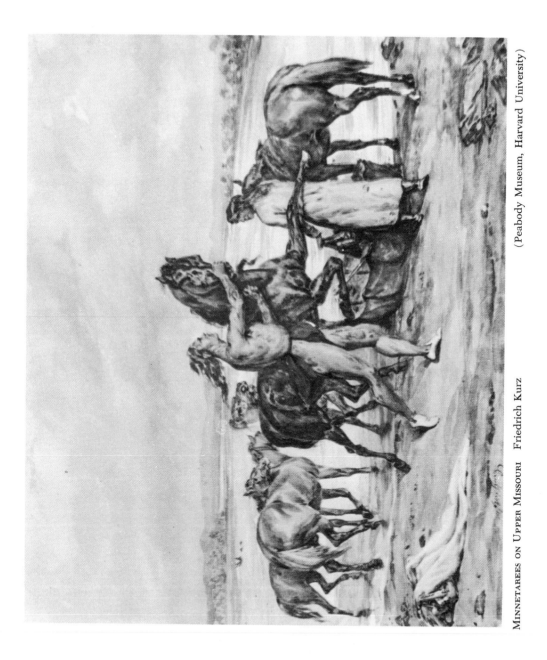

MINNETAREES ON UPPER MISSOURI Friedrich Kurz (Peabody Museum, Harvard University)

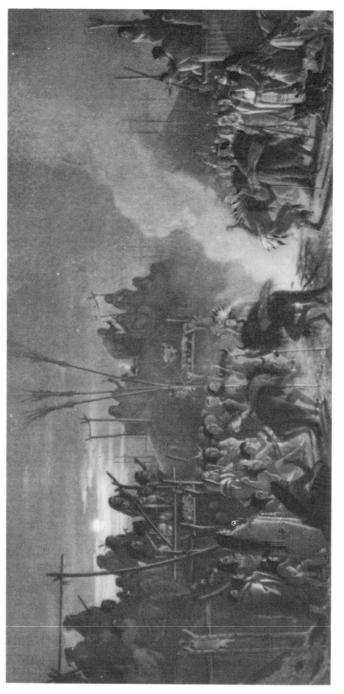

THE BUFFALO DANCE Charles Wimar

(City Art Museum of St. Louis)

Charles Wimar

11 *A Rough Road to Success*

IN THE YEAR 1845, in the rough hurly-burly of the district in St. Louis where the wagon trains were made ready for the long journeys westward across the Plains, a slender teen-age boy worked diligently applying paint to the heavy wooden bodies and big wheels of the prairie schooners. The boy had the appearance of a half-breed Indian and he spoke only broken English, but his accent was distinctly German. He had come to America from his native homeland on the Rhine only a few years before. Painting wagon beds was hardly the best practice for an aspiring young artist, but one must occasionally perform unpleasant tasks to live, even in America. Whenever he had the opportunity, he would add a decorative design as he worked. On rare occasions he got a job painting the paneled body of a conveyance for a local patent medicine salesman or a traveling vendor of household merchandise. Then he was happy and would amaze the other workmen and roustabouts who stopped to watch as he deftly plied his crude brushes. Sometimes, when he was in luck, he painted houses, or store fronts or signs.

Charles Wimar [1] was born in the town of Siegburg, near Bonn, in western Germany, February 19, 1828.[2] Before he was seven years old, his father died and shortly thereafter his mother remarried. His stepfather, Mathias Becker, came to America in 1839 with the hope of bettering his position in the New World, and he settled in St. Louis, where already there was a sizable German population. It was four years before circumstances permitted Mrs. Becker to make the long journey .

[1] The artist was christened Karl Ferdinand Wimar, went by the family nickname Carl, but generally signed his paintings Charles Wimar. This accounts for the variations in his first name.

[2] A rather sketchy biography of this artist appears in *Carl Wimar—A Biography*, by William Romaine Hodges, Galveston, Texas, 1908. The information has recently been corrected, corroborated, and considerably added to in *Charles Wimar—Painter of the Indian Frontier*, by Perry T. Rathbone, Director, City Art Museum of St. Louis, St. Louis, Missouri, 1946 (illus.), with a catalogue of all known paintings. Most of the facts incorporated into the present sketch of Wimar's life are from this latter source, by permission of Mr. Rathbone.

to join him, at which time young Wimar was fifteen. The immigrant family found that their new home was a roadhouse which Becker called "St. Louis Park." The place was on the outskirts of town, near a favorite camping grounds used by the Indians who came to exchange their winter catch of fur for white man's goods. Charles Wimar quickly became interested in the Indians and the life they represented, and his quiet, sympathetic disposition gained for him a friendly reception among them. One old Indian who had been a noted warrior in his younger days took a particular liking to the German lad, was a frequent guest at the Becker family dining table, and took Charles on occasional jaunts into the nearby woods. Gradually, he was introduced to the ways of Indian life.

Not long after his arrival in America, Charles had to begin supporting himself. The job which came nearest his desire was an apprenticeship to a local character who dignified himself as a "fresco artist," but who made most of his living decorating prairie schooners and stores with plain coats of cheap paint. This was Leon de Pomarede, a quaint individual who had won some notoriety decorating the interior of the old Cathedral of St. Louis. Pomarede was a firm believer in piecework, and in quantity. His gaudy attempts at art had been paid for by the square yard, rather than for their esthetic qualities. Extremely limited though his artistic talents may have been, Pomarede's heart was in the right place, and he encouraged his young apprentice to add distinction to his wagon painting and to spend his spare time in serious efforts at art work.

One day stepfather Becker took in a transient wayfarer who had fallen ill and was badly in need of shelter and care. He was of Polish nationality and had no money, but appeared to be of good family background and education. Carl's mother cared for the stranger and nursed him back to health, a task which took considerable time. During the process he became interested in this sixteen-year-old who was already struggling to make oil paintings of Indian scenes. "He should go to Europe . . . to Düsseldorf, in his native Germany . . . to study under one of the great teachers," insisted the star boarder. "He has talent and it should be properly developed." That was far too unrealistic a project for serious consideration by the Becker family, but it added another dream to the boy's already ample collection. Eventually the patient became well enough to go on his way, and his visit was soon forgotten.

Charles Wimar worked for Pomarede for four years. In 1849 the "fresco painter" undertook an ambitious plan to make a giant panorama painting which would portray the whole Mississippi River from its headwaters of navigation to its confluence with the Ohio. The idea was to exhibit this super–art work in St. Louis and elsewhere for admission fees. He took Charles along as assistant and the two

journeyed upriver to the Falls of St. Anthony to begin the work. The project was just getting under way when Wimar received a startling message from his mother. Word had just been received that he had become heir to what seemed like a large fortune. The Polish wayfarer whom the Beckers had kindly nursed back to health had returned to his native land, where apparently he had come into an inheritance. He had not forgotten their hospitality, or the quiet boy who painted wagons and dreamed of becoming a great artist. Before this man had died of his illness, he had made a provision in his will which would make it possible for Wimar to go to Düsseldorf and study under one of the fine teachers. Tremendously elated, Charles quit his job with Pomarede and returned to St. Louis to wait for the money to arrive, but the Beckers soon learned there were legal complications which had to be worked out before the funds could be sent to America.

Time drifted by, but the money was not forthcoming. Charles started working independently at his trade, saving every penny that he could. After three years, without the help of the elusive inheritance, he managed to get together enough money to go to Europe. Early in 1852 he returned to his native Rhineland and enrolled in the Academy at Düsseldorf, as a student of Joseph Fay, the eminent exponent of historical painting. Later he studied under Emanuel Leutze, famous for his *Washington Crossing the Delaware.* Hopes of ever receiving the inheritance had by now almost completely faded and Wimar was severely handicapped by poverty. He "was forced to borrow money from his St. Louis friends and relatives . . . traded one painting with a Düsseldorf tailor for a suit of clothes, and for another took picture frames in exchange." [3] But he was a most prodigious worker and his progress was remarkable. He had immediately begun specializing in Indian and frontier subjects, and within a short time his paintings were being selected for exhibitions in Cologne, Hamburg, and Elberfeld. Almost from the start his canvases were large in scale and ambitious in composition. Some of his pictures were sent back to St. Louis, to be sold, but they failed to find ready buyers. Among the paintings sent back home during his second year as a student was *The Attack on an Emigrant Train,*[4] which was purchased by the Hon. Hamilton R. Gamble, governor of Missouri.

Returning to St. Louis late in 1856 after four and a half years abroad, Charles Wimar launched enthusiastically into his professional career. The frontier had moved farther West, and a new sophistication had robbed St. Louis of much of the colorful hurly-burly of his boyhood days. The Indians had stopped coming to

[3] Perry T. Rathbone, *op. cit.,* p. 14.

[4] *Ibid.* See pp. 34–54 for catalogue of Wimar's paintings, descriptions, sizes, present whereabouts, etc.

camp at the edge of town, and to find the old-time tepee villages one now had to travel a long way into the West. Wimar longed to use his newly developed talent among the red men in their own native wilderness, but first he had old debts to liquidate. Although he had become afflicted by a bad lung congestion, he set up a small studio in St. Louis and began working as hard as ever, painting commissioned portraits and doing whatever other art jobs would bring in money.

Wimar managed to make two or three short trips up the Missouri to get on-the-spot sketches of Indians around the rapidly developing towns and fading trading posts. In the spring of 1858, he boarded the first boat of the season bound for the headwaters of the Missouri, with plenty of materials for sketching and painting, including the latest model box camera to supplement his sketchbook.

On board the boat was a government agent to pay the annual land tributes to the various tribes of Indians who would be waiting at appointed places along the river, and at Fort Randall, a short distance above St. Louis, a company of soldiers was taken aboard as a protection against hostile acts of the red men. Many changes had taken place since George Catlin traveled the same route twenty-six years before. On the first part of the trip, where the big tepee villages once had been, there were towns with stores and churches, hotels with bars and dining rooms, and farms all along the way.

At Fort Clarke the boat was anchored in the evening about seven miles below the old landing place "on account of the notorious thieving propensities of the Arriccarees [Arikaras]. Even at this distance from the Fort, the Captain preferred to anchor a short distance away from the shore. . . . But we had been observed by some of their spies, and a short time after midnight the Indians surrounded our craft with their boats made of buffalo hides, and it was actually necessary to have most vigilant sentinels prevent us from being robbed. . . . [Later] they became very much incensed at the Agent and fired at him once or twice with their muskets, the ball from one of which slightly wounded him in the foot." [5]

The boat made the trip to Fort Union in thirty-one days. After a few days spent there sketching the Assiniboins, without incident or outbreak of any kind, Wimar continued on up the Yellowstone some three hundred miles to Fort Sharpie, where he lingered for some time sketching and painting the Crow Indians. He finally began the long trip back to St. Louis, arriving home in November. An account of this trip was sent to Düsseldorf, where it was published in the journal of the Academy, 1858.

By this time the artist's imposing paintings of Indians and frontier scenes were attracting considerable attention in St. Louis. Wimar himself was a picturesque

[5] *Ibid.* For a complete account, see pp. 18–24.

individual, frequently appearing on the streets in the fringed buckskin garb of a frontiersman. He had straight black hair that fell to his shoulders, and facial characteristics and a gliding gait which emphasized his resemblance to an Indian. The sale of his paintings slowly increased, but never quite fast enough to free him from financial difficulties. His failing health was a more serious problem; tuberculosis weakened him almost daily. Always optimistic about the future, it is reported that he once said to his mother, with undiminished confidence and a wry smile, "Mother, if I last long enough, someday I shall be so rich that I can have a bank account."

In addition to his deep devotion to painting faithful documentary works in his chosen field, Wimar was a staunch proponent of the whole field of fine arts. In 1859 he was one of the founders and supporters of the Western Academy of Art, the first cultural institution of its kind to be organized west of the Mississippi. For the exhibition marking the grand opening of the Academy in September, 1860, he painted one of his finest canvases, *The Buffalo Hunt* (36 by 60 inches), which is reproduced on page 110. The occasion was one of considerable pomp and celebration. It was attended by the Prince of Wales (later King Edward VII) who was at the time official guest of the city of St. Louis, and Lord Lyons, the British Ambassador to the United States. The exhibition was a great success, and one of its outstanding paintings was *The Buffalo Hunt*. It was immediately purchased by William Van Zandt, an early patron of the arts, and made such an impression upon the royal visitors that Lord Lyons commissioned Wimar to paint a replica for him. The original is now the property of Washington University in St. Louis. During the same year the artist painted *The Buffalo Dance*, reproduced on page 112, which is considered one of his best and now hangs in the City Art Museum of St. Louis.

In the spring of 1861, less than two years before his death, he married Anna von Senden of St. Louis. One daughter was born, to whom he gave the Indian name of Winona ("First-born Child"), but the little girl outlived her father by barely two years. The year of his marriage also brought Wimar the most important public recognition of his lifetime, a commission by the city of St. Louis to decorate the new rotunda of the Court House with appropriate murals. He was so grateful for this honor that he offered to do the work for $500, probably less than the fee, measured by the square yard, for which Pomarede had decorated the old Cathedral. Wimar's offer was appropriately doubled by the County Commissioners. The undertaking was of considerable magnitude, requiring several months of labor to complete the four large historical panels which the artist chose as subjects. He went at the challenging task with an enthusiasm which belied the sickness which had by this time hopelessly weakened him. As the paintings progressed, and the

continuous exertion drew heavily upon his failing energy, he lost the strength necessary to climb the long flights of stairs to the scaffold. He insisted upon being carried to his work, and there, high up in the Court House dome, a couch was installed for him to lie on when he became too weak to use his brushes. Carried home one evening after a long day, he said to his wife: "This is my last work—and when it is finished, I shall be finished too." On November 28, 1862, just after the murals were completed, Charles Wimar died at the age of thirty-four.

Ironically, circumstances beyond the artist's control virtually ruined the paintings in the Court House. The plaster on which they were done had not been properly prepared and in a short time the paint began to peel off. Attempts were made in 1888 and later to restore the pictures, but the inferior plaster, soot, time, and the inept hand of the restorer have left little more than the dim shadow of the original beauty of Wimar's last work. Fortunately, a much kinder fate has brought many of his fine paintings into the country's important museums and art collections.

Friedrich Kurz

12 *Wagon Tracks on Prairie Trails*

THE PLAINS INDIANS rode proudly and prosperously into the 1840s. The white man had scattered the questionable blessings of his civilization—material goods—in almost every tribal village from the Mississippi to the backbone of the Rockies. He had also introduced the Indian to the wholesale slaughter of the buffalo for their hides and to various diseases. He had induced the red man to forfeit more and more land rights to vast areas of his domains. But the Indians liked the firewater (*mini-wakan*, or "water spirit," in the language of the Sioux); the herds of buffalo seemed beyond depletion; and there still seemed plenty of land left, always a little farther west. Then came an event in the late 1840s which changed the course of destiny of the West.

Perhaps the most momentous single event in the white man's development of the West was the discovery of gold in California in late 1848. Its stimulating effect on westward migration can hardly be measured. Also in the spring of 1848, the war with Mexico was ended. Going West had now become more than a wild adventure. Enough emigrants had settled beyond the Mississippi for Arkansas to become a state in 1836, and Iowa was sufficiently populated to join the Union ten years later. It was common knowledge that the soil of the free land was rich for agriculture, and no longer were white settlers completely at the mercy of Indian raids. Now came the answer to the wildest of dreams: "In California, the El Dorado, gold can be scratched out with the fingernails . . . and no one returns with less than $50,000!" The sudden stampede was under way. Where the lonely spring brigades of the fur companies had moved westward from St. Louis, a steadily increasing stream of independent emigrant parties spread out, like ants, often blindly, from the new jumping-off places along the Mississippi and the Missouri. Columns of cavalry and infantry marched westward across the plains to drive the recalcitrant redskins out of the path of the fortune seekers, with the frightful slogan, "The only good Indian is a dead Indian!" Solemnly into council went the tribal sachems, to listen to the words of wisdom of their elders, and to try to decide what should

be done about the invasion. They read the signs, clearly and precisely, and responded in the only way self-respecting human beings could. Thus began a struggle that was destined to drag through forty years of bitter and bloody conflict and which could end only in the death of a proud race.

The man who probably had the best opportunity of becoming a delineator of the gold stampede to California was Rudolph Friedrich Kurz—a soldier of fortune with an art pad. He spent the years between 1847 and 1852 along the Mississippi, Missouri, and in the adjacent territory from St. Louis to Fort Union. Born in Berne, Switzerland, January 8, 1818, he came to America at the age of twenty-nine, with a background of twelve years of sound artistic training in Paris and elsewhere in Europe. The five years Kurz spent on our Western frontier were devoted almost entirely to art work and when he returned to Switzerland, he took virtually everything with him. Since that time there has been extremely little of his work seen in America. There is one water color in the Peabody Museum of Harvard University, which is reproduced on page 111, and a sketchbook of drawings that was divided into separate leaves and sold by a New York art gallery in 1946.[1] A number of his American paintings are in the Fine Arts Museum in Berne, and the Historical Museum there possesses a considerable number of his original drawings, some of his sketchbooks, and a lengthy journal, written in German, which the artist compiled during his stay in our West.[2] The Kurz journal is one of the most interesting and pertinent of its kind concerning the Indians and white men of the frontier during the period of the big gold rush.

Kurz arrived in St. Louis on January 17, 1847, having come up the Mississippi from New Orleans, where he had landed the day before Christmas. During the first year he made several short sketching trips up and down the Mississippi and west into the Indian territory from St. Louis. On one of these he visited the Mormon settlement of Nauvoo, near Des Moines, where the big Mormon temple was a much discussed and vehemently protested monument to the sect's unpopular presence on the frontier. "On the ground floor is a large stone basin drawn by

[1] See *Art Digest*, Vol. XX, March 15, 1946, p. 7 (Exhibition of drawings by Rudolph Friedrich Kurz at the Kennedy Galleries, New York).

[2] The journal of Rudolph Fried[e]rich Kurz, consisting of 455 typed pages in German, together with one of his sketchbooks, was located in the Historical Museum, Berne, Switzerland, in 1906 by David I. Bushnell, Jr., of the Smithsonian Institution. He had the journal copied and many of the sketches photographed. See *Friedrich Kurz, Artist-Explorer*, by David I. Bushnell, Jr., Annual Report for 1927, Smithsonian Institution, Washington, D. C., 1928, pp. 507–527. The journal was translated by Myrtis Jarrell and edited by J. N. B. Hewitt, and was published as Smithsonian Institution Bulletin 115, Washington, D. C., 1937. This material, with additional help supplied by the present director of the Berne Historical Museum, forms the basis of the accompanying account of the artist.

FORT PIERRE Friedrich Kurz (Bernisches Historisches Museum)

twelve life-sized oxen carved in stone," Kurz described it in his journal. "In that basin repentant sinners, male and female, bathed naked in the presence of their profet [*sic*] and thereby washed away their sins." The temple was shortly afterward burned down.

Kurz was a casual drifter. He started up the Missouri in April, 1848, with the vague idea of a leisurely journey to the Rocky Mountains, by whatever course might best suit his fancy and offer him the finest Indian subjects for his painting. He stopped at Council Bluffs for a while (see page 109) and then settled down at St. Joseph, about five hundred miles above St. Louis. Formerly a trading post, it had mushroomed into a frontier town some six years before and was showing signs of rapid development. The important attraction for Kurz was the number of Indians who still came there to trade and procure supplies—Iowas, Potawatomis, Foxes, Otos, and Kickapoos. He rented a large bedroom, which served also as a studio, and went to work with his paints and sketch pads. Indians frequently came to pose for him, and a good share of his time was spent at their large camping place on the opposite side of the river.

"Since gold has been discovered in California," he wrote in the summer of 1848, "the fur traders are in the background. Now thousands of gold seekers and emi-

grants throng the streets and taverns." It was not until the next year, however, that the stampede assumed truly frightening proportions. "At the end of January [1849] the first gold seekers [of the year] arrived. . . . They were two rich merchants from New York, who had traveled in a sleigh direct from their home [more than 3,000 miles]. . . . When the Missouri was open to navigation in the middle of February . . . the city became packed so full of people that tents were pitched about. . . . Nobody hereabouts was prepared for such a large number of emigrants. The prices of provisions, cattle, and goods became exorbitant. . . . Ham, formerly 3 to 7 cents a pound, was now 12 cents; butter rose from 8 to 15 cents. Often bread could not be had at all. . . . Play and drink were the order of the day. 'Oh, Californy, you are the land for me!' was their song." The influx of travelers, with all the congestion under unsanitary conditions, brought an epidemic of cholera which spread death among the white men and ravaged the Indian camps.

The artist became a close friend of Kirutsche, a chief of the Iowa tribe and an Indian of considerable distinction. Kirutsche not only taught Kurz the Iowa dialect, but proposed that the artist take his attractive sixteen-year-old daughter Witthoe as his wife (see page 109). This proposal was accepted. "My parents-in-law pleased me quite well," he wrote. "So when Witthoe came back with her mother on January 10 [1850], I received her as my wife. Her mother served hot coffee, fried meat, and bread. . . . Next day I purchased her outfit . . . the usual short skirt of red calico, a woolen underskirt and pantalettes . . . many colored bands for her hair . . . and smaller beads for girdle and garters."

Everything went well with Kurz and his Indian wife and he made many sketches, until spring when the Indian families went away. "Witthoe began to feel like a captive bird. . . . Wrapped in her blanket she sat dreaming of her earlier freedom." Then shortly thereafter: "I found my bird had flown . . . I pondered . . . should I hasten after her and plead with her to come back to me? Never! I loved her; I had taken her in sincerity with good intention; I had treated her well; I hoped she would come back. . . . But that was the end of my romantic dream of love and marriage with an Indian maiden. Brief joy!"

After that, Kurz wanted no more of St. Joseph and decided to join the spring stampede to California. "Gold or death!" was now the cry. Horses were bought and an outfit loaded on the wagon, but at the last minute a partner he had found for the trip backed out, and the scheme had to be abandoned. On June 16, 1851, the fur boat *St. Ange* (see page 124) came up the river and Kurz got aboard. He would go to the headwaters of the Missouri to seek new Indian tribes, new scenes, new friends. The boat was full of cholera; many were sick and dying. The clerk for the fur company became a sudden victim, and the artist was induced to take over

his work. On July 4 they stopped at Fort Pierre (see page 121), and finally the *St. Ange* reached Fort Berthold (western North Dakota) where the company ordered Kurz to get off and continue his duties. He was not displeased, for this fort was "alive with Indians"—Mandans, Arikaras, Hidatsas or Minnetarees, and Crows. And there was always the chance of an attack by the belligerent Sioux.

Two days after the artist's arrival a large herd of buffalo was sighted across the river. Hunters, horses, and squaws were hurriedly ferried over to take advantage of this unlooked-for supply of meat. Then on Sunday, July 13, "while I was industriously sketching, a Mandan rushed into my room and begged for my double-barreled shotgun . . . one of his comrades had been killed by a Sioux." The place became a beehive of excitement and activity. Warriors hurried across the river to avenge the death of their tribesman, Le Boeuf Court Que Que. His wife and child had witnessed the Sioux enemy leap from ambush to fire one fatal arrow and then make a cowardly escape, without taking the scalp or even counting coup on (touching) his victim. Kurz climbed to the roof of his house to watch through a telescope.

"Finally, toward sunset, I saw approaching the escort with the dead . . . in the golden shimmering light that soon deepened to violet, throwing the dark forms into relief. First came the mourning widow, leading the horse across whose back lay her dead husband wrapped in his blanket. Mourning relatives followed, encircled by restive braves whose blood was hot. . . . Having arrived at the burial ground, the dead warrior was taken from his horse and laid out on his blanket. . . . Relatives sat around wailing and howling, jerking out their hair, pounding their heads, tearing their flesh with knife and arrow points until the blood flowed as sacrifice. . . . A scaffold was erected and upon this the Mandan, attired in the manner of Indian warriors, was laid beneath a new red blanket. . . . Only his widow and his mother remained to wail."

After supper Kurz was startled by shots and outcries. An Indian woman poked her face through his open window and made the significant sign for throat cutting and pointed across the river. A few moments later the artist was beside the steep river bank. "Two young braves were returning with their first scalps. What exultation! Everyone was eager to extend the first welcome. The warriors came ashore. Their faces were painted black [the sign of having performed an honorable coup]. . . . One of the welcomers fastened the two scalps to a long pole and strode behind the victorious braves, singing their song of triumph. . . . The scalps were placed beside the dead Le Boeuf Court Que Que." His death had been properly avenged!

Kurz worked diligently almost every day at his sketching and note taking. Within two weeks he had compiled a dictionary of 600 Mandan words. But the

ravages of cholera again spread through the tepees of the Indians, bringing death to hundreds, and someone started the superstitious rumor that the plague was caused by the white man from afar who asked questions so persistently and made pictures of everyone and everything he saw. Threats were made against his life, and the situation became so serious that Kurz was compelled to leave Fort Berthold in a hurry. With one companion he made the long trip on horseback to Fort Union at the mouth of the Yellowstone.

Friedrich Kurz remained at Fort Union from September 1, 1851, through the winter. During that time he sketched and studied the tribes that had inspired Catlin, Bodmer, and Wimar. On April 19, 1852, he wrote in his journal: "Left Fort Union at 11 o'clock this morning to begin my journey home. My studies in this country are now completed." He reached St. Louis on May 25, and "with a heavy heart" continued on his way back to Switzerland. There he became an art teacher in Berne, and painted a considerable number of pastels and oils from the sketches he had made in America. Many of these are now in Switzerland, where Kurz died nineteen years after leaving this country, on October 16, 1871.

During the five and a half years this artist spent on our Western frontier he enjoyed a close and sympathetic relationship with the Indians. Although he was an accomplished professional at his trade, his paintings have remained almost unknown in this country. Had he but followed through in his plan to join the gold rush in 1851, his work might have been of considerably greater historic value.

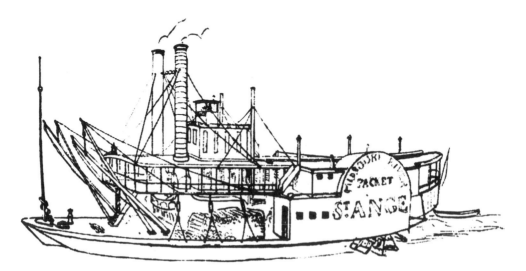

(Bernisches Historisches Museum)

Ernest Narjot William Ranney F. O. C. Darley
Baldouin Möllhausen Arthur Fitzwilliam Tait

13 Stampede Days on the Plains

THE GOLD RUSH to California in 1849 and the early 1850s stands out boldly as one of the most dramatic episodes in the whole American scene, and it had much to do with the settlement and development of the western half of the United States. Many of the stampeders made the trip by boat, via portage across the Isthmus of Panama or the longer route around the lower end of South America. But it was the overland trip across the wild and little-known Great Plains which provided the most difficult and dangerous obstacles, and it is this particular phase of the story which comes within the scope of this book. The hectic days in the boom towns and gold camps of California cannot be considered an integral part of the story of the Great Plains.

There have been many gold stampedes to wild sections of the earth, but none is comparable to this mass migration across a wilderness in a mad gamble for fortune. Long caravans of covered wagons plodded westward, often blindly, with little conception of distance or direction, over open prairies and deserts and into the mountains. There were frequent fights for survival against Indians, and physical hardships, often beyond endurance. Many turned back or died along the way. This episode in our history has provided inspiration for legions of writers, poets, dramatists, and movie makers. It has been responsible for untold numbers of paintings and drawings, mostly in retrospect, through a century of every form of the graphic arts. Yet, strange to say, there was not one artist who gave himself over to depicting a comprehensive eyewitness record of this great epic. There were a number of contemporary artists who might have made the great trek across the Plains their thesis. Seth Eastman was in Texas in 1848–1849, Charles Deas was in St. Louis, John Mix Stanley presumably on the West Coast, and Kurz was on the Missouri. Some devoted part time to the story, but not enough to record it adequately; and none made it a serious firsthand project.

Among those who rushed to California, from as far away as Europe, was the French artist Ernest Etienne Narjot de Franceville—later known simply as Ernest

Narjot.[1] He had sailed around Cape Horn from France and arrived in San Francisco late in 1849. Although thoroughly trained in the art schools of Paris, the possibility of discovering treasure diverted his attention to prospecting. In 1852 he joined a mining expedition to Mexico, where new diggings had been discovered. After thirteen years there, he returned to San Francisco where he took up his brush and became quite successful as a portrait artist and a painter of frescoes for churches and public buildings. Many of his pictures were of prospecting and mining placer gold (see page 132), and he did a few covered wagon scenes (see page 132). Although he had not crossed the Plains with the emigrants, he was intimately acquainted with the whole gold rush episode and could have given us a fine pictorial record. Instead, the climax of his career was the painting of the murals in the Leland Stanford tomb on the university grounds at Palo Alto. While working on the ceiling, paint got into his eyes, ultimately causing complete blindness. He died in San Francisco, August 24, 1898. Many of his finest canvases were destroyed in the earthquake and fire of 1906.

One of the most glamorous characters among the artists of this period was Baldouin Möllhausen.[2] He came to America in 1849, at the age of twenty-four, and after two years of knocking about in the Middle West he joined up with Duke Paul William of Württemberg,[3] a fabulous royal explorer and scholar of the nineteenth century. Prince Paul, known as "the gypsy Prince," was a nephew of King Frederick I, a Doctor of Philosophy and a fine sketch artist. This was his third expedition into our West since 1822. With a third member of the party, Prince Paul and Möllhausen set out for St. Louis, whence they trekked up the Missouri to Fort Laramie and apparently some distance beyond. They were involved in several narrow escapes from hostile Indians, and somewhere along the way the third member left them. On their return trip southeast to St. Louis, in bitter winter weather, they lost some of their horses and it became necessary for one of them to go for aid. They drew lots, and it was Möllhausen's fate to remain in the makeshift camp. He almost froze to death and existed for days on nothing but frozen wolf meat. He was attacked by Indians, and managed to kill one and wound others.

[1] Ernest Etienne Narjot de Franceville, known as Ernest Narjot, was born near Saint-Malo, France, on Dec. 25, 1826. *See California's Pioneer Artist—Ernest Narjot*, by Albert Dressler (privately printed), San Francisco, 1936.

[2] Heinrich Baldouin Möllhausen was born near Bonn, Germany, Jan. 27, 1825, and died in Germany in 1905. See *Baldouin Möllhausen—The German Cooper*, by Preston Albert Barba, University of Pennsylvania Press, 1914. Also *Diary of a Journey from the Mississippi to the Coast of the Pacific*, by Baldouin Möllhausen, translated from the German by Mrs. Percy Sinnett, 2 vols., London, 1858.

[3] See "A Brief Biography of Prince Paul William of Württemberg (1797–1860)," by Louis C. Butscher, *New Mexico Historical Review*, July, 1942.

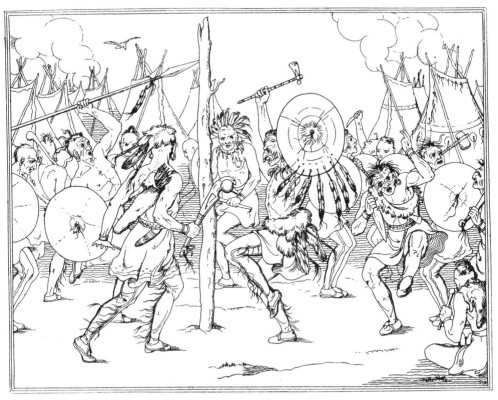

THE WAR DANCE F. O. C. Darley

Later a band of friendly Otos took him to their village where he became a favorite of the medicine man, who wanted him to take his two daughters as squaws and become a member of the tribe. Möllhausen eventually returned to St. Louis, dressed entirely in Indian clothes, long after Prince Paul had come and gone.

The versatile artist went back to Germany as the traveling companion and keeper of a shipment of wild animals for the Berlin Zoo, but shortly returned to Western America for more adventure. He was appointed artist and topographer on the United States government expedition which explored and surveyed the thirty-fifth parallel across the Southwest to determine the best route for a railroad from the Mississippi to the Pacific Coast. He made a third trip to the United States in 1857, accompanying the government expedition under Lt. Joseph C. Ives to explore the Colorado River and its Grand Canyon.[4] Somewhat disappointing reproductions made from Möllhausen's pictures are included in the official reports.

[4] See *Report upon the Colorado River of the West, Explored in 1857 and 1858 by Lieut. Joseph C. Ives . . . under the Direction of the Office of Explorations and Survey . . .* , Washington, D. C., 1861.

This colorful figure is entitled to consideration for the hundreds of illustrations he made for the reports of our government exploring parties, if not for his talent as a painter. Möllhausen, like Kurz, contributed a great deal of importance as a writer of the West, including scientific papers about the Indian tribes on the Colorado River and the famous "petrified forest." In later life the abundance of fiction he wrote about our West, while living in Berlin, caused him to become popularly known as the James Fenimore Cooper of Germany.

One of our most accomplished artists of this period was Felix Octavius Carr Darley (born in Philadelphia, June 23, 1822). He made a sketching trip out beyond the Mississippi in the early 1840s, which resulted in a volume of line drawings of Indian life that was published in 1843,[5] when he was but twenty-one. One of these is reproduced on page 127. With the accompanying text by the artist, the pictures portrayed a series of events in the life of an Indian chief from infancy to death. In a review of this book, Edgar A. Poe, as editor of *The Saturday Museum*, wrote that "every American should purchase this tribute to the aborigines." But Darley was so successful in illustrating the literary classics of the day that he had little time to pursue seriously his early interest in the West. His pictures are to be found accompanying the stories of Washington Irving, James Fenimore Cooper, Hawthorne, Longfellow, Tennyson, Whittier, and many more. He did find time to create a considerable number of idealized Western scenes that were engraved and lithographed into popular framing pictures. One of the most widely printed of these was *Emigrants Crossing the Plains*, shown on page 130, and *Hunting Buffaloes*, reproduced on page 131. He died March 28, 1888.

There was also Arthur Fitzwilliam Tait (1819–1905), who came to the United States from England in 1850. Best known for his animal pictures, from barnyard to wild game, that were profusely printed by Currier & Ives, he also did a number of Western subjects. They were purely pictorial and by no means factual, but they became very popular. Many people in the East formed their conception of life on the plains from reproductions of Tait's paintings, two of which are shown on page 129. A less known but very accomplished painter was William Ranney (1813–1857). He did a number of creditable retrospective pictures of the Revolutionary War and then turned with more success to interpreting frontier life. His *Prairie Fire* is shown on page 131.

Even collectively these artists did not chronicle the trek West for gold as they might have. Men are seldom able to evaluate the significance of contemporary events. Only when they become part of the past is their importance fully appreciated.

[5] *Scenes in Indian Life . . . Drawn and Etched on Stone by Felix O. C. Darley*, Philadelphia, 1843. (Originally published in five monthly parts, April to August.)

ON THE WARPATH Arthur Fitzwilliam Tait

(David B. Findlay Galleries, N. Y. C.)

THE HUNTERS' STRATAGEM Arthur Fitzwilliam Tait (Litho.—Kennedy & Co., N. Y. C.)

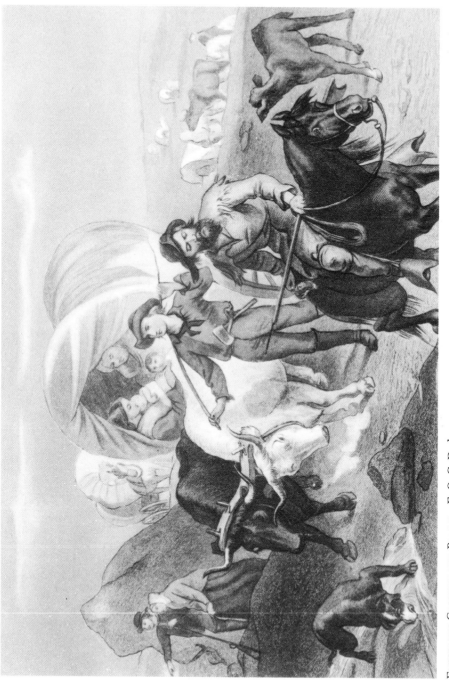

Emigrants Crossing the Plains F. O. C. Darley (Litho.)

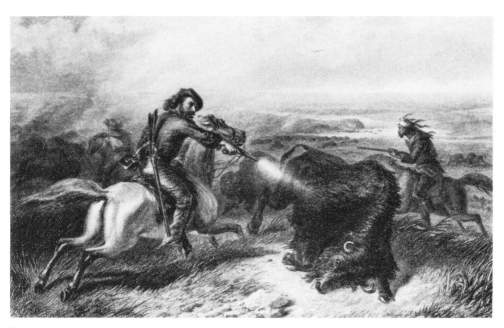

Hunting Buffaloes F. O. C. Darley

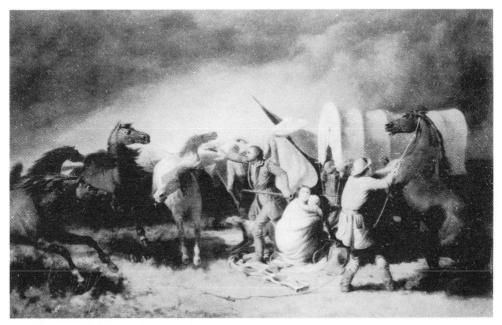

The Prairie Fire William Ranney

(Knoedler Art Galleries, N. Y. C.)

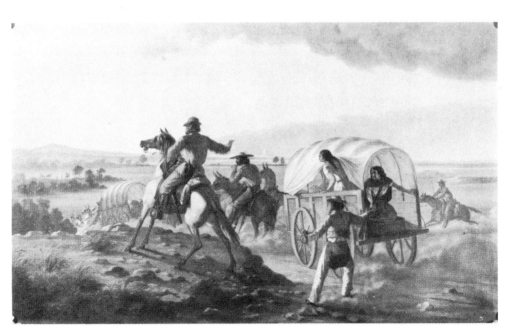

ATTACK ON THE WAGON TRAIN Ernest Narjot (Mannados Bookshop, N. Y. C.)

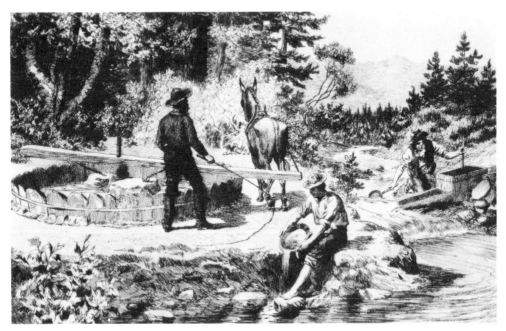

PRIMITIVE METHODS OF EARLY DAYS—PAN, ROCKER, AND ARRASTRA Ernest Narjot

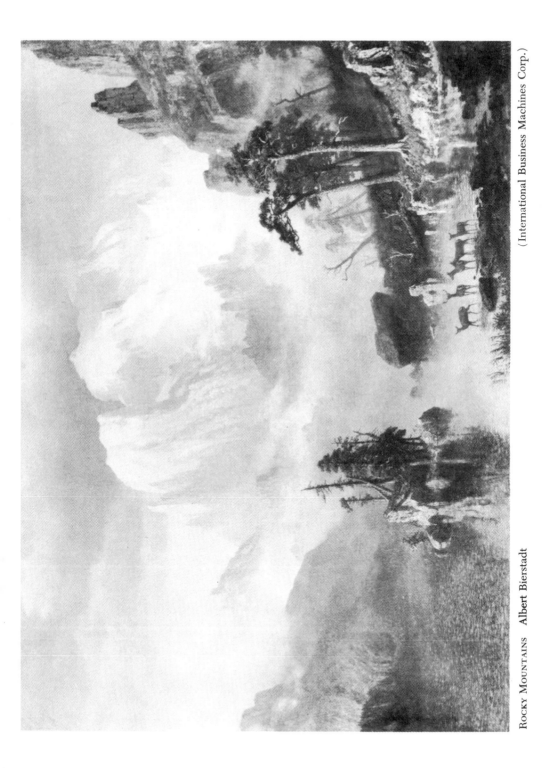

ROCKY MOUNTAINS Albert Bierstadt

(International Business Machines Corp.)

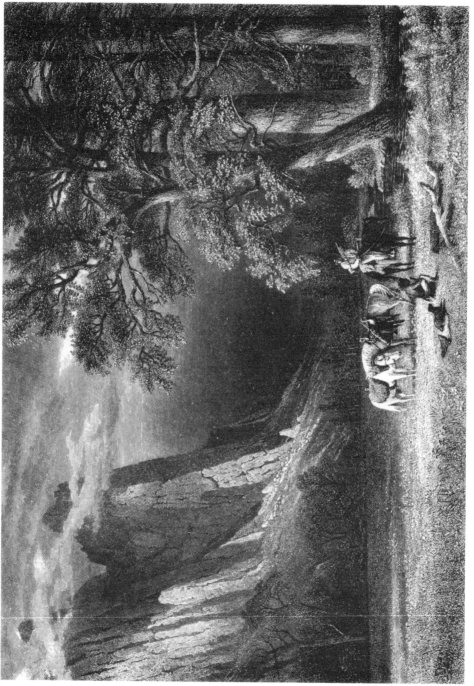

A Halt in the Rocky Mountains Albert Bierstadt (Litho.)

Mount Corcoran Albert Bierstadt

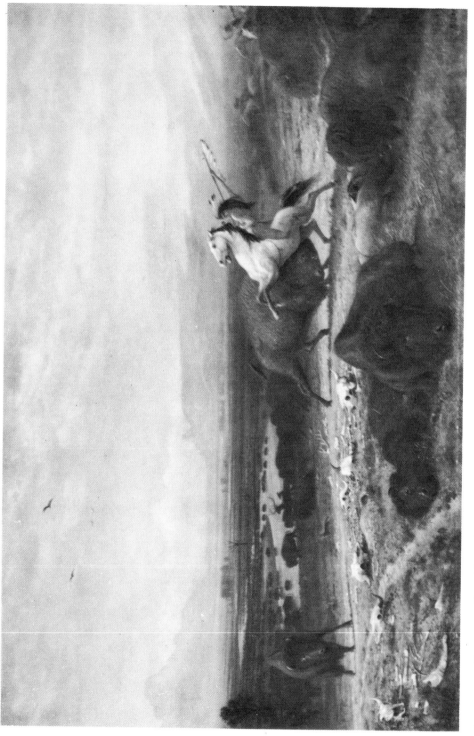

LAST OF THE BUFFALO Albert Bierstadt

Albert Bierstadt

14 *Grandiloquence in the Rockies*

THE PORTRAITURE which had predominated in the first half century of art in America had slowly given way to landscape and genre painting. In most of the work relating to our West, the Indian continued to occupy a place in the center of the canvas and the buffalo and the prairie schooner were equally popular subjects. The scenery and high mountains of the Far West had occasionally been used as a backdrop and some of the artists had done a few landscapes. But it remained for Albert Bierstadt to give our Rocky Mountains their rightful place on canvas. Bierstadt was Mr. Düsseldorf himself—a healthy exponent of that famous European school of painters whose work was characterized by heroic scale and pattern and a strong romantic flavor. He was very much an American in his interests, and closely allied with the Hudson River School, our exponents of landscape art in the best traditions. But his palette and brushes never quite freed themselves of the pompous traits of his Rhineland teachers. The layman can forgive his idiosyncrasies of style, however, and thank him for the dramatic interpretation he gave our Rocky Mountains, as witnessed in the paintings which are reproduced on pages 133, 134, and 135.

Bierstadt was born at Solingen, near Düsseldorf, January 7, 1830. His father emigrated to the United States and settled in New Bedford, Massachusetts, when Albert was less than two years old. We learn from the ever-reliable Tuckerman that the Bierstadt family was not affluent and that his artistic tendencies were discouraged. "He engaged in various employments, always with a predilection for art, which he casually indulged from his earliest years. The usual objectives prevented him from concentrating upon art the attention which circumstances obliged him to diffuse among practical and practicable occupations . . . and those interested in his welfare discouraged his ambition."

Even when young, however, Bierstadt showed substantial progress in his struggle to become an artist, for at twenty-one "he first exhibited in 1851 at the New England Art Union in Boston, a landscape 'painted in crayon'; and in 1853, again

in Boston. . . ." [1] It was in the latter year that he sailed for Europe to study at his Rhineland birthplace. A cousin, J. P. Hasenclever, was something of an important personage in the Düsseldorf Academy, and Albert was depending upon his aid. To his chagrin, he found that the cousin had recently died and another even greater disappointment followed: the great teachers seemed to find little in the work of this newcomer to excite their enthusiasm. It is reported that "he showed no striking proof of possessing any individual merit as an academic disciple." Düsseldorf was crowded with promising aspirants, even proficient postgraduates and practicing artists from all over the world. There were more applicants than the accomplished teachers could take care of. Ultimately, however, Bierstadt must have convinced them of his talent, for he enjoyed the benefits of instruction and personal friendship of such eminent masters as Leutze, Achenbach, Lessing, and Whittredge.

After spending the first winter in intense and profitable study at the Düsseldorf Academy, Bierstadt went on a summer sketching tour through the Alps of Germany and Switzerland. From the beginning he seemed to have a keen interest in mountain landscapes. The following winter he spent in Rome with Worthington Whittredge and on a walking trip through the Apennines with Sanford R. Gifford —two of the great landscape artists affiliated with our Hudson River School. To become the comrade of such men, at such an early age, he must have possessed unusual qualifications of one kind or another.

Bierstadt returned to New Bedford in the spring of 1857, spending the summer sketching in the White Mountains with his brother Edward, who was a scenic photographer of unusual ability. By this time Albert had firmly made up his mind that he would concentrate on painting the grandest mountain scenery in his adopted country. After a short apprenticeship in the mountains of the East, in April of the following year he left for St. Louis to join Gen. Frederick W. Lander's expedition to lay out an overland wagon route from Fort Laramie across the Rockies to the Pacific Coast.

This was ten years after the discovery of gold in California. Many a prairie schooner had made the long trek westward, and little communities were bravely taking root on the banks of rivers and along the overland trails. The opening up of the West was by now a national vision of building a great empire. So much money was being spent on the construction of railroads and other developments in regions which would not be able to repay the investments for years to come,

[1] *M. & M. Karolik Collection of American Paintings, 1815–65* (catalogue), The Museum of Fine Arts, Boston, Massachusetts, 1949.

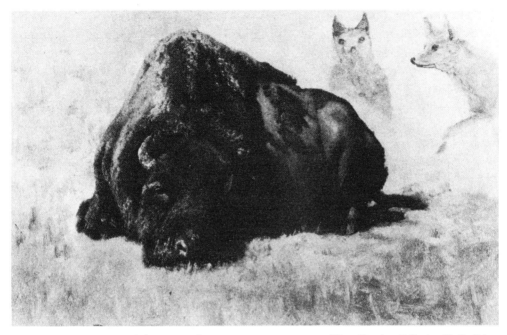

BISON WITH COYOTES Albert Bierstadt (Knoedler Art Galleries, N. Y. C.)

that the financial drain had seriously affected the United States Treasury and brought economic distress to the country at large. Despite this quick growth, the first hookup of a transcontinental railroad line was still twelve years away and the West was far from being tamed. The first "pony express" had not yet crossed the Plains, William F. Cody was a boy of eleven, and our bloodiest Indian wars were just beginning. The farther West the Indian was pushed and the more his ancestral rights and heritages were defiled, the harder he fought to stem the westward tide of the white man.

Bierstadt's principal interest was the mountain scenery, and he saw plenty to inspire him on the trip with General Lander. Tuckerman, in his *Book of the Artists*, quotes the following letter in which Bierstadt significantly expresses his first impression of the great mountains which he had crossed the continent to paint: "July 10th [1858]: The mountains are very fine; as seen from the plains they resemble very much the Bernese Alps; they are of granite formation, the same as the Swiss mountains, their rugged summits covered with snow and mingling with the clouds . . . the colors are like those of Italy." He could not help but see them through his Düsseldorfian glasses.

The party journeyed through the Laramie Mountains, the South Pass of the

Rockies, then up into the beautiful Wind River and Shoshone country of southern Oregon. After a summer of sketching and absorbing the scenic grandeur, the artist made the hazardous trip back to Fort Laramie with only two companions, a trek made all the more interesting because they were entirely dependent on killing game for food. Upon reaching Laramie, he hurried back East to begin work on his large canvases.

Bierstadt exhibited his first Rocky Mountain paintings at the National Academy in 1860, and they won for him immediate popularity. That same fall, only three years after ending his studies in Europe, he was elected a full Academician of the National Academy. Düsseldorfian or not, Americans liked his huge canvases with their bold impressions of massive mountains. The critics found many faults in his work but his reputation steadily increased, and his paintings found buyers willing to pay fancy prices. Two of his early works, *Laramie Peak* and *Lander's Peak, Rocky Mountains*, were particularly well received. The latter was over 6 feet by 10 feet in size, and James McHenry paid $25,000 for it.[2]

He made his second trip into the Rockies in 1863, with Fitz Hugh Ludlow,[3] a popular journalist of the period. This time he traveled through Nebraska, Colorado, Utah, California, and Oregon. His paramount interest remained mountain scenery, although the herds of buffalo seem to have strongly appealed to him as more than just decoration for his landscapes. Ludlow described an incident in which the artist made closehand sketches of a big wounded bull:[4]

"Munger [another member of the party] had ridden upon as big a bull as ever ran the Plains, stopped him with a series of shots from a Colt's army revolver, and was holding him at bay in a grassy basin, for our artist's special behoof. . . . He [Bierstadt] leaped from the buggy, and in a trifle over three minutes from the first halt, the big blue umbrella was pointed and pitched, and he sat under it on his camp stool, with his color box on his knees, his brushes and palette in hand, and a clean board pinned in the cover of his color box. . . . Munger, Thompson and I rode slowly round the bull, attracting his attention by feigned assaults, that our artist might see him in action. . . . For nearly fifteen minutes this process was continued, while the artist's eyes followed each other at the double-quick over the board. . . . As soon as he had transferred the splendid action of the buffalo to his study, he called on us to put an end to the distress, which, for aught else than art's sake, was terrible to see."

[2] *Book of the Artists*, by Henry F. Tuckerman, 1867 ed., New York, pp. 387–393.

[3] *Heart of the Continent*, by Fitz Hugh Ludlow, Boston, 1870. (Parts of this book previously appeared as articles in the *Atlantic Monthly*, April, June, July, and December, 1864.)

[4] *Ibid.*, pp. 62–69.

While the party was stopping in Denver, Bierstadt made a short side trip into the mountains, on which he found the inspiration for one of his most impressive paintings, *Storm in the Rocky Mountains—Mount Rosalie.* The story of the inception of this great picture was told in *The Magazine of Western History,*[5] by William N. Byers, the man who was with him at the time: "He came to Denver [in 1863] in search of a subject for a great Rocky Mountain picture, and was referred to me—probably because I had the reputation of being something of a mountain tramp. The result was that I agreed to show him to where I thought he could get all the picture he wanted. . . ." After a trip into the mountains through stormy weather, they approached the particular location, near the present town of Idaho Springs.

"It was a gloomy day in the dense forest. I was ahead, the pack animals following, with Bierstadt behind to prod them up. . . . At a certain point the trail emerged from the timber and all the beauty, the grandeur and sublimity of the great gorge and the rugged amphitheatre at its head would open to view in an instant, like the rolling up of a curtain. . . . When I rode out into the flower-decked meadow I turned aside so as to be out of the line of vision. . . . Bierstadt emerged leisurely. His enthusiasm had been badly dampened; but when he caught the view fatigue and hunger were forgotten. His face became a picture of intense excitement. . . . He slid off his mule, glanced quickly to see where the jack was that carried his paint outfit, walked sideways to it and began fumbling at the lash-ropes, all the time keeping his eyes on the scene up the valley. *'I must get a study in colors; it will only take me fifteen minutes!'* He said nothing more . . . and at length the sketch was finished. *'There—was I more than fifteen minutes?'* I answered: 'Yes —you were at work forty-five minutes, by my watch.'" That sketch was later transposed into a canvas 12 feet by 7 feet in size. The artist, as was common practice, named the peak in it Mount Rosalie after his wife. The painting was purchased by T. W. Kenard, Esq., for the amount of $35,000, an extraordinary sum for that period.

Bierstadt was riding the crest of a giant wave of success by 1866, when he was only thirty-six. His big colorful canvases were bringing him extravagant praise, both here and abroad, and they were being bought at prices higher than any American painter had previously commanded. He built a magnificent thirty-five-room studio home, of stone and marble, overlooking the Palisades of the Hudson at Tappan Zee just above New York City. He received so many commissions to

[5] "Bierstadt's Visit to Colorado," by William N. Byers, *The Magazine of Western History,* January, 1890.

do paintings for the government that some years later it prompted Samuel Isham to say: "When during these years Congress voted money for a work of art it was usually for a picture—a portrait of Washington or a landscape by Bierstadt." [6] It was during 1866 that he painted the *Rocky Mountains*, which is reproduced on page 133. The following year he and his wife went on an extensive tour of Europe, where his pictures of our Western mountains were hung in the best galleries and collections from London to Petrograd. The artist received royal decorations in several of the countries.

At home in their elegant showplace overlooking the Hudson, the Bierstadts were regularly hosts to rich and royalty—including the Grand Duke Alexis of Russia, for whom the artist made arrangements with the War Department for a well-staged Western buffalo hunt, personally planned by General Sherman.[7] More big canvases of Rocky Mountain grandeur came forth from the studio on the Hudson. Among the finest of these is his *Mount Corcoran* (see page 135), which today hangs in the Corcoran Gallery of Art in Washington, D. C. He made other trips to the West, this time in a style befitting his reputation. In 1872–1873 he had a studio in San Francisco, made sketches for a series of paintings of the Yosemite, and was guest of the Earl of Dunraven at his Colorado ranch near Fish Creek. Bierstadt was a close friend of the English nobleman, and the artist was asked to select the scenic location for the exclusive Lord Dunraven Hotel—the site of which had inspired Bierstadt's painting *Long's Peak*, now hanging in the Metropolitan Museum.

In 1882 his beautiful studio home burned down, and this sad event proved to be the first of a series of misfortunes. The hierarchy of critics, always more severe with his work than the collectors who bought his huge canvases, were aligned against him and condemned his grandiose Düsseldorfian tendencies. In 1889, "the committee of New York artists in charge of the Paris Exposition refused to hang Bierstadt's *Last of the Buffalo*, considering it out of keeping with the developing French influence in American painting." [8] This large painting, which also hangs in the Corcoran Gallery in Washington, is reproduced on page 136. It is today considered by many as one of his finest works.

With the death of his wife in 1893, Albert Bierstadt's fortunes reached their lowest ebb. A second marriage helped his financial situation, and he continued to maintain a studio in New York where he painted his bold and striking mountain scenes until his death, February 18, 1902, in New York City.

[6] *American Painting*, by Samuel Isham, New York, 1905, p. 540.
[7] M. & M. Karolik catalogue, p. 90.
[8] *Ibid.*, p. 75.

Ralph Albert Blakelock

15 *Whimseys in the Moonlight*

IT IS QUITE EASY to imagine an Indian medicine man of the old school lingering pensively in front of a Blakelock painting, perhaps *Indian War Dance* or *The Pipe Dance* or *The Chase*, and nodding in solemn approval.

The man, Ralph Albert Blakelock, has been as much a mystery as the motives behind his strangely beautiful paintings, and the story of his life is certainly one of the most tragic in the annals of art. His pictures have been well known for more than half a century, and have been hung in many fine museums and collections. Yet, until recently, not even the day of his birth or his death was recorded in the vague, inaccurate biographical sketches which existed. He was the painter of colorful, even wild and mysterious, landscapes—that much we knew. And his canvases seemed to catch the special qualities of sun and moonlight. Of the artist himself the world knew next to nothing.

The year 1947 marked the one-hundredth anniversary of the birth of Blakelock. It was also the occasion for celebrating the centennial of the founding of the College of the City of New York as the Free Academy of the City of New York. As part of the celebration the college planned an exhibition honoring the artist as one of its most gifted alumni, and through the offices of the American Art Research Council, extensive research on Blakelock's life and work resulted in the first comprehensive and accurate biographic memoir.[1]

He was born in Greenwich Village, New York City, on October 15, 1847. The son of a doctor, he attended public school and in 1864 entered the Free Academy. He was adept in English and languages, but his real interest was in art and music.

[1] *Ralph Albert Blakelock, Centenary Exhibition in Celebration of the Centennial of The City College of New York—April 22 to May 29, 1947, at the Whitney Museum of American Art, New York.* Introductory text by Lloyd Goodrich, based on the biographical material gathered by Rosalind Irvine, Secretary of the American Art Research Council, and other sources. The present account is largely drawn from this material; and information collected elsewhere has in some instances been made to conform.

143

A fleeting glimpse of him at this time was given by his wife some years later, in 1916: [2]

"When I was a little girl nine years old, my mother one summer took me into the country in Washington County, New York. There I met Mr. Blakelock, who was then eighteen years old. He had previously lost a little sister, of whom he was especially fond. He at once formed an affection for me, putting me in the place of his sister. When I first saw him he was painting on the bank of a stream called the 'Batten Kill.' All that summer we rambled over the country together, I sitting by his side as he sketched and painted. . . . The next time I saw him was soon after he returned from his western trip. I was then in my eighteenth year; our acquaintance continued; and in less than two years we were married."

Against the wishes of his father, who wanted him to enter the medical profession, Blakelock left the college in 1866 to devote all his time to painting landscapes. Although barely twenty, as early as 1867 he had a picture of Mount Washington (New Hampshire) hung in the fall exhibition of the National Academy, and further recognition was accorded his work in the two years that followed. Most of his early paintings were landscapes of the White Mountains, the Adirondacks, and scenes in New Jersey; they showed a love of the wilderness and mountains, of loneliness, stillness, and the melancholy desolation of dead trees. Although he was offered a chance to study abroad, he decided in 1869 to travel in the opposite direction.[3] The finest examples of the subject matter closest to his heart would lie in the wild and untamed West.

Ralph Blakelock was small of stature and slightly built. His slender fingers were far more suitable for playing the piano than handling a six gun. He had a nervous, sensitive disposition, but along with it all an indomitable determination. He did not take the easy way to find experience and inspiration in the West. It was on May 10 of that same year, 1869, that the first transcontinental railway had been completed with the driving of the golden spike at Ogden, Utah, marking the junction of the Central Pacific and Union Pacific. But the young artist evidently wandered far from the railroads, seeking out the most primitive and unspoiled elements he could find. In spite of a haphazard itinerary he kept, and a hundred or more drawings preserved by the family, it has been impossible to make any reliable reconstruction of his travels. His experiences in the West, even the length of time he spent there, must remain as much a mystery as some of his later paintings. From

[2] *Catalog of the Works of R. A. Blakelock, N.A.*, and of His Daughter Marion Blakelock at Young's Art Galleries from April 27 to May 13, 1916, Chicago. Text by J. W. Young. A signed foreword by Mrs. R. A. Blakelock, pp. 5–6.

[3] See *Ralph Albert Blakelock, Centenary Exhibition . . .* , p. 11.

the itinerary and notes accompanying some of the sketches, one concludes he was in the West anywhere from three to seven years and that he journeyed across Kansas, Colorado, Wyoming, Utah, Nevada, and California to the Pacific Coast; and then through Mexico to Panama and the West Indies. The artist's wife is the source of further information that he worked at whatever he could find to do, always painting and always sketching, and that he actually lived among the Indians.[4]

In the case of Blakelock it is really unimportant as to the exact places where he went or the particular Indian tribes he visited—for he was never a documentarian. Somewhere in his travels we do know that a profound metamorphosis came over him. In some mysterious way, his life with the Indians utterly transformed his style of painting. Perhaps the wild dancing figures in buckskin and feathers inspired the artist to a freer, unrestrained expression. There appears a deep strain of melancholy in his painting as if he sensed that this barbaric freedom had already been curbed and a magnificent race of savages destroyed. Before the change, Blakelock's work had been comparatively naturalistic, with little idealization. (See his *Rocky Mountains* on page 155.) His paintings had been hung for seven consecutive years in exhibitions of the National Academy. Then came the transformation in his painting, and perhaps the birth of our first true impressionist of the Western scene. His new type of art cost him the favor of the Academy and representation in its exhibitions, and here the tragedies of his life began.

Whatever his trials and tribulations may have been during his travels, they could not hold a candle to those he suffered upon returning to New York. In lieu of cash, he gave the minister a painting when he was married to Corra Rebecca Bailey on February 22, 1877, in a Brooklyn Church. "Our married life was one of constant struggle with poverty, because it was impossible for Mr. Blakelock to sell his pictures . . . ," wrote his wife in 1916.[5] His paintings were so radically different from the work of his contemporaries that collectors and dealers could not be induced to pay a reasonable price for them—or buy at all. His friends tried many times to persuade him to paint in the more conventional manner but this seemed only to strengthen his determination to go his own lonely way.

They raised a large family, and with each new arrival their difficulties were multiplied. In spite of many rebuffs, he held steadfast to his ideals, taking what little he could get for his paintings. "There was an old curiosity shop on Third Avenue many years ago, in which I saw one day many panels and pictures by Blakelock,"

[4] From the text by J. W. Young, in *Catalog of the Works of R. A. Blakelock, N.A.*, pp. 7–15.
[5] *Ibid.*, p. 6

wrote Elliott Daingerfield,[6] contemporary artist and friend. "The proprietor, a man known to many artists when in difficulty, told me there were thirty-three of them, and remarked calmly, 'I paid one hundred dollars for them all!' "

Blakelock developed one of the most distinctive styles in American art. He reached out beyond the realistic to find the beautiful—the pleasant woodlands, untouched by the hand of the white man, primeval secrets half hidden from view. The Indian makes his appearance in the sanctity of tribal dance or the privacy of home encampment; he is somehow given added dignity by being half obscured from the disbelievers. Blakelock's colors are Indian colors—the browns and yellows of buckskin, the reds and greens of war paint in the glow of moonlight. Even his signature is often enclosed in the symbolic outline of an Indian arrowhead.

Harry W. Watrous, an artist friend and a benefactor of Blakelock's who occupied an adjoining studio, told a fascinating story about the artist. Annoyed one day by a queer tinkling sound, like the rhythmic tune of an aboriginal dance, he finally went in and found Blakelock intently working on an Indian dance scene, and alternately rushing to a piano to play a few strains, then back to the canvas to paint a few touches. "I can't make these Indians dance, Watrous! All day I've been trying and they won't dance!" Then off he went once more to thump out the accompaniment to a tribal dance he remembered from some experience in the West. That painting was *The Pipe Dance*, which now hangs in the Metropolitan Museum, and is reproduced on page 156. Another of his paintings, *Moonlight, Indian Encampment*, which today hangs in the National Collection of Fine Arts in Washington, is reproduced in color on page 153.*

Perhaps America has never quite opened her heart, or her pocketbook, to the purely beautiful; this was particularly true of the late 1870s and the years that followed, when a narrow naturalistic conception of painting dominated both critics and patrons. Connoisseurs either condemned or ignored Blakelock's work. He literally peddled his pictures from door to door in a desperate struggle to keep his ever-increasing family from actual starvation and under a roof. His financial path was ever downward, but he lived on a faith in the goodness of the morrow. The undaunted manner in which the family stuck together and shared this faith is a touching story in itself. "He and I carried pictures around New York many times to try to make a sale," wrote his eldest son, Carl, years later, "but it was the usual thing then to carry them home again." Ultimately the artist broke under the strain. On September 12, 1899, it became necessary to remove Blakelock from his home and place him in an institution for the mentally ill. There were then nine

[6] *Ralph Albert Blakelock*, by Elliott Daingerfield, New York, 1914 (privately printed—250 copies).

*Reproduced in black-and-white in the present edition.

children—the last one born on the very night he was taken away. His inability to sell enough of his paintings to meet the bare necessities of life in all likelihood caused his complete collapse. The doctors termed his malady dementia praecox—a split personality, in which his chief delusion was that he was immensely wealthy.

"One day this genius laid down his paints and entered the door of an asylum," wrote James William Pattison in the *Fine Arts Journal* of October, 1912, "but none of us know exactly about it. There are a wife and some children lost in the wilds of New York City, but former friends hear but little about them. . . ."

Almost as soon as Blakelock was confined in the asylum, his tardy recognition began and the prices of his paintings commenced to climb. Ironically, this acclaim buttered no bread for his destitute wife and their nine children. In 1913, a collection of the artist's work was sold at auction in New York City and one of the *Moonlight* canvases, which Blakelock and his son had peddled from dealer to dealer and had ultimately sold for a pittance, was purchased by Senator W. A. Clark for $13,900. Two years later at another auction, his *Brook by Moonlight* was bought by Edward Drummond Libby for the Toledo Museum for $20,000. Yet the artist and his family did not realize even the price of the auction catalogue for his labors. The year that *Brook by Moonlight* was sold for $20,000 Blakelock's family was living in a little one-room farmhouse near Catskill, New York, having difficulty paying a rent of $50 per year.

An art collector interested in Blakelock visited him in the asylum and found him surprisingly rational until the subject of money came up. Then Blakelock told his visitor confidentially that the United States Treasury was constantly soliciting his aid and drew from his pocket what appeared to be a large roll of bills but which were, in fact, delicately executed landscapes resembling currency. One of these was in the denomination of $1,000,000. "Take this," whispered the artist. "Don't spend it—just live off the interest."

Blakelock was made a full Academician of the National Academy in 1916 but he never fully recovered his sanity and died in poverty on August 9, 1919, in his seventy-second year.

16 *Beauty in the Rough and Rugged*

ALL MEN do not see with the same eyes, especially artists. George Catlin and John James Audubon traveled the same trails of the Upper Mississippi, but a vastly different world filled their vision. One man saw the Indian as a noble utopian, another as a barbarian devil. Even the grandeur of the Rocky Mountains —the most impressive natural feature of the North American continent—stirred a variety of emotions. To Albert Bierstadt, the snow-capped peaks and rocky ridges were like a vision of Wagnerian castles in the clouds—with an accompaniment of musical thunder symbolic of storm and avalanche. To Ralph Blakelock, they were only backdrops for his mysterious and spectral Indians. To Thomas Moran, the Rockies were a quiet symphony of color and beauty.

The changing times also greatly affected the artist's perspective. The earlier painters, Catlin, for instance, traveled by canoe, horseback, and prairie schooner, which brought them into intimate contact with the primitive elements of the frontier. After 1870, a plush seat on a transcontinental steam train offered the artist easy access to many parts of the West. Those who stuck close to railroad tracks and civilization found it difficult to capture the true spirit of the Old West in their work. Others deliberately avoided the easy means of travel, and rode into the back country in the saddle and by stagecoach. One of these was Thomas Moran.

Among the immigrants who came from Europe around 1840 was one Edward Moran.[1] He was the eldest of sixteen children, and his family had toiled for decades as weavers in the textile sweatshops of Lancashire, England. In fulfillment of a wild dream, Edward took the cheapest passage possible to the United States, and arrived with all his possessions tied up in the proverbial bandanna.[2] Taking residence in Philadelphia, Moran began his struggle to become an artist. He chose scenes of fishermen at their toil, ships, and marine views as the theme of his work;

[1] Edward Moran was born in 1829 in Bolton, England; died in Philadelphia in 1901.

[2] "Thomas Moran, Dean of Our Painters," by Harriet Sisson Gillespie, *International Studio*, August, 1924.

and although unaided by formal instruction, he earned enough to be able to send for others of his large family within a remarkably short time. The final contingent was transplanted in 1844 and among the latter was his young brother, Thomas Moran,[3] seven years old at the time.[4] Thus Edward Moran became the founder and guiding spirit of what was to become one of the most distinguished families in the history of art in America. No less than sixteen men and women of the Moran clan earned outstanding reputations as artists. So accomplished did twelve of them become that they were popularly known as "The Twelve Apostles of Art."

The atmosphere of freedom in which Thomas Moran grew up was dominated by the belief that one should work out his own destiny in the field of creative endeavor, without undue influence from others. In his eighteenth year he was apprenticed to a Philadelphia wood engraver, to learn the rudiments of craftsmanship. This was the basis of his technical training for a future in the world of art. In his spare time he worked in water color and after three years devoted himself entirely to painting, taking space in his older brother's studio. The first exhibition of his water colors was held at the Pennsylvania Academy of Fine Arts in 1858, when he was only twenty-one, and two years later he began working in oil. In 1862 Moran married Mary Nimo, also destined to become a fine artist, and sailed to England to study Turner's landscapes. Later he made studies of the French and Italian masters on the Continent.

It was not until Thomas Moran was thirty-four years old and struggling to raise three children in Newark, New Jersey, that he found a special field in which to concentrate his energies as a painter. This discovery grew out of his first trip to the West, in 1871, made at the invitation of Dr. F. V. Hayden, the distinguished geologist and organizer of the United States Geological Survey. Moran accompanied a field party sent out to investigate the area which was later set aside for natural preservation as Yellowstone National Park. The artist was so deeply thrilled by what he saw and the sketches he made, that he returned home to paint the most ambitious canvas of his career. He titled it *The Grand Canyon of the Yellowstone*, and it was so well received that the Congress voted for its purchase at $10,000 and directed that it be placed on permanent exhibition in the National Capitol. This painting laid the foundation for his future.

The dramatic West was not a particularly popular subject in the early 1870s. There was still plenty of wild country and Indian trouble, but steam trains crisscrossed the continent and thousands of settlers were making the Great Plains their permanent home. No art could glorify the manner in which we were herding the

[3] Thomas Moran was born January 12, 1837, in Bolton, Lancashire, England.
[4] East Hampton *Star* (newspaper), East Hampton, Long Island, New York, July 7, 1937.

red men onto reservations and stealing their land, and the wholesale slaughter of the buffalo was hardly an appropriate subject either. Besides, the public had become pretty well fed up with blood and thunder during the Civil War and preferred calmer fare. Throughout the whole year of 1871 there was hardly a "Western" picture in *Harper's Weekly*. But the romanticized beauty which Thomas Moran put into his paintings of the Rocky Mountains proved to be something fresh and appealing.

"There is no doubt that your reputation is made," Dr. Hayden wrote to his now famous young friend, on August 29, 1872.[5] "Still you must do much to nurse it. . . . The next picture you paint must be the Tetons. . . . I have arranged for a small party to take you from Fort Hall up Snake River, thence to the Yellowstone. . . ." By the following spring, however, the Survey's activities became centered farther south, exploring the plateaus of southern Utah and northern Arizona, through which the mighty Colorado River cuts its deep course. Thomas Moran accompanied the expedition. Again he put a wonderful picture on canvas, *The Chasm of the Colorado*, which was also purchased by Congress, as a companion to his painting of the Yellowstone. This painting further established his reputation and deepened his devotion to the scenic mountain landscapes. Henceforth, summer after summer, he traveled in the Far West, returning with sketches which he transposed onto canvases. His work so thoroughly interested the public in our Western mountains that one of the most imposing peaks of the Tetons—a giant flat-topped mountain with a perpendicular streak of granite—was officially named Mount Moran in his honor, although it was not until several years afterward that the artist actually saw for the first time this 12,000-foot natural monument.

The postponed trip to the Tetons materialized in 1879. Moran was accompanied by his younger brother Peter, who was rapidly gaining stature as an animal painter and etcher, and who did some commendable Western paintings himself. With a military escort of twenty men, they left Fort Hall on the Upper Snake River, in the present state of Idaho, on August 21. In a very sketchy and incomplete diary, kept in a little vest-pocket notebook, Thomas Moran recorded some of the experiences of this trip, one of the few times he ever kept a journal.[6] Even this is so abbreviated and modest a comment that it gives but few impressions: "Had our first glimpse of the great Tetons some 70 miles away. . . . Trout this morning for B. & a wind blowing—driving the dust everywhere & covering our breakfast. . . . Ascended the

[5] *Thomas Moran's Journey to the Tetons*, by Fritiof Tryxell, Augustana Historical Society Publications, Rock Island, Illinois, 1932. Quoted from a letter in the possession of Miss Ruth B. Moran, the artist's daughter.

[6] *Ibid.*, p. 38.

canyon again to get a glimpse of the Tetons, but from this point only the top of Mt. Moran is visible. . . . After passing the divide . . . the Tetons here loomed up grandly against the sky & from this point it is perhaps the finest pictorial range in the United States or even in N. America. . . ." The journal indicates how completely his whole interest was absorbed by the scenic beauties of the mountains, although there is no special notice taken of the magnificent mountain named in his honor.

"He was always starting for or coming from strange, beautiful places," his daughter Ruth said reminiscently years later. "We loved him and stood in awe of his work; that came first, with the whole family. . . . He was known intimately to few; but those were great friendships. He was very modest and had no patience with the worldly wise or insincere." [7]

By 1879 Moran had moved into a comfortable studio at East Hampton, out toward the eastern end of Long Island, and was gaining fame with each new Rocky Mountain scene which he put on canvas. Always an experimentalist and even an inventor in the ways of art, he worked at etching as a diversion from his painting, although he never took it as seriously. However, his etchings won fresh laurels for him. John Ruskin, the eminent English critic, singled out one of his plates which was entered in an important London exhibition, and proclaimed it the best etching that had come out of America and one of the best that modern art had produced. He gained the almost unanimous praise of critics at home as well as abroad, for he was, as Alfred Trumble said, "a great painter, as well as a great draughtsman"—and his versatility was on a par with his technical ability.

Through fifty-four years he journeyed into the Rockies with pencil, palette, and brush,

PAIUTE GIRL—1878 Thomas Moran
(Etching—New York Public Library)

[7] East Hampton *Star*, July 7, 1937.

seeking out the most spectacular and colorful of the mountains. The last few years of his long and full life were spent in Santa Barbara, California, where he established a studio closer to his favorite subjects and farther from the severe Long Island winters. At the age of eighty-seven, he made a last trip into Yellowstone Valley, returning home as enthusiastic as he had been after the first trip more than half a century before, to paint another large and successful canvas. The following year he made his last sketching trip to the Grand Canyon in Arizona. One of the fine paintings he did shortly before his death, of the same mountain scene which first brought him fame, is *Mist in the Yellowstone*, shown on page 154.

He was by no means unaware of the artistic importance of the Indian, and while he devoted most of his talent to landscapes, the red man occasionally found a decorative place on his canvases. An interesting example is *Spirit of the Indian*, on page 155.

Thomas Moran declared that the motive and incentive behind his work was "being true to our own country, in the interpretation of that beautiful and glorious scenery with which Nature has so lavishly endowed our land." [8] He held steadfast to that precept. In the year before his death, Harriet Sisson Gillespie, writing in *International Studio*,[9] proclaimed him "dean of American painters, and one of the best beloved artists of our time. Now in his 88th year, as keenly alive to the beauties of nature as when he started his art career in an obscure studio in Philadelphia. . . . Although time has left its imprint upon the countenance of the famous American artist, and his long, white beard lends to his appearance a patriarchal aspect, his mind is as alert, his sympathies as broad, his humor as whimsical, and his love of art as keen as when, early in his career, he was crowned with the laurel wreath placed upon his head by the English critic, John Ruskin."

He died August 25, 1926, at the age of eighty-nine.

[8] 'American Art and American Scenery," by Thomas Moran, in pamphlet *The Grand Canyon of Arizona*, published by the Passenger Department of the Santa Fe Railroad, 1902, p. 86.
[9] *International Studio*, August, 1924.

MOONLIGHT, INDIAN ENCAMPMENT Ralph Albert Blakelock

(National Collection of Fine Arts)

MIST IN THE YELLOWSTONE Thomas Moran

SPIRIT OF THE INDIAN Thomas Moran (Philbrook Museum, Tulsa, Okla.)

THE ROCKY MOUNTAINS Ralph Albert Blakelock (The Berkshire Museum, Pittsfield, Mass.)

The Chase Ralph Albert Blakelock (Worcester Art Museum, Worcester, Mass.)

The Pipe Dance Ralph Albert Blakelock (Metropolitan Museum of Art)

THE SILENCE BROKEN George de Forest Brush

BEFORE THE BATTLE George de Forest Brush (Litho.)

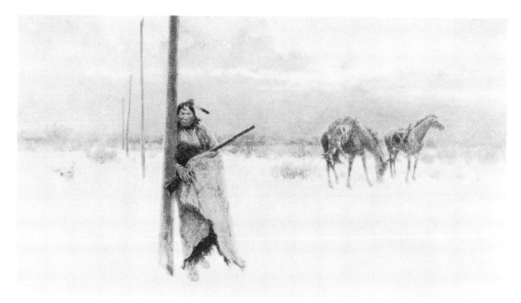

THE SONG OF THE TALKING WIRE Henry F. Farny (The Taft Museum, Cincinnati, Ohio)

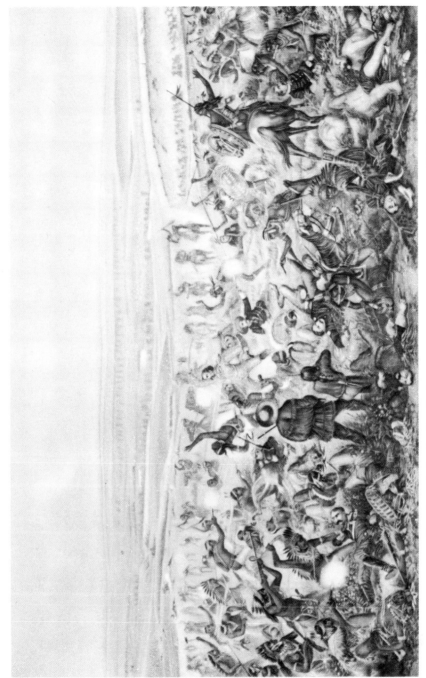

CUSTER'S LAST FIGHT Cassilly Adams—Litho. by Otto Becker

(Litho.–Anheuser-Busch, Inc.)

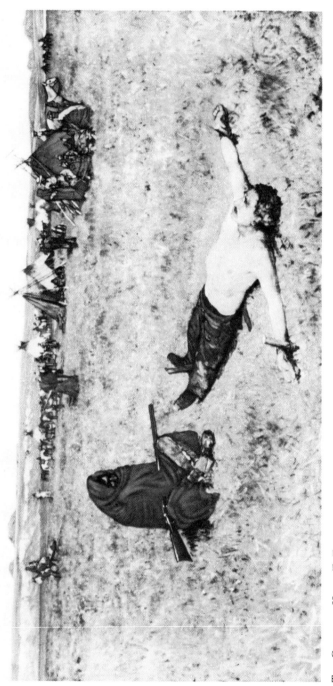

THE CAPTIVE Henry F. Farny

17 *Good Indian! Bad Indian!*

THE INDIAN WAS SYNONYMOUS with the Old West. When the red man was at the height of his buckskin and war-paint culture on the Great Plains, the fur trader, mountain man, and pioneer scout were also in their heyday. As the Indian ethos degenerated, the Old West faded, until both gave way to a new and quite different epoch. Throughout the nineteenth century, the Indian was championed by some and castigated by many more. The viewpoints of historians have been far apart, and the red men themselves have had strong differences of opinion regarding the whites. These varying viewpoints have been strongly reflected in the work of serious artists.

Writing on "The Indian in American Art," in the January, 1856, issue of the art magazine *The Crayon*, the editor had this to say:

"What with the romance and so-called historical painter, he [the Indian] stands . . . as a kind of savage harlequin, lost in a cloud of feathers and brilliant stuffs; or else in the other extreme, hung about with skulls, scalps, and the half-devoured fragments of the white man's carcass. All this is dramatic enough, but it is not the truest color of the historical Indian, absorbed in his quiet dignity, brave, honest, eminently truthful, and always thoroughly in earnest, he stands grandly apart from all the other known savage life."

The half century of bitter and bloody military conflict required to bring the Plains Indian into submission quite naturally fostered a strong aversion to the Indian on the part of the soldier, a fear and dislike that were shared by most of the pioneer emigrants, to whom the Indian was a hazard and an obstruction both in travel and in the acquisition of land. Here is a brief character sketch of the Indians by Col. Richard Irving Dodge, an Indian fighter of long experience:

"Cruelty is both an amusement and a study [to the Plains Indians]. So much pleasure is derived from it, that the Indian is constantly thinking out new devices of torture, and how to prolong to the utmost those already known. His anatomical knowledge of the most sensitive portions of the human frame is wonderfully accurate; and the amount of beating, cutting, slashing, and burning he will make a

human body undergo without seriously affecting the vital powers is astonishing. . . . The bodies of enemies are almost always terribly mutilated. . . . Artistic dissections, partial flayings, dislocations, breaking and splitting of fingers and toes, indicate that the poor fellow went to his long home with all the accompaniments of pain and horror." [1]

Is this melodramatic exaggeration? To claim that this was typical of all the Plains Indians, or on the other hand to contend that nothing like it ever happened; would be as far from the truth as insisting that all the white men in the West during the same period were shining examples of saintly integrity. The War Department records for June to December, 1868, for the whole Plains area, show "one hundred and fifty-four murders [by Indians of all tribes] of white settlers and freighters, and the capture of numerous women and children, the burning and sacking of farmhouses, ranches, and stage coaches." [2] This is not a startling statement, when we consider the large area and number of persons involved in open warfare. The retaliatory destructions of the red men's villages by settlers and miners, while not officially reported, are known to be far greater.

It is unfortunate the Indian has left no written record of his own side of the case. How interesting it would be to read the intimate journals of such warriors as Keokuck, Roman Nose, Geronimo, and Sitting Bull, or the philosophic opinions of some of the patriarchal sages of the important medicine lodges. Having no written language of his own, and stoically silent in defeat, the Indian's important place in this epoch of American history has been set down almost entirely by his enemy and tormentor. There are early biographies of some of the notable Indians, but they were prepared by ambitious journalists specifically for white men's consumption, with heavy accent on the sensational or on the author's imagination.

What one Indian thought of the white man, aside from matters of warfare, was recorded by Julian Ralph in *Harper's Monthly* of May, 1892. [3] A grizzled old Sioux dropped into a bank in Pierre, South Dakota, and upon being asked what he thought of the government purchase of half his reservation, replied:

"All same old story. White men come, build *chu-chu* [railroad] through reservation. White men *yawpy-yawpy* [talk]. Say: 'Good Indian, good Indian; we want land. We give *muz-es-kow* [money]; *liliota muz-es-kow* [plenty money].' Indian say, 'Yes.' What Indian get? *Wah-nee-che* [nothing]. Some day white men want move Indian. White men *yawpy-yawpy*: 'Good Indian, good Indian; give Indian *liliota muz-es-kow*.' What Indian get? *Wah-nee-che*. Some day white men want

[1] *The Hunting Grounds of the Great West*, by Richard Irving Dodge, London, 1877, p. 417.
[2] "A Frontier Fight," by Gen. G. A. Forsyth, U.S.A., *Harper's Monthly*, June, 1895.
[3] "The Dakotas," by Julian Ralph, *Harper's Monthly*, May, 1892, p. 906.

RED RIVER FRANK Bodfish

half big reservation. *Yawpy-yawpy*; good Indian; *liliota muz-es-kow*. Indian heap fool. He say, 'Yes.' What Indian get? *Wah-nee-che*. All same old story. Good Indian, good Indian. Get nothing."

As the white man had contributed to the rise of the Indian, through the introduction of the horse and the fur trade, so also was he responsible for the red man's downfall. After the gold rush of 1849, the next great flood of settlers and upsurge in development of the Plains came as an aftermath of the Civil War. Through the years of conflict between the North and South, interest in the West had temporarily subsided. Of the country's total population of about 32,000,000, some 4,000,000 able-bodied men were directly involved in the war. Nevertheless it was in 1862 that a liberal charter was given for the Union Pacific Railway to connect the two coasts, bringing gold from California and providing an Eastern market for the produce of the Plains. In the same year, one of the most important of a series of Homestead Acts offered land free (for a ten-dollar registration fee) if the settler would contract to develop it for at least five years. In the Southwest, over a period of twenty years, 50,000,000 acres were thus transferred from public to private domain.

With the surrender of Confederate Gen. Robert E. Lee at Appomattox, on April 9, 1865, over a million volunteers and militiamen were quite suddenly mustered out of the service, and a large number of Regular Army units were made available for transfer to frontier duty. For most of the discharged soldiers, their former business ties, if any, had been lost beyond recovery, and many young men had grown up abruptly on the battlefield with a taste for adventurous freedom and excitement. It was only natural that a great many of these suddenly freed men should turn to the West.

The government census figures for the years 1860 and 1870 show that the population of seven principal Western states increased from approximately 1,900,000 to 3,300,000. Kansas showed a rise from 107,206 to 364,390. The Indian population

in Kansas in 1870 is given as 9,814, in Iowa only 348, and by this time there were but 75 Indians left in the whole state of Missouri.[4] The report of the Commissioner of Indian Affairs for 1870 gives the total number of Indians in the entire United States as 287,640. These figures point to the almost explosive force of postwar Western migration and are strong evidence that bands of wild red men were not lurking behind every clump of tree to ambush small helpless groups of emigrants as they wandered by. Already the Indian was overwhelmingly outnumbered, and with his back pushed against the dwindling wilderness, was fighting desperately for survival.

With the increase in population came the important development of the great cattle industry, which had had its beginning in southwestern Texas long before the Civil War. The earliest Spanish explorers took cattle along on their expeditions, and those who stayed north of the Rio Grande bred the stock. Some of the cattle strayed away, as did the horses, and formed wild herds which multiplied at a rapid rate. The Indians were not interested even in killing them for food, for the "longhorn cattle" were not only wilder and more dangerous than buffalo, but their meat was considered less desirable. (Theodore Roosevelt, who knew the West, was once asked what was the most dangerous game in North America, and he replied: "The Texas longhorn steer.") The country made an ideal habitat for these cattle. According to the Tenth Census of the United States "Report upon the Statistics of Agriculture"(1880), in 1830 there were about 100,000 head of cattle in Texas, in 1850 there were 330,000 head, and the official figure for 1860 is 3,535,768. But they had very little value. In 1865 they brought only three dollars and four dollars per head, with few buyers! Up North, however, where settlers were swarming out onto the Plains and towns were mushrooming, the same cattle were in demand at thirty dollars and forty dollars a head. All that stood in the way of handsome profits was transporting the cattle to the market, across 1,200 to 1,500 miles of wild and dangerous country, and the only way of doing this was to drive them there on the hoof. This was a difficult task, but the Texan settlers were a hardy lot and set about it with vigor and determination. They had already learned to herd cattle on horseback, thus becoming the first American "cowboys."

The first drive of three hundred to a thousand head of unbranded cattle from the Rio Grande country into the North was in 1837–1838. The earliest authenticated record of a cattle drive (a thousand head), as a business venture, from Texas to Ohio was in 1846 by Edward Piper, and the first drive to Chicago was ten years later, in 1856. Thus came into existence the historic Abilene, Ellsworth,

[4] "Report on Indians Taxed and Indians Not Taxed in the United States . . . ," *Eleventh Census: 1890*, Washington, D. C., 1894, p. 22.

and Newton trails, the Goodnight and Dodge City trails, and later the Chisholm (sometimes called the Chisum) Trail. From 1866 to 1880 approximately five million head of Texas cattle were delivered on the hoof to the waiting markets in the North.

Along with the flood of emigrants who went West in the period following the end of the Civil War went a number of journalists and illustrators, to report on the development of the West for Eastern periodicals—whose editorial policy was more concerned with fat hogs and new farms than any phase of Indian or wild Western life. Most of the pictures which resulted were sadly lacking in artistic qualities, and many of them were crude and inaccurate. Among the best of these were William Holbrook Beard, Theodore A. Davis, Henry Arthur Elkins, H. C. Ford, Alfred E. Mathews, and A. R. Waud, as well as a few able cartoonists like Bodfish (see page 163). There were also a great number of books published on the West, both good and bad, some of historic importance, and others by men who had but the slightest license to write on the subject. Some were so badly illustrated that the pictures were not even signed. Then there was the romantic fare offered by the dime novels, which have their place in Western Americana and interest in which will probably increase as the years go by; but they contributed only confusion to any serious estimate of life in the West, or Western art.

A number of artists who gained lasting renown in other fields of art made brief excursions into Western painting, although the results of these were so heavily overshadowed by their endeavors in other milieus that they have become all but lost to the record. Among these was the celebrated Emanuel Leutze (1816–1868), teacher of so many young American painters who made the pilgrimage to Düsseldorf and creator of that canvas known to every American schoolchild, *Washington Crossing the Delaware*. In the early 1850s he made a sketching trip to the Rocky Mountains to fulfill a commission by the United States Congress which resulted in the large canvas *Westward the Course of Empire Takes Its Way*. It hangs today in the House wing of our National Capitol building. A similar case is that of Worthington Whittredge (1820–1910), who made a Western trip in 1866 and again in 1870, and whose *Crossing the Ford, Platte River, Colorado* (40 by 68 inches) today hangs in the Century Club in New York City. There were also John Frederick Kensett (1818–1872) and Sanford R. Gifford (1823–1880), two members of the Hudson River School who went West to gain inspiration and a fresh perspective from the Buckskin Group. But, for the most part, the artists of the West whose work has endured were not the casual visitors but the painter-pioneers who could ride and hunt, and who carried provisions for a week in one saddlebag and a sketchbook in the other.

The trails across the Plains became roads, the steam railroad made regular trips from St. Louis to San Francisco, and farmers' homes with children playing in fenced yards became a more frequent sight along the way. Progress had its victims, however; the Indians were being pushed farther and farther into the remote and inaccessible badlands and out of the fertile plains. Fiercely proud and faithful to his own primitive concepts of warfare, he fought back savagely and, by our standards, cruelly. He faced the disadvantage of being widely separated in independent and often antagonistic tribes, but man for man in combat he was fully the equal of his white adversary; our own cavalry experts credited the Indians with being the finest light horsemen the world has ever known, unexcelled even by Bedouin, Cossack, or Nordic. As strategists in wilderness warfare, their leaders repeatedly tricked, outthought, and outmaneuvered our Army of the West. For years Geronimo and his elusive raiding parties outsmarted the best military men we could send to pursue him. The defeats of such men as General Custer have been strangely glamorized and glorified for young readers of history. If a white general meets defeat in a history book, invariably it is because he was outnumbered at least ten to one by the wicked savages. We have never given the Indian the credit he deserves as a fighting man.

As the Old West began to slip slowly into the limbo of history, carrying with it all the colorful and dramatic characteristics of the epoch, our artists became retrospectively inspired. Some were idealists, and some realists; some saw good Indians, some saw bad. But, strangely enough, as the Old West began to fade, some of its best interpreters started practicing their art.

John Mulvaney Cassilly Adams Henry F. Farny

18 *Massacre & Martyrs*

THE TRAGIC DEFEAT of Gen. George Armstrong Custer in the battle of the Little Big Horn, on Sunday, June 25, 1876, came as an ironic climax in the great drama of the red man's struggle in defense of his homeland and nomadic existence. Under the master mind of the Sioux medicine chief Sitting Bull, and the leadership of the crafty war chief Crazy Horse, the Indians won that battle about fifteen miles south of what is now Hardin, Montana. It was the red man's last major victory, although fourteen years remained to be played out in his bitter saga. From the Indian's side the Little Big Horn battle was a counterstrike against a well-planned attack under the direction of a general whose long and successful experience had made his name a word of fear at the Indian council fires. While the red man's losses were very light, the only living thing under Custer's command to survive was Comanche, the horse of one of his captains. "Massacre!" was the cry of the white man, as news of the battle of the Little Big Horn spread quickly eastward.

The Custer battle was one of the most widely publicized events in American history. It instilled awe in the public and fired anew the whole Indian controversy, as no other single event had done. The entire United States Army declared unofficial retaliation to avenge the General and his lost battalion of the Seventh Cavalry, an attitude that was widely endorsed in newspapers and magazines of the period. Sitting Bull became Public Enemy Number One of the 1870s and fled into Canada. To some he symbolized the martyr of his race. Helen Hunt Jackson's poignant book *A Century of Dishonor* [1] was published in 1881 and was one of the notable efforts to swing popular opinion in favor of the Indian. It found a surprisingly large and receptive audience. ". . . The Government of the United States has often plighted its faith to the Indian, and has broken it as often, and, while punishing him for his crimes, has given him no status in the courts except as a criminal, has been sadly derelict in its duty toward him, and has reaped the whirlwind only because it has sown the wind."

[1] *A Century of Dishonor*, by Helen Hunt Jackson, Boston, 1881, p. 2.

In July of 1881 Sitting Bull returned and surrendered at Fort Buford, Dakota Territory, under protection of the government's promise of amnesty. But his zeal for the Indian cause was not subdued, and he started building a fanatical determination among his tribesmen for one final act of resistance. On December 15, 1890, he was killed on the reservation at the Standing Rock Agency while resisting arrest by Sergeants Red Tomahawk and Bullhead, members of his own race who had joined the United States Indian Police. Two weeks later, the same Seventh Cavalry, under Colonel Forsyth, evened their score at Wounded Knee; and with the few skirmishes that immediately followed, the curtain was lowered on the last act in Indian warfare in the United States. Many of the Indian characters in that wonderful drama survived to wander about, homeless, some joining Buffalo Bill's Wild West Show, others compelled to accept the life of the reservation.

The Custer battle of the Little Big Horn has been depicted by more artists than any other single event on the Western scene. Most of these pictures, based on various degrees of research, have been considerably idealized and are highly imaginary in content. Among the earliest and most noteworthy is the immense canvas *Custer's Last Rally*, by John Mulvaney (1844–1906).[2] After a prolonged visit at the scene of the tragedy and among the Sioux who participated, Mulvaney spent a full year in painting the 11- by 21-foot picture in his Kansas City studio and completed it in 1881. It was transported East for exhibition in several large cities and made a great impression, more because of its size and dramatic implications than its historic accuracy or artistic merits. Walt Whitman was "completely absorbed" by the massive painting and gave this classic contemplation of the incident which it portrayed: "Nothing in the books like it, nothing in Homer, nothing in Shakespeare; more grim and sublime than either, all native, all our own, and all fact."[3]

Whitman induced Mulvaney to take the picture to Paris, to convince Frenchmen that America was as good as France in the production of historic and heroic art. On its return to this country the painting continued its peripatetic exhibitions. In 1900 it was purchased by H. J. Heinz Company, of Pittsburgh, and its last public appearance was a prolonged display at the Heinz Ocean Pier in Atlantic City, where it was viewed daily by hundreds of admiring visitors. It has since been sold and its whereabouts is not generally known.

About 1885 Cassilly Adams completed his *Custer's Last Fight*. This 9-foot-6-

[2] Born in Ireland; died May, 1906, N.Y.C. To U.S. at age twelve. Self-taught until after service in Civil War; studied in Munich, Antwerp, Paris. Returned to U.S. about 1870; exhibited at Nat. Acad., 1876.

[3] *American Painting*, by Virgil Barker, New York, 1950, p. 561.

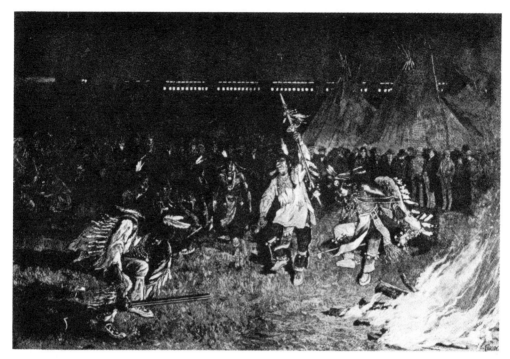

A Dance of Crow Indians Henry F. Farny (*Harper's Weekly*)

inch by 16-foot-5-inch painting was also exhibited in various cities for an admission fee, after which it came to rest in a swank St. Louis saloon which was headquarters for city politicians and visiting dignitaries. When the owners went out of business, the big picture was purchased by Anheuser-Busch, Inc., the St. Louis brewing firm. Shortly afterward, in 1896, the new owners had an advertising lithograph made of the painting by the Milwaukee Lithographic and Engraving Company, which was given tremendous circulation (see page 159), and even today the reprints still being sent out have brought the total to well over a million copies. Unfortunately, the lithographer, Otto Becker, took more than ordinary liberties in copying the picture. The original canvas was presented to the Seventh Regiment, United States Cavalry, by Adolphus Busch in the 1890s. The picture, however, does not seem to have been very popular with the regiment or the United States Army, and it underwent a series of misadventures which caused its virtual ruin. In 1934 it was resurrected from dilapidated discard at abandoned Fort Grant, Arizona. The canvas had been removed from its frame, folded, torn, and badly cracked. Finally restored by a WPA art project, it was in 1938 once more returned to Fort Bliss, headquarters of the Seventh Cavalry, where it hung

in the Officers' Club until June 13, 1946, when a fire destroyed the building and the famous painting.[4] Prominent among the long list of artists who have also depicted the Custer battle are William M. Cary, Rufus Zogbaum, Frederic Remington, Charles M. Russell, Ernest L. Blumenschein, J. H. Sharp, W. H. Dunton, W. R. Leigh, and recently Harold von Schmidt.

The artists who seriously chose the Indian as a subject of their work were for the most part less biased than most of the writers. This applies particularly to the more accomplished artists. Sensationalism was generally the tool and technique of inept illustrators without firsthand experience. Henry F. Farny (1847–1916) is a good example of an artist of the late nineteenth century whose perspective on the Indian was wise and just. Brought to the United States from his native Alsace at the age of five, he spent his early boyhood in the forest country on the headwaters of the Allegheny River in western Pennsylvania, where occasional contact with Seneca Indians no doubt stimulated his interest in the subject. About 1859 the family moved to Cincinnati, where he became an apprentice in a lithographing firm. As early as 1865, at the age of eighteen, he was doing art work for *Harper's Weekly*,[5] and shortly afterward went to Europe to spend three years studying art at Düsseldorf, Vienna, and in Italy. He also did some book illustrating, including the famous *McGuffey Readers*. With this background, he turned to the fading West in search of a major theme for his career. In 1878 he made a 1000-mile canoe trip down the Missouri River with the journalist George Smalley; and in 1881, attracted by the glamour of Sitting Bull and his fanatical adherents of the forbidden Ghost Dance (a violent ceremony aimed at inciting the Indians against the white man), Farny made a trip to the Sioux Agency at Standing Rock, under the military shadow of Fort Yates, and filled his sketchbooks with drawings. Returning to his Cincinnati studio, he took a middle-of-the-road documentary viewpoint of the Indian problem, and his first Western work met with quick sale and acclaim. Reproductions of his Indian paintings and important assignments by both *Harper's* and *Century*, criterions of success in that period, were promptly forthcoming.

The fall of 1883 saw the completion of another transcontinental railroad, the Northern Pacific. Special trains carrying 350 invited guests left St. Paul to witness the ceremonies marking the driving of the last spike near Missoula, Montana. Many notables from Washington and from foreign countries went along, including Gen. U. S. Grant. Henry Farny accompanied the party. En route, a number of gala events were arranged, including a stop at Bismarck, the present capital of

[4] *The New York Times*, June 14, 1946.
[5] *Harper's Weekly*, Sept. 30, 1865, pp. 620–621.

North Dakota, to witness laying the cornerstone of the territorial capitol. Sitting Bull and many of his tribesmen came up from the Standing Rock Agency to add color and significance to the occasion. Another stop was made near the Crow Reservation (Montana), where a hundred of the reservation Indians engaged in a tribal Grass Dance, against the night glow of flaring campfires and the background of brightly lighted trains, for the amusement of the sight-seers. Farny made a picture of this, *A Dance of Crow Indians*, which appeared as a full page in *Harper's Weekly*, December 15, 1883 (see page 169). His accompanying text read in part: "The lurid light of the campfires, deafening drum beats, jingling bells of the dancers, and weird monotonous chant of the singers were echoed by the whistle of the locomotives as the excursion trains successively drew up." The Old West had become a side show and the Indian dance a sham.

Farny made numerous trips into the West. He developed a strong sympathy for the Indians, and while his pictures were done with considerable restraint, their implications were nevertheless clear and impressive. His fine water color *The Captive* (see page 160), which hangs in the Cincinnati Art Museum, suggests the impending torture for which the red man was so often infamous. Col. Richard Irving Dodge, whose book *The Hunting Grounds of the Great West* is quoted earlier, cited a specific instance to tell the melodramatic and terrible story of Indian torture in *Our Wild Indians* (1882):

"These fiends in human shape stripped and tied him to a tree, and for some hours tormented him in every way their ingenuity could devise. Becoming tired of this, they procured some 'fat' pine knots, and splitting them into small splinters, stuck them into the skin until the unfortunate boy bristled like a porcupine. Then they set fire to the splinters, and danced and yelled with delight when the poor boy cried and screamed with anguish."[6]

Another of Farny's pictures which very graphically tells the Indian story is *The Song of the Talking Wire* (see page 158), now in the Taft Museum of Cincinnati. There is mingled sadness and bitterness on the face of a lonely brave, still wearing the buffalo robe of his father but reduced to hunting the lowly deer with the white man's gun, while he stops on his way home to contemplate the mysterious humming of the white man's "talking wire"—a symbol of the red man's destruction.

[6] *Thirty-three Years among Our Wild Indians*, by Col. Richard Irving Dodge, Hartford, Connecticut, 1882, p. 525.

19 *Poetic Justice*

GREAT CHANGES were still taking place on the frontier between 1875 and 1885. A Montana pioneer, Granville Stuart,[1] described vividly the sudden new developments on his part of the range. "In 1880, the country was practically uninhabited. One· could travel for miles without seeing a trapper's bivouac. Thousands of buffalo darkened the rolling plains. There were deer, elk, wolves, and coyotes on every hill and in every ravine and thicket. In the whole territory of Montana there were but 250,000 head of cattle. . . . In the fall of 1883, there was hardly a buffalo remaining on the range, and the antelope, elk and deer were indeed scarce . . . but there were 600,000 head of cattle on the range. The cowboy . . . had become an institution." The rancher and the farmer had come to stay. This sudden upsurge in development was typical of large areas throughout the West.

That same decade between 1875 and 1885 saw the beginning of several careers which stand out prominently in the history of Western art. Most notable among these are George de Forest Brush, Charles M. Russell, and Frederic Remington, all of whom started their Western experience between 1878 and 1880. These three are entitled to special attention because they distinguished themselves as delineators of three different and important phases of the Western scene. They had the advantage of extensive firsthand experience in the West before the old days were entirely gone; they were blessed with a clear and honest perspective; and they were all able artists. Each left a contribution of real historic value.

There were others: Joseph Henry Sharp, Peter Moran, Julian Scott, Gilbert Gaul, Thomas Hill, Arthur I. Keller, Harry Fenn, and J. Carter Beard, to mention only a few. Two names, not of artists but of men who also went West in 1880 and whose qualities one must associate with things Western, warrant mentioning— Owen Wister, who went to Wyoming to begin collecting material for such books as *The Virginian, Red Men and White,* and *When West Was West;* and Theodore

[1] *Forty Years on the Frontier,* Vol. II, pp. 187–188, Granville Stuart, Arthur H. Clark Company, Glendale, California.

Roosevelt, who took up ranching on the Little Missouri in Dakota Territory, with little thought of becoming a historian or making history as President of the United States.

George de Forest Brush presented the Indian from a viewpoint quite different from any of his predecessors. His paintings were not directly concerned with warfare, ceremonial display, or the more sensational aspects of primitive life, but rather they were interpretations of the philosophy of the Indian. He was the poet of our Indian painters. The editor of *Century Magazine* in 1892 put it this way: "His work is like opening a window and looking out into another age, upon another race, almost in another world." [2]

Brush was born in Shelbyville, Tennessee, September 28, 1855,[3] but spent his early boyhood in Connecticut where his father was, for a time, the captain of a whaling ship. His mother was a highly cultured woman and an amateur portrait painter of considerable ability. She devoted much time to fostering the development of her son's artistic inclinations, and shortly after the family moved to Ohio, when George was about sixteen, arranged for him to begin serious study at the Academy of Design in New York City. When he was nineteen he was sent to Europe, spending the six years between 1874 and 1880 in Paris as a student of the celebrated Jean Léon Gérôme (1824–1904). Upon his return to the United States at twenty-five, he had a technical training far superior to that of most young painters. The year of his return his work appeared for the first time before the American public, a picture hung in the exhibition of the Society of American Artists and inspired by Bret Harte's story of the West, *Miggles*.[4] Already he showed a strong inclination toward the Western scene.

According to a note in *Harper's Weekly* of November 20, 1886, Brush passed four years traveling and sketching in the northern Plains region and up into Canada, spending considerable time on various reservations and becoming deeply interested in the lives and problems of the Indians. From the beginning he understood the tragedies implicit in our treatment of the Indians. He wondered particularly at our attempts to force upon them our own ideas and concepts of how life should be lived. All that their ancestors had taught them to respect as righteous and honorable was torn out by the roots, and what we offered in its place left a moral and spiritual vacuum which could only result in the decay and deterioration of a once proud people. Here Brush found the inspiration for his painting—the

[2] *Century Magazine*, February, 1892, p. 638.

[3] Most of the biographical facts regarding George de Forest Brush are from information supplied this writer by the artist's daughter, Mrs. Nancy Douglas Bowditch.

[4] *Century Magazine, loc. cit.*

reconstruction of the life that had been and was no more. "Every one who goes far West," he wrote after his return, "sees about the streets of the little railroad towns a few Indians. The squaws are fat and prematurely wrinkled, and the men give the impression of dark-skinned tramps, and we seldom look under their dirty old felt hats to study their features. . . . So deep is the prejudice against them that travelers who are aware of this sentiment . . . and who know how much of interest and good there is to be told, are tempted to counterbalance prejudice with over-statement. . . . Their old people are blind and dirty, with brutal jaw and uncombed hair; and blood on the faces of old women, who have cut themselves in mourning, and which they refuse to wash off. . . . The vulgar think that only roses are beautiful; but the weed which we root up also illustrates the Divine Law of harmony. It is not by trying to imagine the Indian something finer than he is that the artistic sense finds delight in him." [5]

Brush saw much more than just the romantic side of the Indian's background, for he was extremely sympathetic to their mode of life. His olive skin, dark hair and eyes gave him an additional kinship to the red men. Well received among them, he learned many of their skills and crafts. He was an expert horseman, and developed considerable skill at building tepees, making bows and arrows, and cutting out and sewing moccasins. He became a serious student of their traditions and folklore, participated in some of their public ceremonies, and learned to dance the Dog Dance "with gusto" (see page 62). He also witnessed the display and torture of the Sun Dance, described so vividly by George Catlin, which very few white men were permitted to attend.

Out of this experience came many of his fine paintings, of which one of the best known is *The Silence Broken*, reproduced on page 157. Here, as in other pictures, the artist caught on canvas in eloquent terms the world of the Indian before the white man came. In this painting one senses the pleasant and expansive solitude, broken only by the soft sound of the swan in flight, and the light touch of a birch bark canoe on the surface of the stream. Here is man living peacefully as a harmonious part of nature. Our own raucous civilization seems somehow ridiculed in comparison, and this is the message of Brush's pictures. In his *Before the Battle*, shown on page 158, there is something which penetrates beyond the externals of life and deep into the spirit of the civilization depicted. The artist looked back far beyond the "dark-skinned tramps" which he saw on his first visit to the West.

Recognition and acclaim were promptly forthcoming for Brush, as a result of his poetic Indian paintings and his accomplished draftsmanship. He was elected a

[5] "An Artist among the Indians," by George de Forest Brush, *Century Magazine*, May, 1885.

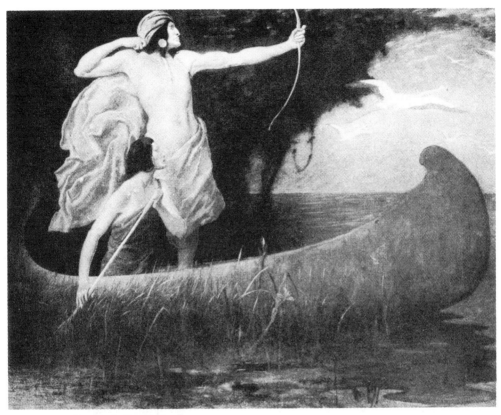

AT DAWN George de Forest Brush

member of the Society of American Artists in 1882, and in 1888 he won the first Hallgarten Prize in the exhibition of the National Academy and was elected an Associate Academician the same year. Shortly afterward, he established a studio in Dublin, New Hampshire, where he continued laboring at his easel. However, in spite of the acclaim of critics and public, there were so few purchasers of his Indian paintings that about 1890 Brush was compelled to give up the Western theme and seek some other field of art as a means of supporting his growing family.

Returning to Europe for further study and in search of a new thesis, Brush took up temporary residence in Florence and became interested in the tradition of the Italian Renaissance. He developed a modernized version of the "madonna" motif, using his wife and children as subjects, and this new theme brought him fresh laurels and generous purchasers of his work. He won gold medals at several international expositions, a charter membership in the National Institute of Arts and Letters in 1898, election to the National Academy in 1901, and an honorary de-

gree from Yale University. But the American Indian and Western art had lost one of its most poetic and accomplished exponents. Ironically, today his Indian subjects are much more sought after than his madonnas.

Brush's paintings, both Indian and madonna, were often requested for public exhibitions. In 1905 he received such a request from the Lewis and Clark Exposition at Portland, Oregon. The artist wrote to a wealthy patron who had but recently purchased one of his favorite pictures, asking if the owner could be induced to lend the painting to the exhibition. An answer was promptly forthcoming: "Of course we will lend you the painting. It really belongs to you. Our possession of it is only incidental." It is a classic reply, and indicative of an ideal attitude not always practiced by collectors and patrons of the arts. Another side light on this artist's career is the fact that he was one of the first to suggest camouflaging warships. When the United States was at war with Spain in 1898, he and Abbott H. Thayer, a fellow artist, proposed this innovation to the Navy Department—but the idea was, at the time, turned down.[6]

In all the phases of his work, Brush went far beyond the stereotyped routines of expression; and yet he had a violent distaste for the tendency toward modernistic painting. "Artists are producing canvases for which they ought to be arrested," he said in 1910. "Ten years ago, if an effort had been made to exhibit some paintings being shown today, police would have been called in. Real art is on the wane; and it has become so enmeshed in the mad whirl and swirl of modern times that true artistic sense is deadened." [7]

George de Forest Brush worked industriously in his Dublin studio for nearly half a century, until it was destroyed by fire in 1937. Fortunately, by this time most of his important Indian pictures had found their way into private collections and museums. He worked at his easel almost to the last, and died on April 24, 1941, at Hanover, New Hampshire, at the age of eighty-five.

[6] *The New York Times*, Apr. 25, 1941—in the artist's obituary.
[7] *Ibid.*

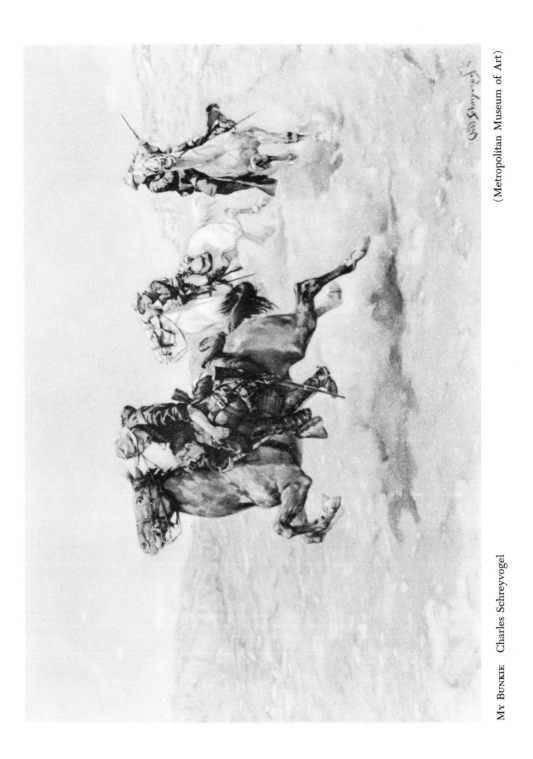

My Bunkie Charles Schreyvogel

(Metropolitan Museum of Art)

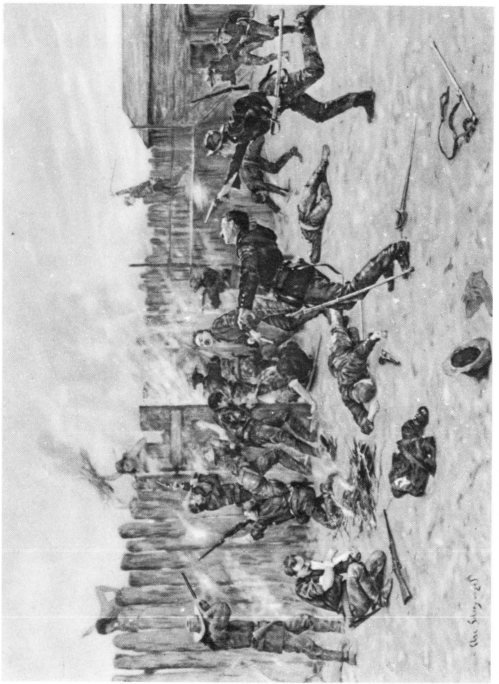

Defending the Stockade Charles Schreyvogel

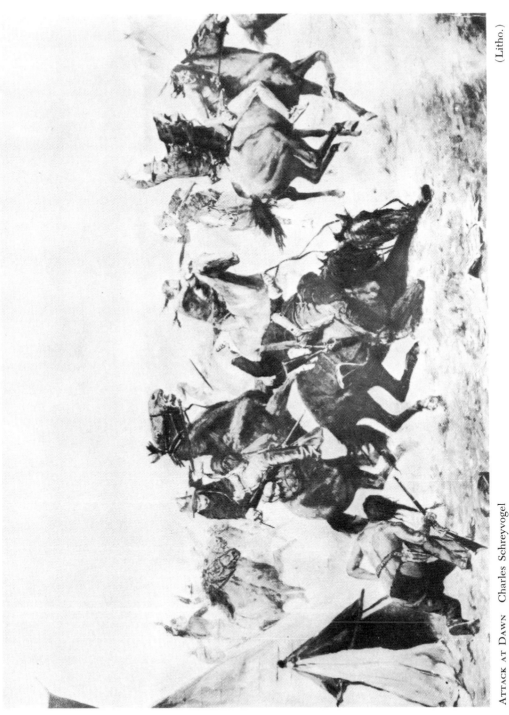

Attack at Dawn Charles Schreyvogel

(Litho.)

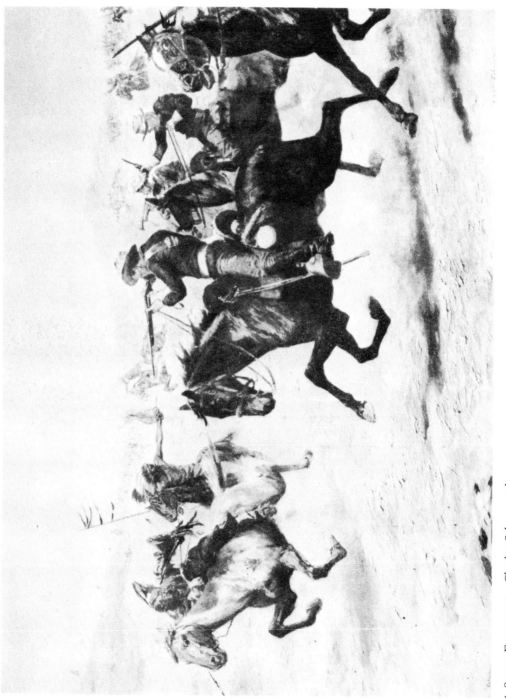

A Sharp Encounter Charles Schreyvogel

(Litho.)

PAINTING THE BUFFALO ROBE Charles M. Russell

("The Mint"—Knoedler Art Galleries, N. Y. C.)

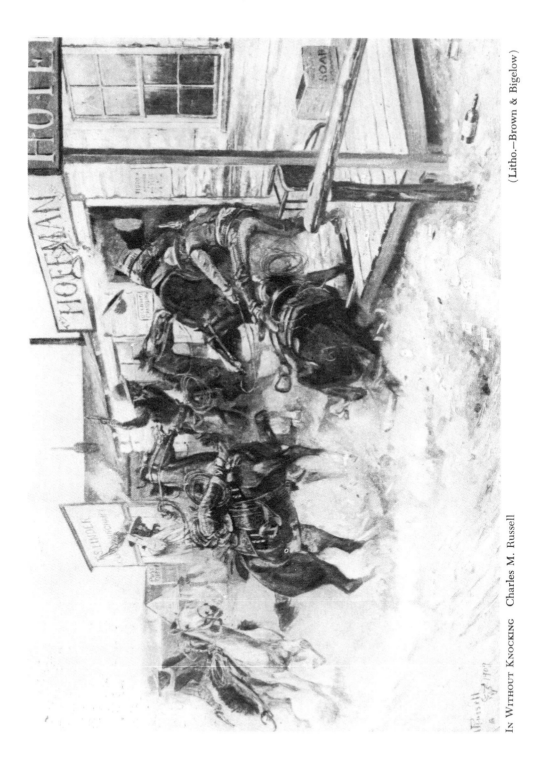

In Without Knocking Charles M. Russell

(Litho.—Brown & Bigelow)

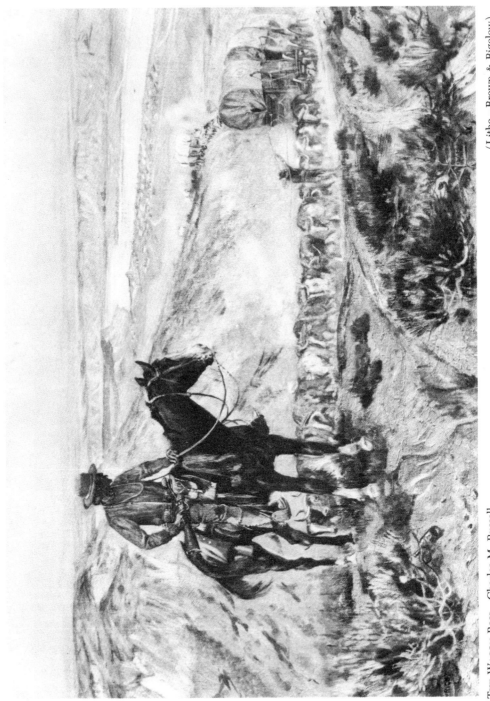

THE WAGON BOSS Charles M. Russell (Litho.—Brown & Bigelow)

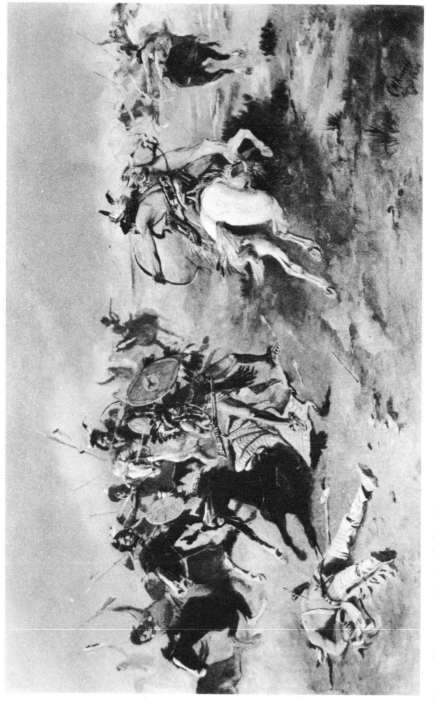

INDIAN WARFARE Charles M. Russell

("The Mint"—Knoedler Art Galleries, N. Y. C.)

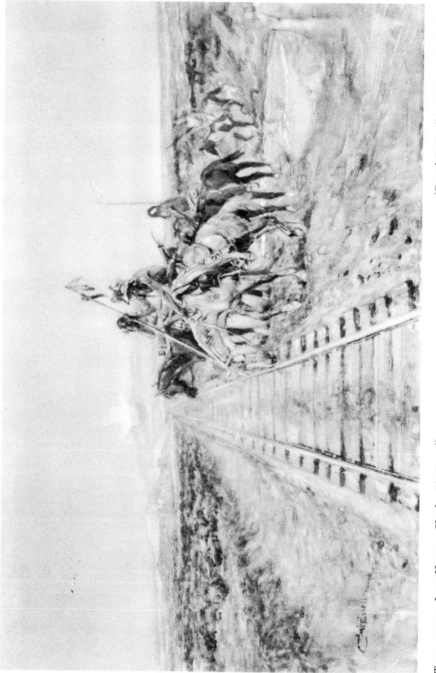

TRAIL OF THE IRON HORSE Charles M. Russell (David B. Findlay Galleries, N. Y. C.)

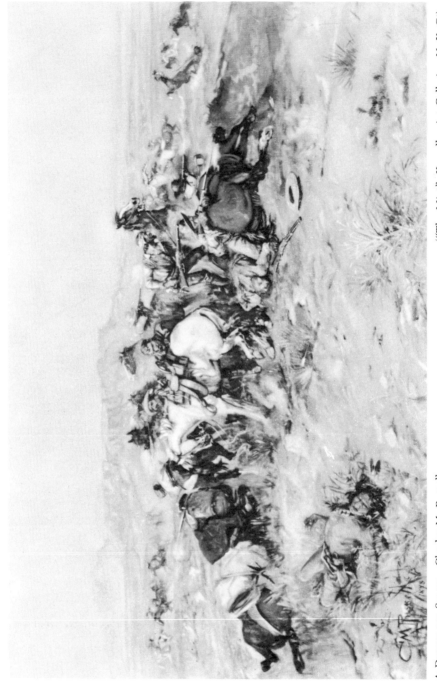

A Desperate Stand Charles M. Russell ("The Mint"—Knoedler Art Galleries, N. Y. C.)

Charles Marion Russell

20 *The Cowboy in His Day*

THE CAVALCADE of our Western history is particularly rich in colorful types which are strictly our own. Some have become traditional symbols of life in America—and not the least of these is the cowboy. The product of a comparatively brief era on the Great Plains, he was fashioned in sinew and guts, and ordained in the roughest practices of civilized men. "The cowpuncher's play-ground in those first glorious days of his prosperity, included battle and murder and sudden death as every-day matters," wrote Owen Wister in 1895. "Saxon boys of picked courage (none but plucky ones could survive) from South and North, from town and country. . . . Some had known the evening hymn at one time, others could remember no parent or teacher earlier than the street; some spoke with the gentle accent of Virginia, others in the dialect of baked beans and codfish; here and there a baccalaureate, already beginning to forget his Greek alphabet. . . . What motlier tribe, what heap of cards shuffled from more various unmatched packs could be found? Yet this tribe did not remain motley, but soon grew into a unit . . . watching for Indians, guarding huge herds at night, chasing cattle, wild as deer, over rocks and counties, sleeping in the dust and waking in the snow, cooking in the open, swimming the swollen rivers . . . face to face with the eternal simplicity of death."[1]

A lot of the cattlemen were born into their trade or turned to it from closely associated occupations, but many came out as green youngsters, lured by the vague glamour, the adventure and freedom which a life in the saddle promised. They learned the hard way. Among these romantic youngsters was a husky boy who lived in St. Louis and whose name was Charles Marion Russell. Born of a prosperous St. Louis family on March 19, 1864,[2] he was a great-nephew of William

[1] "The Evolution of the Cowpuncher," by Owen Wister, *Harper's Monthly*, September, 1895, pp. 608–609.

[2] Although most lexicons of artist biographies, and Charlie Russell himself, gave his birth year as 1865, "the vital statistics in St. Louis give the date as 1864"—according to Homer Britzman's biography *Charles M. Russell—The Cowboy Artist*, Pasadena, 1948, p. 1.

Bent, who along with Kit Carson and Jim Bridger had made history in the early days of the West. Bent, his father's uncle, had built a trading post and fort on the Arkansas River in 1824 and was the first permanent white settler in what later became the state of Colorado.

Charlie Russell followed in the footsteps of his famous great-uncle of whom he had heard so much exciting talk when he was a boy. In the spring of 1880, barely past his sixteenth birthday, he took off for the West, sketchbook in hand. Here is what he himself had to say about his early days, writing in 1904 when his tough struggles were mostly behind him and he had a studio in Great Falls, Montana: [3]

"When I came to Montana twenty-four years ago I engaged as a sheep herder in the Judith Basin. I did not stay long, as the sheep and I did not get along well, but I did not think my employer missed me much, as I was considered pretty ornery. I soon took up with a hunter and trapper named Jake Hoover. This life suited me. We had six horses, a saddle horse apiece and pack animals. One of these is the pinto I have today. I stayed about two years with Hoover, when I had to go back to St. Louis. . . . I brought back [to Montana] a cousin who died of mountain fever at Billings two weeks after we arrived. When I pulled out of Billings I had four bits in my pockets and 200 miles between me and Hoover. There was still much snow, as it was April, but after riding about fifteen miles I struck a cow outfit coming in to receive 1,000 dougies [sic] for the 12Z and V outfit up the Basin. The boss, John Cabler, hired me to night-wrangle horses. We were about a month on the trail and turned loose on Ross Fork, where we met the Judith roundup. They had just fired their night herder and Cabler gave me a good word, so I took the herd. It was a lucky thing no one knew me, or I never would have had the job.

"I was considered worthless, but in spite of that fact I held their bunch, which consisted of 300 saddle horses. That same fall old True hired me to night herd his beef, and for eleven years I sung to the horses and cattle.

"In 1888 I went to the Northwest Territory and stayed about six months with the Blood Indians. In the spring of 1889 I went back to the Judith, taking my old place as a wrangler. The Judith country was getting pretty well settled, and sheep had the range, so the cow-men decided to move. All that summer and the next we tailed the cattle north to Milk River. In the fall of 1891 I received a letter from Charlie Green, better known as 'Pretty Charlie,' a bartender in Great Falls, saying that if I would come to their camp I could make $75 a month and grub. It looked good, so I saddled my gray and packed Monty, my pinto, and pulled my freight

[3] "Russell, the West's Cowboy Artist," *The Outing Magazine*, December, 1904, p. 269.

for said burg. When I arrived I was introduced to Mr. G., who pulled a contract as long as a stake rope for me to sign. It showed that I was beginning to get a reputation as an artist, for according to the contract, everything I drew, modeled or painted in a year was to be his. I balked. Then he wanted me to paint from six o'clock in the morning until six o'clock at night, but I argued that there was some difference in painting and sawing wood, so we split, and I went to work for myself.

"I put in with a bunch of cowpunchers, a roundup cook and a prize fighter out of a job, and we rented a two by four on the south side. The feed was very short at times, but we wintered. Next spring I went back to Milk River and once more I took to the range. In the fall I returned to Great Falls, took up the paint brush and have never 'sung to them' since."

SELF-PORTRAIT Charles M. Russell
(David B. Findlay Galleries, N.Y.C.)

This brief autobiography, told with the cowman's lack of ostentation, gives little idea of the adventure and the struggle which form the background of this fine cowboy artist. One line only does he devote to six months spent living with the Blood Indians in Alberta, Canada—an experience on which a whole book might be written. Charlie did not live just "among" the Bloods, he lived "with" them—hunted with the young men of the tribe and sat at the lodge fire with the old men, listening to their tales of war and ancient lore handed down through many generations. His hair grew long and his cowboy clothes, when worn out, were supplanted with working buckskins. Some of his friends proposed he take himself an Indian wife and become a permanent member of the tribe. His friendship with these Indians, and the red man as a race, was deep and genuine. "I've known some bad Indians," he once said, "but for every bad one I kin match 'em with ten worse white men. . . . When he's a good friend, he's the best friend in the world."[4]

From the beginning of his experience in Montana in 1880, he was continually sketching the scenes around him. As a youngster in St. Louis he had enjoyed a little instruction in the fundamentals of drawing—but beyond that he was entirely self-taught, like so many of our important Western artists. His art student days

[4] *Charles M. Russell—The Cowboy Artist*, by Ramon Adams and Homer Britzman, Pasadena, 1948, p. 95.

were beside the night fire of a cattle outfit, under the broad canopy of the stars, when the rest of the wranglers were rolled in their blankets with a saddle for a pillow. Few artists ever knew their thesis better than did Charlie Russell. His

painting and his life were one; no amount of academic training could have added to the spirit and color of the paintings which have so well established Russell in his chosen field.

He had become a Montana cowboy, outside and in. All else was subordinate to this—a characteristic which he never lost. As can be seen from the self-portrait reproduced on page 189, Charlie Russell was a sturdy hombre—bull-necked, big of bone, and lantern-jawed. The cowboy's lot in those days was a tough one and it paid mighty little money. In the 1880s, cattlemen were not called upon to face the hazards of Indian attacks or starvation on the desolate plains, but their everyday life was an ordeal of physical hardship and every man had to stand squarely on his own two feet, whether he was a painter of rare genius or just another cowhand. Rustlers were an almost constant problem, and faulty justice in the local courts left law and order pretty much in the hands of vigilantes, who asked few questions and wasted little time in carrying out their drastic punishments. When there was reasonable doubt of guilt, the simple notice of a skull and crossbones painted on a cabin door or a corral gate was usually

COWBOY Charles M. Russell sufficient warning to make the suspect haul his freight to a new location in a healthier climate. Men carried six-guns strapped to their legs and they used them often. The winter cow camps were usually freezing cold; often the temperature slid down to 40 and 50 below zero, splitting big trees wide open, above the snow line. The wild, half-crazed cattle would grow emaciated and desperate in their futile search for food, and finally would be impossible to control.

The winter of 1886–1887 was one of the worst in the history of the Montana cattle days and a tough one for Charlie Russell. Without a job and broke, he sat it out on one of the ranches where he worked. It started snowing in mid-November and each day the temperature dropped farther below the freezing mark. Cattle died by the thousands. Some of the outfits lost as high as 65 per cent of their herds. The herd belonging to Theodore Roosevelt, on the Little Missouri, in Dakota, was all but exterminated. From this experience Charlie Russell drew a little water-color picture, about post-card size, of a lone cow standing hunched

over in the snow, half starved and frozen, surrounded by waiting prairie wolves. It was sent to a cattle owner in Helena as a report on conditions on the range. Charlie titled the little picture *Waiting for a Chinook*. It made such a dramatic impression and was shown to so many cattlemen around Helena that it gave the unknown cowboy artist considerable local fame. It was later reproduced very widely, sometimes with the title *The Last of Five Thousand*.

Russell continued to knock about from one cattle outfit to another, struggling through the lean winters for more than ten years before he began collecting hard cash for any of his pictures. Then it was an empty stomach and the thirst for a drink which forced him to seek money for the realistic little scenes of cattle, cowboys, and Indians which he so easily put on paper. The men with whom he worked and drank, rough and unconcerned about the niceties of fine art, dug down in their pokes and forked out five and ten dollars to own one of Charlie's pictures of the life they knew so well. But it was during the winter of 1890–1891 in Lewistown, Montana, that he really broke into the professional field and began to cash in on his talent. He was commissioned to decorate the iron door of the local bank, on which he painted an elaborate mural showing a cowboy on horseback watching a grazing herd. When it was completed he was paid the munificent sum of twenty-five dollars! According to Homer Britzman, the artist's biographer and

Cow Pony Charles M. Russell

friend, that was more money than Charlie Russell had ever received for his work.

Drawing and painting pictures began taking more and more of Charlie's time, although the necessities of life still had to be bought by long hard days and nights in the saddle. He had a few of his pictures published in the late eighties in *Harper's Weekly* and *Leslie's*, and he sold increasing numbers to the local market, often across the bar for a few drinks. It was not until the fall of 1896, when he married Nancy Cooper, that he really settled down to make art his serious career. "Mame," as he affectionately called his wife, had a lot to do with that. "Mame's the business end, an' I jes' paint," he later said. "We're pardners. . . . She could convince anybody I was the greatest artist in the world. . . . An' y'u jes' can't disappoint a person like that." [5]

By 1903 he had a studio in Great Falls and his reputation as an artist was well established. He also had a log lodge on the shore of Lake McDonald, in what is now Glacier National Park, where he spent the summers painting. Russell's roots were sunk deeply into the soil of Montana and almost all of his pictures dealt specifically with life in that state. He was "Mr. Montana" himself and extremely proud of his provincialism; he never cared to live or paint anywhere else. It was in 1903 that he made his first trip to the East to sell his pictures in New York City, probably Mame's idea more than his own. Charlie called New York "the big camp" and was not impressed. "And the style of those New York saloons," he was quoted as saying in the Great Falls *Daily Tribune*, February 16, 1904. "The bartenders won't drink with you even. Now I like to have the bartenders drink with me occasionally, out of the same bottle, just to be sure I ain't gettin' poison." It was on this second trip to the big city that Charlie met Will Rogers, another Westerner just beginning his climb up the ladder of fame, and began his lifelong friendship with the gum-chewing cowboy-humorist.

Charlie Russell and Will Rogers had a lot in common. Both became famous personalities, each an artist in his own field, but essentially they remained cowboys of the most unadulterated breed. No amount of success, wealth, acclaim, fancy grub, or social polish could change them, outside or in. "Time only changes the outside of things," Russell's biographer, Homer E. Britzman, quotes him as saying. "It scars the rocks and snarls the trees, but the heart inside is the same." The people that Russell put in his pictures were externally rough-cut types, engaged in the business of living strenuously, sometimes dangerously, always close to the land. Underneath his own saddle-leather exterior was the refreshing spirit of a homespun philosopher, modest but sure-sighted. "Nobody is ever important

[5] *Ibid.*, pp. 141–144.

enough to feel important" was the personal adage he once expressed in a letter to a friend. To another he wrote, "Don't look too long at the shadow but cast your eyes in places where the sun still shines." His world was the great out-of-doors of the West, before it was too scarred by concrete highways, hot-dog stands, and roadside motels. Toward the end of his life he often looked back toward the past. "Today I know more dead men than live ones. Old Dad Time has made me a stranger in my own country. . . . When I backtrack memory's trail, it seems all the best camps are behind . . . but in spite of gasoline, the biggest part of the Rocky Mountains belongs to God." It is only natural that the principal character in Charlie Russell's paintings should be the old-time cowpuncher. "Old Maw Nature's adopted son," he called him—a fitting epitaph for the artist himself.

The late 1880s and early nineties saw another wave of transition spread over the Great Plains. This time it was the "nesters" (farmers), the sheepmen, and the "damn barbed-wire fence" which spelled the end of the old-time cattle herding and the original picturesque cowboy. The newcomers who settled on homesteads and fenced off the open range had the law and the inexorable power of change and progress on their side. Agriculture, industry, and urbanity were spreading order and sobriety over the fertile West of the United States. But the past was safely rounded up and preserved in the soul of Charlie Russell, and his canvases perpetuate the cowboy of his day for future generations.

Although best known as an artist, Charlie Russell was also a colorful writer. His "Rawhide Rawlins Stories" are classics of Western literature, as are also many of his poems. He had the old-time plainsman's gift for spinning a yarn, highly savored with earthy philosophy and humor, gathered from the campfires of frontiersmen and the solemn council lodges of Indian patriarchs. His characters had such colorful handles as Mormon Murphy, Gumboot Williams, Long Wilson, Bowlegs, and Dad Lane the Wolfer. Even the letters he sent to his friends have become treasured collectors' items of Western Americana, because of their unique flavor and the choice bits of his art with which they were generally embellished. He wrote as he spoke, in the picturesque vernacular of the Old West, with ease and grace. The scenes and characters he depicted in his writings are as clear-cut as those he portrayed with paint and brush.

It is appropriate that, until recently, one of the most important collections of Russell paintings hung in "The Mint," the famous old saloon in Great Falls, Montana. Sid Willis, the proprietor in Russell's time and a close friend of the artist, accumulated the pictures over a period of years. It is said that Kit Carson was one of the original owners of "The Mint." Three of the paintings are reproduced on pages 181, 184, and 186: *Painting the Buffalo Robe, Indian Warfare,* and *A Des-*

perate Stand; and now this famous collection is destined to be preserved in a fine Western museum. One of Russell's most popular cowboy scenes, *In Without Knocking*, is shown on page 182. Others are *The Wagon Boss* (page 183) and *Trail of the Iron Horse* (page 185).

In the introduction to the artist's book *Trails Plowed Under*,[6] published a few months after his death on October 25, 1926, Will Rogers wrote: "We may have Painters in time to come, that will be just as good as Charley. We may have cowboys just as good. . . . But us, and the manicured tribe that is following us, will never have the Real Cowboy, Painter and Man, combined that Charley was ·. . . and if by a Miracle we did get all that combination, why it just wouldn't be Charley."

[6] *Trails Plowed Under*, by Charles M. Russell, New York, 1927.

Charles Schreyvogel

21 *Bugle Calls on the Plains*

FROM THE END of the Civil War until the decisive defeat of the Sioux at the battle of Wounded Knee in 1890, it was the task of our little Indian-fighting Army to keep the peace, from the Mississippi to the Rockies and from Arizona to the Montana border. Such colorful leaders as Custer, Sheridan, Sherman, and Forsyth led their troops against Geronimo of the Apaches and Crazy Horse of the Sioux, Red Cloud, Sitting Bull, Roman Nose, and many other illustrious Indian chiefs. Although this era of American history now seems a part of the distant past, as recently as 1915 the presence of United States troops was required in Colorado to pacify the Piutes.

Against the advancing horde of settlers were arrayed the Sioux, the Cheyennes, the Piegans, the Assiniboins, the Comanches, the Apaches, and the Arapahos. These were the formidable leaders of many other Indian tribes which attempted to halt the westward migration. The Sioux, at the height of their power in the 1860s, had managed to press the settlers back to the eastern border of the Plains while the white men were occupied in fighting each other, and in 1862 they arose in bloody rebellion and massacred some 650 white settlers in Minnesota and South Dakota.

Our Indian-fighting Army established a tradition on the Great Plains which shall long endure. It fell to the lot of these military men to protect the many small groups of emigrants trekking westward and those who were permanently settling the land. "Not statesmen but riflemen and riders made America," [1] as Emerson Hough wrote in *The Passing of the Frontier*.

The greatest of our Indian Wars took place after 1865. In the earlier days, our pioneers had to take care of themselves. Until the gold rush of 1849 opened the floodgates of migration, the little Army of the West was fairly free to carry out its own campaigns. Occasionally it was called upon to serve as supplementary guard for a big caravan, and its presence in the country was a constant warning to the

[1] *The Passing of the Frontier*, by Emerson Hough, "Yale Chronicles of America," Yale University Press, Vol. 26, p. 3.

Indians. In those days the field command enjoyed the prerogative of making its own decisions with relatively little interference from Washington.

The military problems increased after 1850 when emigrants and settlers drifted westward in smaller parties and spread out over a vaster area. At no time during the period of the Indian Wars were there more than 14,000 soldiers on Indian duty west of the Mississippi. The area which they had to cover, from the Mississippi to the Rockies, was well over 1,400,000 square miles, or an average of more than 100 square miles to the man. In 1870 there were in this area about 128,000 "no-madic" or off-reservation Indians.[2] Of these, some 25,000 were warriors. To this figure must be added the considerable number of reservation Indians who were constantly turning renegade to make hit-and-run forays upon settlers and settle-ments. Even the peaceful reservations tied down many soldiers who had to keep the vastly larger number of our "wards" under control. The little army assigned to this widespread and variegated duty was sadly inadequate for the task. According to General Sherman, "no other army in the world had such an amount of work put to the same number of men."

The Indian tactics were to make swift attacks, at widely separated points, and then quickly disappear. Their warriors traveled so lightly equipped that escape into the roughest country was no problem. They were never handicapped by the heavy, slow wagon trains of equipment and supplies which followed our military units. As an indication of their fighting ability, the casualties which they inflicted were greater, in proportion to the number of men involved, than the losses on either side during the Civil War. The Indian also enjoyed a considerable psychological advantage. A white soldier, no matter how brave, could hardly relish the prospect of finishing his career as the principal figure in a torture ceremony, his stripped body decorated porcupine-fashion with an assortment of arrows—all for thirty dollars per month.

These Indian fighters could hardly have understood the deeper moral problems posed by our invasion of the red men's territory. To them the Indian was a devil on horseback, an abominable savage skilled in torture and only too eager to scalp women and children. Col. Richard Dodge—hunter, rider, and Indian fighter par excellence—once described, with bitter eloquence, the environment of a young Indian. He wrote:

"As a child, he is not brought up. . . . There is no right and no wrong to him. . . . The men by whom he is surrounded, and to whom he looks as models for his

[2] "Report on Indians Taxed and . . . Not Taxed in the United States . . . ," *Eleventh Census: 1890*, Washington, D. C., 1894, p. 22.

future life, are great and renowned just in proportion to their ferocity, to the scalps they have taken, or the thefts they have committed. . . . Virtue, morality, generosity, honor are words not only absolutely without significance to him, but are not accurately translatable into any Indian language on the Plains."

Occasionally, in a spirit of hysterical revenge, the militia emulated Indian methods of making war. In November of 1864, a war party of Sioux and Cheyennes massacred a group of emigrants near Denver and the dismembered bodies were exhibited in town. Fear and anger swept through the populace and a fanatical ex-preacher, Col. J. M. Chivington, organized the militia for a raid on a nearby encampment of Cheyennes and Arapahos. Despite the fact that peace negotiations were then going on and the chief of the Cheyennes had run up an American flag, the troops launched a vicious attack on the camp which ultimately killed 300 Indians, 225 of them women and children. Whether or not these were the same Indians who murdered the emigrants remains a moot question and one that hardly bothered the hysterical Colonel Chivington. His troops carved up the bodies of their dead foes and took more than 100 scalps. Happily, the public were sickened when they heard the story of Chivington's revenge and the Colonel escaped court-martial only because he left the service before the court could be called into session.

The best the troops could expect on a campaign was dust and sweat, or snow and frostbite, bad rations and low pay. They received thirty dollars a month, and often had to supply their own horses with food in the bargain. In 1878 Congress even failed to pass the necessary appropriation to provide any army pay whatsoever, for either enlisted men or officers. The latter had to use their own savings or borrow money, at usurers' rates of interest, to provide food and clothing for themselves and their families. In spite of all, the Army of the West remained loyal and effective. They were a durable, hard-swearing, tobacco-chewing outfit. They were not responsible for our Indian policy or our repeated repudiations of treaties made with the Indian tribes. Yet they did their best to create order out of chaos and fought bravely and skillfully under the most adverse conditions.

The amount of literature and drama inspired by our Indian-fighting Army is enormous. Many of our artists have depicted the dramatic episodes and characteristics which the dashing trooper of the Plains and the infantryman have made a part of our Western legend. The man who most seriously and most successfully undertook to perpetuate the cavalryman in action against his red-skinned foe, and the foot soldier in defense of stockade and wagon train, was Charles Schreyvogel. This was the theme to which he devoted practically his whole career, and no one has left us a finer or more graphic report on this particular phase of Western life,

despite the relatively small number of his canvases that are in existence today.

Charles Schreyvogel [3] was born in New York City, January 4, 1861. Of a poor family, he sold newspapers as a youngster and later worked as an office boy for a New York firm. [4] When still quite young, his parents moved to Hoboken, New Jersey, which henceforth was his home. His nearest approach to art in the way of an early occupation was an apprenticeship at carving meerschaum pipes—then as a gold engraver—and later in a lithographing establishment. In the meantime he struggled alone with drawing and painting, trying to scrape together enough savings to afford some instruction in the profession. He progressed quickly in his self-taught efforts and was soon designing lithographic sketches and by 1880 was earning extra money giving lessons to others in drawing and painting. By 1887 he was able to realize his long-delayed ambition to go abroad for serious study, made possible by his own savings and the assistance of two gentlemen who had faith in his future, H. August Schwabe, president of the Newark Art League and himself an artist, and Dr. William A. Fisher. In Munich, Schreyvogel studied for three years under Carl Marr and Frank Kirchbach. When he returned, in 1890, he was an accomplished draftsman and fine colorist. However, his health had failed to such an extent that for a whole year he was unable to put brush to canvas. Doctors told him that his only chance of regaining his strength was to go West. This was something he had always wanted to do, but it was financially impossible.

As soon as he was able to work again he began painting a little, principally portraits and landscapes, miniatures on ivory, and sketches for lithographers. There was not much money in these activities, but gradually he was sharpening his skill and improving his techniques. His friend Nate Salisbury, manager of Buffalo Bill's Wild West Show, gave him complete freedom of the show grounds and permission to use the Indians, cowboys, and other personnel as models for sketches and paintings. Colonel Cody also became his friend and encouraged the frail artist in his work, and ultimately, in 1893, Schreyvogel made the first of several trips to the West. At Ignacio, in the big Ute Reservation in the southwest corner of the state of Colorado, he was the guest of Dr. McDonald, an army surgeon. It was here that the Apaches and Navahos came for their government rations and other supplies. For five months the artist reveled in the opportunities which were at last his. He quickly became a fine rider, which gained for him the favor of the army men, and he learned to use sign language, which gave him a means of conversing

[3] Most of the biographical information regarding Charles Schreyvogel which is incorporated into this chapter has been supplied by the artist's wife, now Mrs. Louise S. Feldmann, and by his daughter, Mrs. Ruth S. Carothers.

[4] Kansas City *Star*, Jan. 24, 1901, p. 21.

with the Indians. Even the superstitious Apaches did not show their usual aversion to having their pictures drawn by Schreyvogel—until one day he made the serious mistake of making a profile portrait of one of the braves. The red man was furious when he viewed his likeness. Only one eye? He had *two* eyes! The artist quickly did another—this time with two eyes—and all was well.

He made short trips into nearby Arizona and afterward spent several months on a large ranch there studying and sketching the cowboy and cow pony in their natural element. Life in the open had given him new health and vigor and Schreyvogel determined to become the foremost interpreter of the United States Army man of the old-time Indian campaign days. When he finally returned to Hoboken he had enough ideas and sketches to keep him busy on canvases for a good many years.

The pictures he painted had both action and realism. They won the adulation of his little group of friends in the lithographing trade and a few who were interested in the more academic fields of art. But Schreyvogel's paintings of the troopers of the Plains did not sell in the East. Among his friends was Robert Stevens, grandson of the founder of Stevens Institute in Hoboken, and Schreyvogel often visited at the castle built by John Stevens, overlooking the Palisades. One day Mrs. Stevens commissioned him to paint their distinguished ancestor, and the work was done so well that he was paid $800 for the picture. On the strength of this success the artist married. But no other rich portrait commissions were forthcoming, and he was still unable to find purchasers for the Western military paintings which were his real interest in art. He turned to doing miniatures on ivory and these sold quite readily, one of them winning second prize in an exhibition. But working under a magnifying glass proved too hard on his eyes and he was shortly compelled to turn to something else. Portraits, work on glass, lithographing subjects—he tried almost everything—still spending his major effort on canvases of Indian-fighting soldiers, dashing about on horseback and firing their guns in the heat of desperate conflict. And it was always the same story—no sales and family poverty.

"At one time we were *vis-à-vis de rien*," his wife told me years after his death. "My brother-in-law, who was living with us, my husband, and I were sitting in the kitchen pooling our assets—thirty-six cents. What now? The bell rang and Charles went to the studio to admit a caller. After a while he came running in, beaming and waving something in his hand. It was a hundred-dollar bill! The visitor had bought one of his paintings!"

One of the canvases he had finished at this time was titled *My Bunkie* (see page 177). He had put into it everything he knew and felt about the West and he was confident that it was well done. Disappointment after disappointment was his only

reward as he carried it from one prospective buyer to another. In desperate straits, he decided to sell it for any price that was offered, and finally a lithographer agreed to take it at a ridiculously low fee. Then even this hope was blasted when the offer was repudiated because the dimensions of the picture did not conform to the particular requirements. Intensely discouraged, he did not have the heart to carry the painting back home one day, and he gave it to the proprietor of a little down-town café where he occasionally ate, to hang where someone might see it and make an offer. Later he learned that *My Bunkie* had been hung in a dark corner, where no one could possibly see it. Angered by this final slight, the artist took it away.

"Why don't you offer it to the National Academy exhibition?" suggested a friend. Schreyvogel had tried to make the Academy in 1897, with another of his paintings, and while that picture was hung, it was hardly noticed and the artist was unre-warded. In desperation he carried *My Bunkie* to New York and left it at the Academy shortly before the deadline for the 1900 exhibition, and literally forgot about it.

When the exhibition opened and the elite of the art world paraded in to see which paintings the judges had chosen for their acclaim, they found, to the amaze-ment of many, that a newcomer had been honored with the highest prize of all, the Thomas B. Clarke prize—*My Bunkie*, by Charles Schreyvogel. But who was Schreyvogel? No one around the Academy had ever heard of him. Where did he live? The critics and the newspapers wanted the story. Harry Watrous, the secre-tary of the National Academy, was asked about him. "You are about the hundredth person who has asked me," he replied. "I never heard of the artist. Unless he strolls in here, he won't know until he reads about it in the newspapers. All we know is that his name is Charles Schreyvogel and that he has painted a great picture." He had not even left an address! [5]

To add to his sorrow and his difficulties, the artist's brother had died on Jan-uary 1, 1900, and on opening day of the Academy exhibition Schreyvogel had gone to New York to attend to funeral arrangements. His wife had arranged to meet him later at a friend's home. As she approached the place at the appointed time, she was startled to see him running along the street to meet her. Throwing his arms around her, he was too excited to talk. He had just heard the news. The news-paper reporters had been trying to locate him, but he didn't want to see them until

[5] For a full account of this incident see "A Painter of the Western Frontier," by Gustav Kobbe, *The Cosmopolitan*, October, 1901. For a listing of his paintings, with reproductions and the stories represented in a number of the most important ones, see *Souvenir Album of Paintings by Chas. Schreyvogel*, by L. W. Schreyvogel, Hoboken, New Jersey, n.d.

she could be with him. Next morning there were headlines in the art news: "UNKNOWN ARTIST LEAPS INTO FAME." One night and one picture, *My Bunkie*, had lifted him from obscurity. There was a sudden rush to buy his other paintings. By request of the New York jury of the Paris exhibition, the painting was sent to France, where it was awarded the bronze medal in the same year, and later it received a similar award at the Pan-American Exposition in Buffalo. Yet such a short time before, the artist had been unable to sell it, for any price or for any purpose! This painting was acclaimed by many contemporary authorities, including Theodore Roosevelt, as one of the finest and most authentic works portraying our Indian-fighting Army. A group of the artist's admirers later purchased the picture at a high price and presented it to the Metropolitan Museum of Art. Unfortunately its present-day fate has much in common with Schreyvogel's early experience with the freshly painted canvas. It has been relegated to virtual obscurity on permanent loan to an uptown Manhattan military hospital.

With poverty and financial worries behind him, Schreyvogel gave his whole attention to the ideal to which he had been faithful so long, and began creating a series of colorful paintings of Western army riders in action. Among the finest of these is *The Silenced War Whoop*, which is reproduced as the frontispiece in this book. Others are *Attack at Dawn* (page 179), *A Sharp Encounter* (page 180), *Defending the Stockade* (page 178), *Custer's Demand*, *How-Kola*, and many more —all large canvases and each painting depicting some particular incident in the spectacular story of the cavalry or the infantry on the Western Plains.

Theodore Roosevelt, then President of the United States and always deeply interested in everything relating to the Old West and the cavalry in particular, invited the artist to the White House. In addition to paying high tribute to Schreyvogel's work, he gave him a presidential permit to visit any army post or Indian reservation in the United States, in pursuit of his work.

He went to the Ute and Sioux and Crow reservations and to Fort Yates and to Pueblo and many other places in the West. Everywhere he made sketches of the troopers and Indians, and listened to the stories of their bitter encounters in the earlier days. He was always searching for new ideas for paintings, and he collected all sorts of old-time Indian paraphernalia, decorative adornment, and armament; his Indian collection eventually became one of the finest owned by any white man. Schreyvogel and his wife had some exciting times in the West. While on the Blackfoot Reservation in Montana there arose some superstitious difficulties over the procurement of an ancient war shield, as a result of which one of the older and more orthodox of the Indian patriarchs gave warning that if the article was not returned before evening the Great Spirit would send a terrific storm. "It was a beautiful

cloudless day," Mrs. Feldmann recently told me. "But that night a terrible storm of hail and drenching rain came, wrecking our dining room, stampeding the cattle and doing considerable damage to the Indian village. . . . Then my husband got a tip, that we had better get out. The Indians were also rebellious because their rations had been withheld—and there was no telling what might happen. We went to the Army post near Crawford, Nebraska, where we were the guests of Captain Cavanaugh. My husband was always well received at any Army post, as they realized that all his paintings were a tribute to the life and valour of the U.S. trooper. He rode with the troopers on their practice marches and made a great many sketches. He was an excellent rifle shot and brought home many trophies. . . ."

Schreyvogel's work was admired by many of the notable personalities of the Old West. One was Colonel Cody (Buffalo Bill), and the artist often traveled with his Wild West Show. The great showman sometimes personally enacted a tableau of Schreyvogel's painting *The Last Drop*, depicting a lone trooper kneeling down in the desert in front of his horse and giving the animal the last water in his hat. A bronze sculpture was also made of this.

From his experience with the cavalry and his admiration for their exploits in warfare against the Indians, it might be expected that Schreyvogel would be deeply imbued with the soldier's attitude toward the Indian. When asked for an opinion on this touchy subject, he replied: "I have not met any Fenimore Cooper Indians, although I have had the pleasure of knowing some good, honorable red men. The Indian is, as a rule, silent, stoical, and taciturn to a wonderful degree until he gets to know you. Then he thaws out. One Indian I know is really voluble. That is Black Bull. He always opens his conversation with an introduction to himself such as 'Black-a-Bull, big chief.' He likes to talk. . . . I have many Indian friends and I have many friends in the Army. Some of the finest men I know are stationed on the frontier." Although they always appeared as "the opposition" in his cavalry paintings, Schreyvogel depicted the red men as dignified and worthy antagonists —ferocious and savage in combat, bold and courageous—men fighting in a lost cause for their hunting grounds and the land of their fathers.

He died on January 27, 1912. "My husband's last illness was caused by a sliver of chicken bone lodging in his gum and resulting in blood poisoning," his wife told me. "He passed away a few days after his fiftieth birthday."

Almost all of Schreyvogel's work was done on canvases of considerable size, and because of this he did not produce the large volume of pictures that were left by other Western artists. Art prints were made of a considerable number, but he has not enjoyed the wide popular acclaim which he rightly deserves for his fine interpretations of the trooper of the Plains in action.

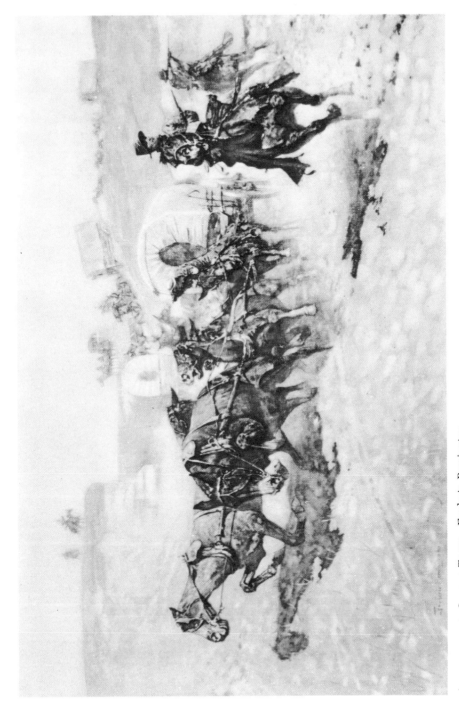

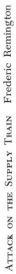

ATTACK ON THE SUPPLY TRAIN Frederic Remington

FRIENDS OR ENEMIES? Frederic Remington

(Knoedler Art Galleries, N. Y. C.)

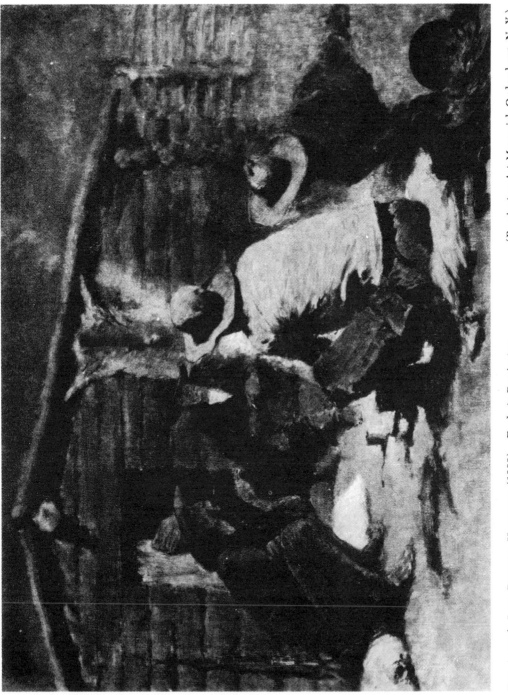

THE ARTIST'S LAST PICTURE—UNTITLED (1909) Frederic Remington

How Order No. 6 Came Through Frederic Remington ("21" Club, N. Y. C.)

The Death of Minnehaha Frederic Remington (R. W. Norton Art Foundation)

SET UP A WAILING LIKE VULTURES Frederic Remington (*Harper's*)

THE BUFFALO DANCE Frederic Remington (*Harper's*)

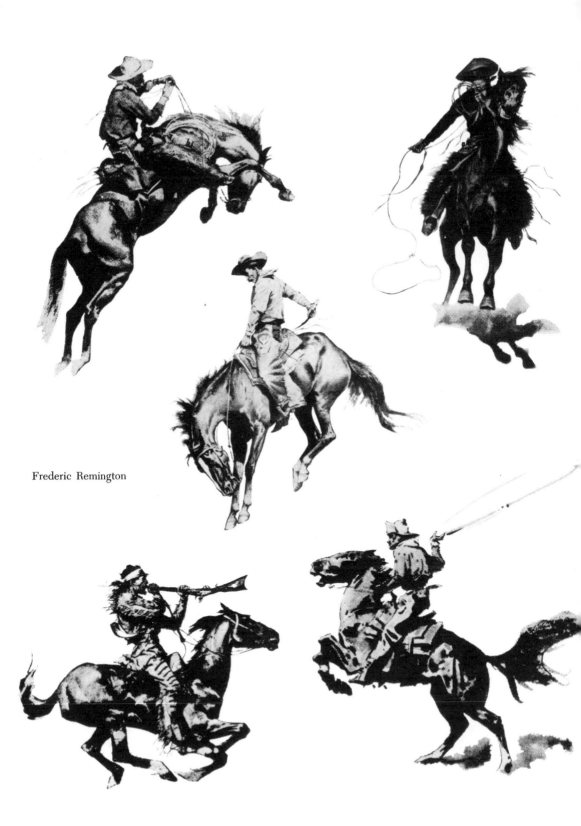

Frederic Remington

Frederic Remington

22 *The West As It Was*

IN OUR SEARCH to reconstruct the West's colorful past, we find one man who aids us more than any other. This is Frederic Remington.[1] His 3,000 pictures cover almost every period and phase of our Western history, from Cabeza de Vaca[2] in the early sixteenth century to the death of Sitting Bull and the last campaign in the white man's conquest of the Indians' domain on the Great Plains. His graphic record embraces every section of the West, from Old Mexico well up into Canada, and he was not only an artist of great ability but an extremely accurate documentarian. The Indians whom he depicted are not just Indians, as in the case of many other artists; they are San Carlos or Tontos Apaches, or Oglala or Hunkpapa Sioux, each with his proper garb, ornaments, and armament. His were not just Indian horses, for he was aware of the differences between cayuse, mustang, and Cherokee pony. He made the same careful distinctions between the cowboys and settlers of the different geographical areas and historical periods—the mountain man, the packer of mules, the trooper, the Texas type, the boomer, and so many others. In addition to his painting, Remington was also an accomplished sculptor and a prolific writer. Many of his pictures were accompanied by factual articles and bits of literary fiction, and one of his books was dramatized on Broadway. For his versatility, accuracy, and ascendant artistic talent, his name has become synonymous with a pictorial record of the Old West.

Frederic Remington was an Easterner by birth and of old New England stock. He was born on October 1, 1861, and there was little about his boyhood in the town of Canton in upstate New York which might suggest the career that followed. His father was a newspaper publisher and distinguished himself as a lieutenant colonel of cavalry in the Civil War. Remington attended a military academy and later Yale,

[1] For the complete story of the life and work of this artist see *Frederic Remington—Artist of the Old West*, by Harold McCracken, Philadelphia, 1947. This book contains a check list of about 98 per cent of the pictures and writings that the artist did and where they first appeared.

[2] *Collier's Weekly*, Oct. 14, 1905 (color plate).

but stayed in its Art School less than two years, long enough to gain a strong and lasting distate for academic art. There is no evidence that he won any scholarly laurels at Yale, although he did gain considerable reputation as an athlete, with a more than ordinary touch of glamour. He became one of the leading heavyweight boxers in intercollegiate competitions, and was an important member of the Yale varsity football teams of 1878–1879 and 1879–1880, especially celebrated because they were captained by Walter Camp. It is said of Remington that on the evening before the annual Yale-Harvard game, after the usual pep-meeting on the campus, he led some of his more ardent student followers to the local slaughterhouse, where he smeared with blood the playing shirt which he was to wear in the game next day.

The death of his father left Remington a modest inheritance and he quit Yale to take a minor political job, which he found equally intolerable. Spurred on by a restless and even reckless disposition, Remington went West at the age of nineteen, in 1880. Almost immediately he found the raw life on the Plains the answer to his desires. Already an expert horseman, he quickly learned to use a lariat with the skill of a veteran cowboy and to handle a six gun better than most. He was so good

with his fists that at one time he considered pugilism as a profession, and this stood him in well with the cowboys, saloon keepers, and troopers who were to become his friends. He also had the important advantage of having sufficient money to permit his going wherever he wanted. He became deeply interested in the life of the old days that was so rapidly fading and set out to see as much of the still unspoiled West as he could find. He worked as a cowboy, prospected for gold, and rode with military troops on campaigns and with posses after renegade Indians. He traveled such routes as the Oregon and Santa Fe trails and followed in the paths of pioneers like Kit Carson and Jedediah Smith.

Art as a profession had appealed to Remington when he was a boy, in a vague sort of way, but his brief experience at Yale had dulled that interest. He went West in search of adventure and with the avowed intention of "becoming a millionaire," planning to invest his inheritance in one of the get-rich-quick schemes for which the rapidly developing territory had become famous. But early in this wandering spree, while traveling across Montana with an old-time wagon freighter and sharing the campfires and reminiscences along the way, Remington came to realize that a colorful era was passing, one that could be pre-

A FATHER
OF THE INDUSTRY

served only in art for future generations. As he describes this realization himself:

"Evening overtook me one night in Montana and I by good luck made the camp-fire of an old wagon freighter who shared his bacon and coffee with me. I was 19 years of age and he was a very old man. Over the pipes it developed he . . . had gone West at an early age. . . . During his lifetime he had followed the receding frontiers, always further and further West.

"'And now,' said he, 'there is no more West. In a few years the railroad will come along the Yellowstone. . . .'

"There he was, my friend of the open, sleeping in a blanket on the ground (it snowed all night), eating his villainies out of a frying pan. . . . He had his point of view and he made a new one for me. The old man had closed my very entrancing book almost at the first chapter. I knew the railroad was coming. I saw men already swarming into the land. I knew the derby hat . . . and the thirty-day note were upon us in a restless surge. I knew the wild riders and the vacant land were about to vanish forever—and the more I considered the subject, the bigger the *forever* loomed.

"Without knowing exactly how to do it, I began to record some facts around me. . . ." [3]

There was still enough of the Old West scattered throughout the vast country to give him true perspective, and he set out to get thoroughly acquainted with it. He filled his crude sketchbooks with detailed drawings of old-time characters, Indians of many tribes, horses, cattle, military expeditions, cattle roundups. Although virtually without training, he had a photographic eye for detail and an intense determination to be accurate.

After three years of wandering and serious study of his subject, he bought a little ranch in Kansas to settle down. He spent so much of his time painting, however, that the ranch was a far from profitable venture. He kept open house for any cowboy or wayfarer who cared to partake of his hospitality, and the more colorful and eccentric they happened to be the more cordial a welcome they received. Eventually he began to sell an occasional water color or oil painting in nearby Kansas City and gave up the ranch to move into town, already an important center of the thriving cattle industry. With what remained of his inheritance and some money borrowed from a relative back East, Remington bought a third interest in one of Kansas City's

THE NORTHERN COWBOY

[3] "A Few Words from Mr. Remington," *Collier's Weekly*, Mar. 18, 1905.

A TEXAS COWPUNCHER

prominent saloons and at the same time seriously began his career as an artist. His pictures appealed to the cattlemen and others who knew the rough side of Western life. What his early work lacked in professional draftsmanship was more than made up for in realism and the virile "caught-in-action" feeling, which became the stamp of his genius.

On the strength of his "business," Remington returned East and at Gloversville, New York, on October 1, 1884, married Eva Adele Caten, his boyhood sweetheart. They returned to Kansas City, but there things did not go so well. The artist was cheated out of his silent partnership in the prosperous saloon, and he soon found that selling pictures was not sufficient to support a wife and home. Within a few months the new bride was compelled to return to her father, who had disapproved of the marriage from the first. In one last desperate gamble to strike it rich, Remington went south to the Arizona Territory on another gold prospecting trip. He failed again.

Summer came to the Southwest, scorching the sands and making humid bake ovens of the canyons. After days of aimless wandering, Remington found himself on Arizona's San Carlos Reservation, a vast tract of desert and mountains on the Gila River where the militia rode herd on the Apache Indians. As he often did in his wanderings, Remington had ridden with a cavalry command and on the reservation bunked with a friendly army officer. In an article published in *Century Magazine* a few years later, the artist described what he saw:

"Hundreds of ponies, caparisoned in all sorts of fantastic ways, were standing about. Young girls of the San Carlos tribe flitted about, attracting my attention by the queer ornaments which, in token of their virginity, they wear in their hair. Tall Yuma bucks galloped past with their long hair flying out behind. The squaws crowded around . . . and received the great chunks of beef which a native butcher threw to them. Indian scouts in military coats and armed with rifles stood about to preserve order. Groups of old women sat on the hot ground and gossiped. An old chief, with a respectable adipose under his cartridge belt, galloped up. . . ." [4]

That evening an old government Indian scout led Remington away from the troopers' fires to his own *jicail*. After a frugal evening meal, they sat in silence on

[4] "On the Indian Reservation," by Frederic Remington, *Century Magazine*, July, 1889.

the bluffs and smoked. Remington describes the scene in the following manner:

"It grew dark and we forbore to talk. Presently, as though to complete the strangeness of the situation, the measured *'thump, thump, thump'* of the tom-tom came from the vicinity of a fire some short distance away. One wild voice raised itself in strange, discordant sounds, dropped low, and then rose again. . . . By the flickering light of the fire . . . half-naked forms huddled with uplifted faces in a small circle around the tom-tom . . . the waves of sound rose and fell; and the tom-tom . . . kept a binding time. We grew in sympathy with the strange concert . . . and listened for hours. It was more enjoyable in its way than any trained chorus I have ever heard." [5]

Ultimately the wandering had to stop. Remington wound up in New York City in the fall of 1885, with a total capital of three dollars, bulging sketchbooks and portfolios of Western drawings, and a renewed determination to break into the art and illustrating business. His wife, Eva—he called her "Missie"—met him there and they started life together again, in a cheap furnished room in Brooklyn.

He had previously sold two pictures to *Harper's Weekly,* both of which had to be redrawn. The first had appeared on February 25, 1882—*Cowboys of Arizona: Roused by a Scout; drawn by W. A. Rogers from a sketch by Frederic Remington.* On March 28, 1885, another of his Western scenes was published, this one redone by T. de Thulstrup. With this slight ray of encouragement, Remington walked the unfriendly streets of New York from one publishing house to another trying desperately to interest someone in his Western pictures. He borrowed money on which to live and attended a few classes at the Art Students League but again found it impossible to become interested in formal art instruction.

Finally, Henry Mills Alden, the art editor of *Harper's Weekly,* bought a picture which appeared in its original form on the front page of the issue of January 9, 1886. This initial success broke the ice. The same year he illustrated a story for *St. Nicholas,* a number of his Western drawings were published in *Outing Magazine,* and his pictures began appearing with increasing regularity in *Harper's.* He worked with intense industry and perseverance, getting up at 6 A.M. and laboring into midafter-

THE ARIZONA TYPE
Frederic Remington

[5] *Ibid.*

noon, and in an amazingly short period editors were seeking him out. Within a year, one of his paintings, *The Courier's Nap on the Trail*, was hung in the annual exhibition of the National Academy. Few artists ever climbed so far in such a short period of time, not on the strength of any one picture but a profusion, all with the same theme, the Old West. Four years later, in 1890, *Harper's Weekly* published 119 of Remington's illustrations, *Harper's Monthly*, 36; and *Century Magazine*, 18, all in a single year.

Remington became a close friend of Theodore Roosevelt and illustrated his first book, *Ranch Life and the Hunting Trail*. He also painted a memorable series of pictures to illustrate Longfellow's *The Song of Hiawatha* (see page 206). In a letter dated December 3, 1888, and written by the artist's wife to his uncle, H. D. Sackrider,[6] she said: "Fred has just left for Boston . . . to see Houghton, Mifflin & Company about illustrating 'Hiawatha'. . . . Ever since he has done any illustrating he has dreamed about doing that and now he hopes he can." This was the first of many literary classics, including Francis Parkman's *Oregon Trail*, to which Remington added his touch of genius.

Success did not cause Remington to settle down in the comforts of metropolitan studio life. With lucrative commissions for his work, he continued to search every summer for the fading remnants of the Old West. He lived as he had before, with the old-time characters, cowboys, troopers, and Indians. He studied them against their natural background with meticulous deliberation, and he made a large collection of the finest raiments and paraphernalia of Indians and cowboys, for detail use in his pictures.[7] Few men were better informed on the whole Indian situation. Remington had watched the smoldering fire of rebellion which Sitting Bull had been quietly fanning among his followers. The artist understood the deep implications of their revived Ghost Dance, and he anticipated the last desperate uprising of the Sioux with such accuracy that he was on hand in the Dakotas in late December, 1890, for this final act in the prolonged and bloody warfare between the red man and the United States

[6] H. D. Sackrider was a brother of Frederic Remington's mother. This letter, with a large and important collection by the artist and his wife, was presented to this writer by Henry M. Sackrider, son of the recipient and Remington's closest living kin. He has also contributed a great deal of intimate information regarding his illustrious uncle.

[7] This collection, with many of the artist's paintings, bronzes, etc., is now preserved in the Remington Art Memorial, Ogdensburg, New York.

Army. Riding into the Bad Lands with one of the military units, in subzero weather, he barely escaped death at the hands of the Sioux warriors. He rode at the side of Lt. Edward Casey, famous as chief of the Army's Cheyenne scouts, who was killed in another engagement a few days later. By that time Remington had dashed across-country to New York to report his experiences in pictures and writing in *Harper's Weekly*. This important series of illustrated articles began in the issue of January 24, 1891.

By 1895 Frederic Remington was recognized as our foremost exponent in art of the Western scene. He was also known as an important writer of short stories and articles, which were always illustrated with his own pictures. His literary work, as well as his art, appeared constantly in the best magazines, and was always favorably received. After reading *Massai's Crooked Trail*, Theodore Roosevelt, then Assistant Secretary of the Navy, wrote the author: "Are you aware, O sea-going Plainsman, that aside from what you do with the pencil, you come closer to the real thing with the pen than any other man in the Western business?" And this in the face of such competition as Owen Wister, Bret Harte, Alfred Henry Lewis, Joaquin Miller, and Stewart Edward White!

In 1895 Remington turned to sculpture, and although he had virtually no technical instruction in this medium, his first bronze, *The Bronco Buster*, was an immediate success. From the little furnished room in the Brooklyn boardinghouse, the Remingtons moved in three jumps to an estate in fashionable Westchester County. There he had a studio so spacious that he was able to bring in live horses with mounted riders for models. Ultimately he became one of the world's highest paid illustrators, and his paintings were sought after by exhibitions, museums, and wealthy collectors.

WESTERN TYPE

Remington's work has broad appeal. Easterners and Westerners, cowboys, metropolitan tycoons, and bank clerks are numbered among his ardent admirers. His pictures hang in museums, night clubs, private galleries, drawing rooms, and waterfront saloons. If it is true that "a work of art is great in ratio of its power of stirring the highest emotions of the largest number of cultured people for the longest period of time,"[8] then Frederic Remington belongs in the front rank.

He died following an emergency operation for appendicitis, on December 26, 1909, in the prime of life and at the height of his popularity, at forty-eight.

[8] *Great Works of Art*, by F. W. Ruckstull, New York, 1925, p. 89.

The only epitaph he ever expressed a desire to have on his tombstone was: "He knew the horse." The paintings, line drawings, bronzes, and writings that he left behind would suggest that he knew more than just the horse—the Indians, the pioneers, the wagon trails, the cattle roundups, in fact just about everything there is to know about the life of his choice.

The Old West is gone beyond all recall. Perhaps to Frederic Remington, more than to any other single artist, we owe a great debt of gratitude for so successfully perpetuating that colorful and important era of American history.

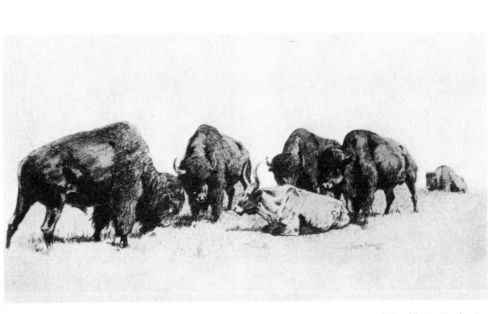

A RECRUIT FROM CIVILIZATION (Harold McCracken)

Biographical Check List

of Western Artists

Following is a list of those who did Western art from firsthand observation before all semblance of the Old West was gone. They were all born prior to 1876. Many of them made it their life's thesis, although some stepped only briefly into the field. There are a good number of National Academicians among them, and others are important for documentary rather than artistic reasons. There are pertinent facts missing in the information regarding some, and there are undoubtedly others who deserve a place on the list. They constitute a school as distinctive as the Hudson River School; and it is hoped that this list, and this book, will lead to the assembling of a complete record of all our Western artists and their work.

ABBREVIATIONS

B.—born

D.—died

L.B.I.—little biographical information available

P.—pupil of, or student at

S-T.—self-taught

S.M.—special medium

Illus.—illustrations, or illustrated

Rep.—representative works

Nat. Acad.—National Academy of Design

Inst.—institute

A.N.A.—Associate Member of National Academy of Design

N.A.—Full Academician of National Academy of Design

Pa. Acad.—Pennsylvania Academy of Fine Arts

Exhib.—exhibited in, and exhibition

N.Y.H.S.—New York Historical Society, New York City

A.S.L.—Art Students League, New York City

N.Y.C.—New York City, N.Y.

ADAMS, Cassilly (1843– ?) See Chapter 18.

ARIOLA, Fortunato (? –1871) No biog. information available. A Mexican landscape painter who spent some time painting in Calif. in early days.

AUDUBON, John James (1785–1851) Date, place, and circumstances of birth not well es-tablished. Mantel Fielding gives: *B.* Apr. 26, 1785, Haiti, West Indies. *D.* Jan. 27, 1851, N.Y.C. *P.* in France, under Louis David. Came to America, presumably on second visit, in 1807, and traveled in U.S. and Canada making sketches for his *Birds of North America* and *Quadrupeds of North America*. Went to La. late in 1824, until 1826. Made trip up Missouri River in 1843. Celebrated as painter

of birds and animals; also did portraits. *Rep.* 486 of originals in N.Y.H.S.

BANVARD, John (1815–1891) *L.B.I.* Grew up in N.Y.C. At early age supported self by portrait painting in New Orleans. In 1840 spent several months making some 400 sketches of 1200 miles of Mississippi River below St. Louis; settled in Louisville to join them into a 1200-foot-long panorama, which was exhibited in U.S. and abroad. It is claimed the first chromo made in America was taken from one of his paintings in 1861. Settled in S. Dak. about 1880.

BEARD, Daniel (1850–1941) *B.* June 1, 1850, Cincinnati, Ohio, *D.* Jan. 11, 1941, N.Y.C. *P.* A.S.L. and under William Sartain and Carol Beckwith. *Illus.* Mark Twain's works, many articles for *Harper's, Scribner's, Cosmopolitan*, etc., including Western animals.

BEARD, James Carter (1837–1913) *B.* June 6, 1837, Cincinnati, Ohio. *D.* Nov. 15, 1913, N.Y.C. *S.M.* animals, landscapes, and figures. *Illus.* in Theodore Roosevelt's *The Wilderness Hunter, Hunting Trips of a Ranchman*, etc., and many magazine articles on big and small game, game birds, fishing, etc. *Exhib.* Nat. Acad., etc.

BEARD, James Henry (1814–1893) *B.* May 20, 1814, Buffalo, N.Y. *D.* Apr. 4, 1893, N.Y.C. Early part of life spent in Cincinnati, devoting art work to portrait painting (apparently S-T.) Moved to N.Y.C. in 1846; in later years most of work was animal subjects. One of organizers of Century Club, N.Y.C.

BEARD, William Holbrook (1825–1900) *B.* Apr. 13, 1825, Painesville, Ohio. *D.* Feb. 20, 1900, N.Y.C. *P.* early instruction by elder brother, James H. Began career as traveling portrait painter. Studio in Buffalo, N.Y., 1850. To Europe in 1857, studying and working in Düsseldorf, France, Italy. Settled in N.Y.C. in 1860. N.A., 1862. Traveling companion of Bayard Taylor on Western trip in 1866. *Illus.* for many magazines and books. *Rep.—The Bear's Temperance Question* in Chicago Art Inst.

BECKER, Otto (1854–1945) *B.* Jan. 28, 1854, Dresden, Germany. *D.* Nov. 12, 1945, Milwaukee, Wis. *P.* as young man in Royal Acad. of Arts, Dresden. To U.S., 1873, worked as lithographer and artist in Boston and St. Louis, moving to Milwaukee in 1880, where he lived until his death. Made and copied numerous Western pictures for lithographing by Milwaukee Lithographing & Engraving Co., including *Custer's Last Fight*, by Cassilly Adams.

BERNINGHAUS, Oscar E. (1874–1952) *B.* 1874, St. Louis, Mo. *D.* Apr. 27, 1952, Taos, N. Mex. *P.* St. Louis School of Fine Arts. Affiliated with Taos Students' Assoc. *Rep. Winter in the West*, in City Art Museum of St. Louis; two lunettes in Missouri State Capitol Bldg., Jefferson City, Mo.; and in several libraries and schools.

BIERSTADT, Albert (1830–1902) See Chapter 14.

BINGHAM, George Caleb (1811–1879) *B.* Mar. 20, 1811, Augusta County, Va. *D.* July 7, 1879, Kansas City, Mo. Taken to Missouri when eight years old. When nine met Chester Harding, which inspired him, and seven years later same artist gave him sufficient instruction to begin as portrait painter. In 1837 briefly attended Pa. Acad. In middle 1840s returned to Missouri and began series of local color paintings some of which were engraved or lithographed and widely distributed: 1845, *Fur Traders Descending the Missouri*; (original in Metropolitan Museum); 1847, *The Jolly Flatboatmen* (original in City Art Museum, St. Louis); 1850, *Raftsmen Playing Cards*; etc. To Europe, 1856, spent three years working in Düsseldorf and elsewhere.

BLAKELOCK, Ralph Albert (1847–1919) See Chapter 15.

BODMER, Karl (Carl) (1809–1893) See Chapter 6.

BOREIN, Edward (1873–1945) *B.* Oct. 21, 1873, San Leandro, Calif. *D.* May 19, 1945, Santa Barbara, Calif. *S-T.* At 17 became cow-

boy, drifting from one ranch to another in Calif. and Mexico; began sketching scenes of cowpunchers and cattle. In 1902 established studio in Oakland. Numerous sketching trips. In 1907 to N.Y.C.; studied etching at A.S.L. under Childe Hassam, Ernest Roth, etc. Returned to Calif. where he had a studio in Santa Barbara until his death.

BORGLUM, Solon H. (1868–1922) *B.* 1868, Ogden, Utah. *D.* Jan. 30, 1922, Stamford, Conn. *P.* Cincinnati Art Acad. under Louis T. Rebiaso and in Paris under Fremiet and Puech. A.N.A., 1911. *S.M.* sculpture. *Rep. Bucky O'Neil*, Prescott, Ariz.; *Border of the White Man's Land* and *Bulls Fighting*, Metropolitan Museum, N.Y.C.

BOYLE, Ferdinand Thomas Lee (1820–1906) *B.* 1820, England. *D.* 1906, U.S. Came to U.S. in childhood. *P.* Henry Inman. Settled in St. Louis in 1855; organizer of Western Acad. of Art. To N.Y.C. in 1866, where he became portrait painter of celebrities; for number of years professor at Brooklyn Inst. of Art. *Rep.* Union League Club, Brooklyn.

BRUSH, George de Forest (1855–1941) See Chapter 19.

BURBANK, Elbridge Ayer (1858–1949) *B.* 1858, Harvard, Ill. *D.* Mar. 22, 1949, San Francisco, Calif. *P.* Chicago Art Acad. and in Munich, Germany. *S.M.* Negro subjects until 1897, when he went to Fort Sill to paint portrait of Geronimo; afterward devoting most of effort to Indian portraits, covering more than 125 types and most areas of West. Painted many famous Indian chiefs. *Rep.* Field Museum and Newberry Library, Chicago; Smithsonian Inst., Wash., D.C.

CARY, William de la Montagne (1840–1922) *L.B.I. B.* 1840. *D.* 1922. In 1861 left N.Y.C. on trip West, which took him via St. Louis to Fort Union on Upper Missouri River, Fort Benton, across the Rocky Mts. to Walla Walla and by stage to San Francisco. Also made other trips into West for sketching. Studio in N.Y.C. Painted numerous Western subjects,

1861–1875. *Rep. A Crow Hunting Camp, Crossing the Plains in '49, Watching the Fire Canoe,* etc.

CATLIN, George (1796–1872) See Chapter 4.

COUSE, Eanger Irving (1866–1936) *B.* Sept. 3, 1866, Saginaw, Mich. *D.* Apr. 25, 1936, Taos, N. Mex. *P.* Nat. Acad.; also Ecôle des Beaux-Arts, Paris, under Bouguereau, Ferrier, and Robert-Fleury. Upon return to U.S. established studio in N.Y.C. Won 2d Hallgarten prize, Nat. Acad. exhib. 1900 and 1st Hallgarten prize 1902. Became deeply interested in Indians of Southwest and specialized in painting them. Had studio in Taos. N.A., 1911. *Rep.* Metropolitan Museum; Nat. Gal., Wash., D.C.; numerous other museums.

CRAIG, Charles (1846– ?) *L.B.I. B.* 1846, Morgan Co., Ohio. *P.* Pa. Acad. *S.M.* Indians, cowboys, Western landscapes. *Exhib.* Denver, 1883; Minneapolis Expos., 1886; St. Louis, 1889.

DALLIN, Cyrus (1861–1944) *B.* 1861, Springville, Utah, *D.* 1944. *S.M.* sculpture. To Europe in 1889, studied in Ecôle des Beaux-Arts and Julian Acad., under Chapu and Dampt. Worked with Rosa Bonheur during time Buffalo Bill and his show were in Paris. Made numerous statues of Indian subjects. *Rep. The Medicine Man*, Fairmount Park, Phila.; *Appeal to the Great Spirit*, in front of Boston Museum of Fine Arts; etc.

DARLEY, Felix Octavius Carr (F.O.C.) (1822–1888) See Chapter 13.

DAVIS, Theodore R. (1840–1894) *B.* 1840, Boston, Mass. *D.* Nov. 10, 1894, Asbury Park, N.J. Went West in 1865 or 1866 for *Harper's*, to Denver, Santa Fe, etc., writing and illus. the contemporary scene. In 1867 made 2600-mile trip by stage across Plains and spent some months with Gen. Custer on Indian campaigns, which was written and illus. for *Harper's Weekly* beginning Sept. 7, 1867; also *Harper's Monthly*, Feb., 1868, etc.

DEAS, Charles (1818–1867) See Chapter 9.

DELLENBAUGH, Frederick Samuel (1850–1935) B. Sept. 13, 1853, McConnelsville, Ohio. D. Jan. 29, 1935, N.Y.C. P. in Buffalo, also Munich and under Carolus-Duran at Julian Acad. in Paris. Artist on Major Powell's 2d Colorado River Exped., 1871–1873; also Harriman Exped. to Alaska and Siberia, 1899. Made numerous sketching trips through West; also author.

DEMING, Edwin Willard (1860–1942) B. Aug. 26, 1860, Ashland, Ohio. D. Oct. 15, 1942, N.Y.C. P. A.S.L. and under Lefebvre and Boulanger in Paris. Spent considerable time among several Indian tribes in West and illus. numerous magazine articles and books, mostly Indian and animal subjects. Also did sculpture. Rep. The Mourning Brave, Nat. Museum, Wash., D.C.; two bronzes in Metropolitan Museum, N.Y.C.

DIXON, (Lafayette) Maynard (1875– ?) L.B.I. 1875, Fresno, Calif. Began as newspaperman in San Francisco. Illus. numerous magazine articles and stories; also did murals; mostly of Western life and Indian scenes.

EASTMAN, Seth (1808–1875) See Chapter 5.

EATON, C. Harry (1850–1901) L.B.I. First exhib. at Nat. Acad.; Paris Expos. 1889; World's Fair, Chicago, 1893. Did Western landscapes, etc. Rep. The Three Tetons in Theodore Roosevelt's Hunting Trips of a Ranchman.

ELKINS, Henry Arthur (1847–1884) L.B.I. B. May 30, 1847, Vershire, Vt. D. 1884, Colo. S-T. Moved to Chicago in 1856. In 1866 made trip across Plains and to Calif. in emigrant train; also art work in Mont. Rep. Crown of the Continent, New Eldorado, etc.

FARNY, Henry F. (1847–1916) See Chapter 18.

FENN, Harry (1845–1911) B. Sept. 14, 1845, Richmond, Surrey, England. D. Apr. 21, 1911, Montclair, N.J. Began as wood engraver, then pencil work. S-T. Came to U.S. at 19 "to see Niagara Falls" and stayed six years. To Italy, 1860, to study art. Upon return to U.S. illus.

Whittier's Snow Bound, first illus. gift book produced in U.S. In 1870 made extensive trip through West to make sketches for illus. in Picturesque America. Then to Europe, returning in 1881. Also illus. in Picturesque California, ed. by John Muir, illus. with etchings, photogravures, wood engravings, etc., by eminent U.S. artists, J. Dewing Pub. Co., N.Y.C. and San Francisco, 1888. A founder of Amer. Water Color Soc. and Salmagundi Club, N.Y.C.

FOOTE, (Mrs.) Mary Hallock (1847–1938) B. Nov. 19, 1847, Melton-on-Hudson, N.Y. D. June 25, 1938, Boston, Mass. P. Cooper Inst. and School of Design for Women, N.Y.C.; and under William Rimmer and William J. Linton, wood engraver. Went West in 1876, to Colo., Mexico, and finally settled in Calif. Illus. for Scribner's and Century, 1878–1882; "Pictures of the Far West," Century, 1888–1889.

FORD, Henry Chapman (1828–1894) L.B.I. B. 1828, Livonia, N.Y. D. Feb. 27, 1894, Santa Barbara, Calif. P. in 1853 in Paris and Italy. In 1873, president of Chicago Acad. Made several sketching trips to West, in 1875 established studio in Santa Barbara, Calif.

FRENZENY, Paul (? – ?) L.B.I. Presumably of French descent. Illus. in Harper's Weekly in 1868 indicate he was previously in Mexico. In 1873 made trip across continent (with Jules Tavernier) for Harper's and sent back pictures of contemporary life. Spent about two years covering wide area of West; settled in San Francisco. Illus. for Harper's Weekly, 1873–1876; also books.

GAUL, Gilbert (1855–1919) B. Mar. 31, 1855, Jersey City, N.J. D. Dec. 21, 1919, N.Y.C. P. Nat. Acad., under J. G. Brown and at A.S.L. A.N.A., 1879. N.A., 1882. Made a study of all phases of military life as background for art. His Charging the Battery awarded medal at Paris Expos., 1889. Traveled extensively in West, visiting Army posts and Indian reservations. Illus. numerous articles in this field for Century, Harper's, Scribner's, etc.; also "Re-

port of Indians Taxed and . . . Not Taxed . . .",
11th Census: 1890; etc.; and canvases exhib.
throughout U.S.

GIFFORD, Robert Swain (1840–1905) *B.* Dec.
23, 1840, Naushon Island, Mass. *D.* Jan. 15,
1905, N.Y.C. *P.* Albert Van Beest, marine
painter, New Bedford, Mass. Moved to Boston
in 1864 and exhib. at Nat. Acad. same year.
Established studio in N.Y.C., 1866. A.N.A.,
1867. In 1869 began travels through West for
sketching and painting, mostly landscapes.
N.A., 1878. *Illus.* in Roosevelt's *Hunting Trips
of a Ranchman.*

GIFFORD, Sanford Robinson (1823–1880) *B.*
July 10, 1823, Greenfield, N.Y. *D.* Aug. 29,
1880, N.Y.C. *P.* Nat. Acad., under R. Smith;
also in Paris and Rome. Traveled considerably
in West and Rocky Mts. Studio in N.Y.C.
A.N.A., 1851. N.A., 1854. *Rep.* Metropolitan
Museum, N.Y.C.; Corcoran Gal., Wash., D.C.;
etc.

GOOKINS, J. F. (1840–1904) *L.B.I. B.* 1840,
Terre Haute, Ind. *D.* May 23, 1904. *P.* in Italy
and France. Had studio in Chicago. Made
trip across Plains in 1866. *See Harper's
Weekly,* Oct. 13, 1866.

GRAHAM, Charles (1852–1911) *B.* 1852,
Rock Island, Ill. *D.* Aug. 9, 1911, N.Y.C.
Early experience as surveyor on Northern Pa-
cific Ry. in early 1870s. About 1876 became
member of art staff of *Harper's Weekly,* for
which he did numerous illus., later for *Cen-
tury* and other magazines. Did some serious
painting in later life. Apparently *S–T.*

GRISET, Ernest Henry (1844–1907) *L.B.I. B.*
1844, France. *D.* March 22, 1907. Lived in
England and traveled through our West in
early days. Thirty of his water colors of West-
ern Indian life, etc., in Smithsonian Inst.,
Wash., D.C.; others in Victoria and Albert
Museum, England. *Illus.* for *The Plains of the
Great West,* by Col. R. I. Dodge, 1877.

GROLL, Albert Lorey (1866– ?) *L.B.I. B.*
1866 or 1868, N.Y.C. Studied in London and
Munich. Had studio in N.Y.C. N.A., 1910.

Rep. Corcoran Gal., Metropolitan Museum,
N.Y.C., Boston Museum of Fine Arts. Did
some fine Plains scenes.

HANSEN, H. W. (1854–1924) *B.* June 22,
1854, Dithmarschen, Germany. *D.* Apr. 12,
1924, Oakland, Calif. *P.* in Hamburg, Ger-
many, and in 1876 in London. Came to U.S.
in 1877 and studied at Chicago Art Inst. Went
to Calif. in 1882 and settled in San Francisco.
Made several sketching trips into various parts
of Far West and West. *Exhib.* in San Fran-
cisco, 1901, where his *The Pony Express*
brought considerable attention. Did horses
particularly well and his Western canvases
popular among private buyers in early 1900s.
His work has been favorably compared with
Remington's. Some of his paintings made into
art prints.

HAYES, William Jacob (1830–1875) *B.* Aug.
8, 1830, Catskill, N.Y. *D.* Mar. 13, 1875, Mill-
brook, N.J. *P.* Nat. Acad.; John Rubens Smith;
and Julian Acad., Paris. *Exhib.* at Nat. Acad.
and Pa. Acad. In 1860 made trip up Missouri
River as far as Fort Union; made series of
drawings of various forts along the river
(Clark, Randall, Stewart, Union, etc.), as well
as Indians, game, etc. *Rep. Buffalo Hunt* and
The Bull at Bay, canvases in The American
Museum of Natural History, N.Y.C. *The Herd
on the Move* was made into colored litho-
graph in 1863. Also made paintings of Eastern
game animals.

HEMING, Arthur (Henry Howard) (1870–
1940) *B.* Jan. 17, 1870, Paris, Ont., Canada.
D. Oct. 30, 1940, Hamilton, Ont. Attended art
school, 1887–1890; illus. in Canadian publica-
tions till 1899; A.S.L., under Frank Brang-
wyn; also at Royal Academy, London, 1904.
Traveled extensively through central and
northern Canada at various seasons of year
and made special study of Canadian wild life.
His art has distinctive style. Artist and author.
*Illus. Mooswa, Across the sub-Arctics of Can-
ada,* etc.; numerous magazine articles. *Rep.*
Canadian Nat. Gal. and Royal Ontario Mu-
seum.

HILL, Thomas (1829–1908) *B.* Sept. 11, 1829, Birmingham, England. *D.* June 30, 1908, Raymond, Calif. Came to U.S. in 1840 and settled in Taunton, Mass.; later in Philadelphia where he studied at Pa. Acad. In 1853 was awarded 1st medal of Maryland Inst., Baltimore. In 1861 went to Calif. In 1865 awarded 1st Prize at San Francisco Art Union exhib. In 1866–1867 studied under Paul Meyerheim in Paris. Painted notable landscapes of Yellowstone and Grand canyons, Donner Lake, the Sierras, etc. *Rep.* in *Picturesque California* (1888). His painting *The Last Spike* (8 ft. x 11 ft.) commemorating completion of first transcontinental railroad (May 10, 1869) at Promontory Point, Utah, hangs in Calif. State Capitol Bldg., Sacramento.

HITTELL, Charles J. (1861– ?) *L.B.I. B.* 1861, San Francisco, Calif. *P.* San Francisco School of Design, 1881–1883; Royal Acad. of Fine Arts, Munich, Germany, 1884–1888; Julian Acad., Paris, 1892–1893. Did figures and landscapes of our West. *Rep.* The American Museum of Natural History, N.Y.C.; Zoological Museum, Berkeley, Calif.

HORSFALL, R(obert) Bruce (1868–) *B.* Oct. 21, 1868, Clinton, Iowa. *P.* Cincinnati Art Acad., 1886–1889; in Munich and Paris on scholarship, 1889–1893. First exhib. at Chicago, 1886; Chicago Expos., 1893; afterward frequently at various cities. *S.M.* animals, birds, natural hist. *Illus.* for Amer. Mus. of Nat. Hist., N.Y.C., 1898–1901; *Century* and *St. Nicholas*, 1899–1921; *Nature Magazine*; *Land Mammals of Western Hemisphere*, 1912–1913; *Birds of the Rockies*; *Birds of California*; etc.; also backgrounds for museum habitat groups.

HUDSON, Grace (1865– ?) *L.B.I. B.* Feb. 21, 1865, Potter Valley, Calif. *P.* Mark Hopkins Inst., San Francisco. Spent considerable time among Poma Indians in Calif. and made specialty of painting those natives. *Exhib.* Carnegie Inst., Pittsburgh, and in San Fran-

cisco, Denver, Cincinnati, Paris, etc., receiving number of medals and awards.

INNESS, George, Jr. (1854–1926) *B.* 1854, Paris, France. *D.* July 27, 1926, Cragsmoor, N.Y. *P.* of his father, George Inness, sometimes referred to as "the greatest American landscape painter." Signed his pictures "Inness, Jr." Shared studio with father in Paris, Boston, and N.Y.C. until 1880; afterward had own studio in Montclair, N.J., and Paris. A.N.A., 1893. N.A., 1899. *Illus.* number of articles on Western big game hunting for *Scribner's* and *Century*, 1881–1885. *Rep.* Metropolitan Museum, N.Y.C., etc.

JACKSON, William Henry (1843–1942) *B.* Apr. 4, 1843, Keesville, N.Y. *D.* 1942. Best known for early photographs of the West, but also did numerous sketches and paintings. Went West in 1866, crossing Plains with wagon train and reaching Los Angeles Jan. 31, 1867. Was with Thomas Moran in the Yellowstone region in 1871; subsequently made pictures in most sections of West. See *Picture Maker of the Old West*, by Clarence S. Jackson (his son), 1947.

JOHNSON, Frank Tenney (1874–1939) *B.* June 26, 1874, Big Grove, Iowa. *D.* Jan. 1, 1939. *P.* Lorenz, Heinie, and Henri, A.S.L., N. Y. School of Art. Studio in N.Y.C. and later Calif. Dir. Biltmore Salon, Los Angeles. Awarded Shaw prize, Salmagundi Club, N.Y.C., 1923; Edgar B. Davis prize, San Antonio, 1929; etc. Best known for moonlight scenes of Western cowboys. *Rep.* in Nat. Gal., Wash., D.C.; Fort Worth Mus. Art; Nat. Arts Club, N.Y.C.; Royal Palace, Copenhagen, Denmark; Dunedin Mus., New Zealand; etc. A.N.A., 1929; N.A., 1937.

JOUILLIN, Amedee (1862–1917) *B.* June 13, 1862, San Francisco, Calif. *D.* 1917, San Francisco, Calif. *P.* in San Francisco, later in Paris at Julian Acad., under Bouguereau and Robert-Fleury. Returned to San Francisco where maintained studio until his death. *Exhib.* Nat. Acad., 1901; gold and silver medals

at St. Louis Expos., 1904. Specialized in paintings of Indians.

KANE, Paul (1810-1871) See Chapter 10.

KEITH, William (1839–1911) *B.* Nov. 21, 1839, Aberdeenshire, Scotland. *D.* Apr. 13, 1911, Berkeley, Calif. To N.Y.C., 1850, served apprenticeship as engraver, working at this trade until 1859, when he went to Calif. and became landscape and portrait painter. In 1869 to Düsseldorf for study. Returned to Calif., 1871. For a time in 1880s resided in New Orleans. In 1893 went back to Europe and studied in Munich and Spain. He has been called California's "most representative" painter—best known for his landscapes. See *Picturesque California.*

KELLER, Arthur I. (1866–1924) *B.* July 4, 1866, N.Y.C. *D.* Dec. 1, 1924, Riverdale, N.Y. *P.* Nat. Acad., under Wilmarth and Ward; and in Munich Acad., Germany, under L. von Loefftz. *Exhib.* N.Y.C., Phila., Paris, Munich, etc. Did historical subjects and illus. for Owen Wister's *The Virginian*; Bret Harte stories; editions of Longfellow, Hawthorne, Stockton, etc.; also in *Picturesque California.*

KEMEYS, Edward (1843–1907) *B.* Jan. 31, 1843, Savannah, Ga. *D.* 1907, Wash., D.C. Studied in N.Y.C. and later in Paris. *S.M.* sculpture of American animals and Indians. *Exhib. Fight between Buffalo and Wolves* at Paris Salon, 1878; other sculpture at exhib. in London, N.Y.C., Phila., St. Louis, etc. *Rep.* colossal head of buffalo for Pacific Ry. station, St. Louis; some 50 small bronzes in Nat. Gal., Wash., D.C.

KENSETT, John Frederick (1818–1872) *B.* 1818, Cheshire, Conn. *D.* 1872, N.Y.C. In 1840 to Europe to study, spending about seven years in England and in Italy. Returned to U.S. in 1847 or 1848, establishing studio in N.Y.C. N.A., 1849. In 1856 made trip up Missouri. In 1870 trip through West with Sanford R. Gifford and Worthington Whittredge. Best known as painter of Hudson River School. *Rep.* (Western) in Century Club, N.Y.C.; and in Metropolitan Museum.

KURZ, (Rudolph) Friedrich (Friederich) (1818–1871) See Chapter 12.

LEIGH, William Robinson (1866–) *B.* Sept. 23, 1866, Berkeley Co., W. Va. *P.* Maryland Inst. of Art; Balt.; Royal Acad. in Munich, under Geyses, Loefftz, and Lindinschmed. *Exhib.* Nat. Acad.; Chicago World's Fair, 1893; St. Louis World's Fair, 1904; and each year at Grand Central Gal., N.Y.C. Made several trips into West to sketch and paint Indians and landscapes. Indians of Southwest a specialty, although did numerous canvases of cowboys in dramatic action. Studio in N.Y.C. for many years.

LEUTZE, Emanuel (1816–1868) *B.* May 24, 1816, Emingen, Württemberg, Germany. *D.* July 18, 1868, Wash., D.C. Parents came to U.S. and settled in Philadelphia when he was a child. Early instruction in portrait painting by John A. Smith. In 1841 to Düsseldorf and studied under Lessing; to Italy, 1842. Studio in Düsseldorf, 1845, executing a number of important paintings and becoming teacher of many outstanding American artists. In 1850 awarded gold medal in Berlin for *Washington Crossing the Delaware* (brought to U.S., 1852, and was exhib. in Nat. Capitol, Wash., D.C.). Shortly afterward commissioned by Congress to paint *Westward the Course of Empire Takes Its Way*, for House of Rep. wing of Capitol. For this made sketching trip to Rocky Mts. In 1863 established permanent studio in Wash., D.C.

LEWIS, Henry (1819–1904) *L.B.I. B.* Jan. 12, 1819, Newport, England. *D.* Sept. 16, 1904, Düsseldorf, Germany. At close of Black Hawk War, 1837, made sketching trip up Mississippi River; from these sketches made gigantic panorama, exhib. in various cities from about 1849. Volume of 78 of his pictures reproduced in color plates at Düsseldorf in *Das Illustrirte Mississippithal* (1857).

LEWIS, James Otto (? – ?) See Chapter 3.

LUNGREN, Ferdinand Harvey (1859– ?) *L.B.I. B.* Nov. 13, 1859, Md. (also reported as

1857 in Toledo, Ohio.) *S.M.* Indian subjects; landscapes. Presumably spent considerable time among several Indian tribes. *Illus.* for *Harper's, Century, St. Nicholas. Rep. The Snake Dance, Night in the Desert, A Ford on the Rio Grande,* etc.

McARDLE, H. A. (1836–1908) *L.B.I.* Irish descent; studied art in Balt.; served in Confederate Army during Civil War, afterward settled in Texas. *S.M.* historical painting. *Rep. Dawn at the Alamo* and *Battle of San Jacinto* done on commission by state of Texas for Senate Chamber, Austin.

MacNEIL, Hermon Atkins (1866–1947) *B.* Feb. 27, 1866, Everett, Mass. *D.* Oct. 2, 1947, College Point, N.Y. *S.M.* sculpture of Indian subjects, murals, etc. *P.* at Mass. State Normal Art School, Boston; Julian Acad. and Ecôle des Beaux-Arts, Paris. *Exhib.* Chicago Art Inst.; Pa. Acad.; Belli Arti, Rome; Paris Salon; etc.; many high awards. N.A., 1906. *Rep. The Sun Vow,* Metropolitan Museum; etc.; *Indian Group,* City Park, Portland, Ore.; etc.

MATHEWS, Alfred E. (1831–1874) *L.B.I. B.* June 24, 1831, England. *D.* Oct. 30, 1874, Colo. Brought to U.S. as child by parents who settled in Rochester, Ohio. Did Civil War pictures, some lithographed. Went West shortly after War. *Rep. Pencil Sketches of Colorado* (1866); *Pencil Sketches of Montana* (1868); *Gems of Rocky Mountain Scenery* (1869).

MAURER, Louis (1832–1932) *B.* Feb. 21, 1832, Biebrich, Germany. *D.* July 19, 1932, N.Y.C. To U.S., 1850; in 1853 began long career as artist and lithographer with Currier and Ives. Specialized in sporting and racing scenes. Apparently *S-T.* In 1884, at 52, began serious study of oil painting under William Chase. In 1885 was guest of Buffalo Bill Western trip; later did considerable number of pictures of Western animals and Rocky Mts. In 1931, on 99th birthday, had his first one-man show of paintings, N.Y.C.

MAYER, Frank Blackwell (1827–1899) *B.* Dec. 27, 1827, Balt., Md. *D.* July 28, 1899,

Annapolis, Md. *P.* Alfred Jacob Miller, Baltimore. In 1851 to Minnesota to sketch Indians; attended treaty at Traverse des Sioux. To Paris in 1862 and studied under Charles Gleyre and Gustave Brion, returning to Baltimore in late 1870. See *With Pen and Pencil on the Frontier in 1851,* by Bertha L. Heilbron, Minnesota Hist. Soc., 1932.

MILLER, Alfred Jacob (1810–1874) See Chapter 7.

MÖLLHAUSEN, Heinrich Baldouin (1825–1905) See Chapter 13.

MORAN, Peter (1842–1914) *B.* Mar. 4, 1842, Bolton, England. *D.* Nov. 13, 1914. Brought to U.S. when three years old. Began career as apprentice lithographer. *S-T.* At 16 became pupil of his brothers Edward and Thomas. *S.M.* landscape and marine subjects. In 1863 to London to study work of Landseer. In 1879 accompanied Thomas Moran to Rocky Mts., and made other trips to West. Rep. plates in ". . . Indians Taxed and . . . Not Taxed . . . ," *11th Census: 1890.* (See Chapter 16.)

MORAN, Thomas (1837–1926) See Chapter 16.

MULVANEY, John (1844–1906) See Chapter 18.

NARJOT (DE FRANCEVILLE), Ernest (Etienne) (1826–1898) See Chapter 13.

NESEMAN, Eno (1861– ?) *L.B.I. B.* 1861, Maysville, Calif. *P.* Alfred Hart. *Rep. The First Discovery of Gold in California,* in De Young Memorial Museum, San Francisco, Calif.

PARRISH, Maxfield (1870–) *B.* July 25, 1870, Phila., Pa. *P.* Pa. Acad., under Howard Pyle. A.N.A., 1905. N.A., 1906. Did some landscapes, etc., of Southwest, in his distinctive style: *The Grand Canyon of the Colorado; Pueblo Dwellings;* etc., reproduced in *Century Magazine,* June, Nov., 1902.

PAXON, Edgar Samuel (1852– ?) *L.B.I. B.* 1852, East Hamburg, N.Y. *Rep. Custer's Last Fight,* exhib. in numerous cities; 6 Western

murals in Montana State Capitol Bldg.; 8 in Missoula County Court House.

PHILLIPS, Bert (1868– ?) *L.B.I. B.* July 15, 1868, Hudson, N.Y. *P.* A.S.L. and Nat. Acad., N.Y.; in Paris under Jean Paul Laurens and Benj. Constant. *Exhib.* Nat. Acad.; Pa. Acad., etc. *Rep.* murals in Court House, Des Moines, Iowa.

PIERCY, Frederick (? – ?) No biog. information available. In 1850 series of pictures of overland route from St. Louis to Montana and over South Pass to Great Salt Lake.

POORE, Henry Rankin (1859– ?) *L.B.I. B.* Mar. 21, 1859, Newark, N.J. *P.* at Nat Acad., at Pa. Acad., under Peter Moran; and in Paris under Bouguereau and Lumenas. A.N.A., 1888. Did Western landscapes and animal subjects in oil and considerable illustrating.

POWELL, Lucien Whiting (1846– ?) *L.B.I. B.* Dec. 13, 1846, in Va. *P.* Pa. Acad.; West London School of Art, under Fitz; and in Paris under Leon Bonnet. *Exhib.* Centen. Expos., Phila., 1876; N.Y.; London; etc. *Rep. The Afterglow, Grand Canyon, Arizona,* in Corcoran Gal., Wash., D.C.; *Grand Canyon of the Yellowstone* and *Colorado Canyon,* in Henderson Collection, Wash., D.C. (1906).

PROCTOR, Alexander Phimister (1862–1950) *B.* Sept. 27, 1862, Ontario, Canada. *D.* Sept. 4, 1950, Palo Alto, Calif. *P.* in Paris, under Puech and Ingalbert. *S.M.* sculpture, also some painting. A.N.A., 1901; N.A., 1904. *Rep.* statuary in public parks in N.Y.C., Denver, Pittsburgh, etc.; also *Indian Warrior* in Corcoran Gal., Wash., D.C.; Metropolitan Museum, N.Y.C.; St. Louis Art Gal.; etc.

RANNEY, William (1813–1857) *L.B.I. B.* 1813, Middleton, Conn. *D.* 1857, N.J. A.N.A., 1850. Did considerable number of Western subjects. *Rep. Duck Shooting,* in Corcoran Gal., Wash., D.C. (See Chapter 13.)

REAUGH, Frank (1860– ?) *B.* Dec. 29, 1860, Morgan Co., Ill. *P.* St. Louis School of Fine Arts; Julian Acad., Paris; and in galleries of Belgium and Holland. *S.M.* Texas land-

scapes with cattle, in oils and pastels. *Exhib.* Chicago World's Fair; St. Louis Expos.; Pa. Acad.; etc. *Rep. Driving the Herd,* in Dallas Public Library.

REMINGTON, Frederic (1861–1909) See Chapter 22.

RINDISBACHER, Peter (1806–1834) See Chapter 3.

RIX, Julian (Walbridge) (1851–1903) *L.B.I. B.* 1851, San Francisco, Calif. *D.* Nov. 19, 1903, N.Y.C. Studio in N.Y.C. In 1893 *Quarterly Illustrator* editor's note: "The rugged scenery of California engaged the brush of Mr. Rix for many years and his early reputation was founded on his stirring delineations of wild Western landscapes." *Rep.* Corcoran Gal., Wash., D.C.; *Picturesque California.*

ROGERS, William Allen (1854–1931) *B.* 1854, Springfield, Ohio. *D.* Oct. 20, 1931, N.Y.C. *S-T.* Began as cartoonist and joined staff of *Harper's* as engraver and artist. In 1878 sketching trip to Dakotas and Canada; in 1879 to Colorado and New Mexico; in 1898 to Oregon. *Illus.* in *Harper's Weekly* 1879–1900. See *A World Worth While,* artist's autobiography, 1922.

RUNGIUS, Carl (1869–) *B.* Aug. 18, 1869, near Berlin, Germany. Studios in N.Y.C. and Banff, Alberta. *P.* Berlin Art School; School of Applied Art; and Acad. of Fine Arts, under Paul Meyerheim—all in Berlin, Germany. To U.S., 1894. In 1895 made sketching trip to Wyoming and Yellowstone Park, and painting American big game animals became his specialty. Traveled extensively, sketching and painting, from Arizona to Arctic. N.A., 1920. Fine landscape backgrounds add to his outstanding animal portrayals. See *Carl Rungius —Big Game Painter,* by William J. Scholdach, 1945.

RUSSELL, Charles Marion (1864–1926) See Chapter 20.

SANDHAM, Henry (1842–1912) *L.B.I. B.* 1842, Montreal, Canada. *D.* Jan. 6, 1912, Lon-

don, England. Worked in Canada until about 1880, when he went to England, later coming to U.S. and establishing a studio in Boston. Specialized in historical painting; and did considerable illus. of Western subjects for *Harper's*, etc.; also Edgar Allan Poe's poem *Lenore* (1885); etc.

SCHREYVOGEL, Charles (1861–1912) See Chapter 20.

SCOTT, Julian (1846–1901) *L.B.I. B.* Feb. 15, 1846, Johnson, Vt. *D.* July 4, 1901, Plainfield, N.J. Served in Civil War and became colonel —first to receive Medal of Honor for bravery on battlefield. *P.* Nat. Acad. and under Leutze. Did paintings and drawings for number of plates in ". . . Indians Taxed and . . . Not Taxed . . . ," *11th Census: 1890,* which are signed and dated at various locations in West and Far West.

SETON, Ernest Thompson (1860–1946) *B.* Aug. 14, 1860, South Shields, England. *D.* Oct. 23, 1946, Santa Fe, N. Mex. *P.* Toronto Collegiate Inst., Toronto, Canada; Royal Acad., London; and in Paris under Bouguereau and Gerome. Lived in backwoods of Canada, 1866–1870; traveled on our Western Plains, 1882–1886; official naturalist to Manitoba government, 1886. Wrote and illus. *Mammals of Manitoba* (1886) and *Birds of Manitoba* (1891). Has long list of books, principally on animals, which he authored and illus. In later life founded College of Indian Wisdom, and Seton Inst., on 2500-acre tract of wild land near Santa Fe, N. Mex., dedicated to conservation of Indian lore, religion, and crafts.

SEYMOUR, Samuel (1797–1882) See Chapter 3.

SHARP, Joseph Henry (1859– ?) *B.* Sept. 27, 1859, Bridgeport, Ohio. *P.* Cincinnati Art Acad.; Royal Acad. of Antwerp, under Charles Veriat; Royal Acad. of Munich, under Carl Marr; in Paris under Jean Paul Laurens and Benj. Constant; and in Italy and Spain with Duveneck. Instructor at Cincinnati Art Museum, 1892–1902; resigned to study and paint

Indian subjects. *Illus.* Indian subjects for *Harper's*, etc. Had studio on Crow Indian Agency, Mont., and at Taos, N. Mex. *Rep.* 11 portraits of famous Indians in Smithsonian Inst.; 50 Indian subjects in Univ. of Calif.; also Cincinnati Art Museum; etc.

SHAW, Stephen William (1817–1900) *L.B.I. B.* Dec. 15, 1817, Windsor, Vt. *D.* Feb. 12, 1900, San Francisco, Calif. *S-T.* One of pioneer painters of Pacific Coast. Principally a portrait painter.

SHIRLAW, Walter (1838–1909) *B.* Aug. 6, 1838, Paisley, Scotland. *D.* Dec. 26, 1909, Madrid, Spain. Came to U.S. in 1852 and became banknote engraver. *S-T.* In 1861 exhib. oil painting at Nat. Acad. *P.* in Munich, Germany, 1870–1877. First president of Soc. of Amer. Artists, 1875. Did numerous genre subjects and illus. Evidently had experience in West. Plates in ". . . Indians Taxed and . . . Not Taxed . . .", *11th Census: 1890.*

SMEDLEY, William Thomas (1858– ?) *L.B.I. B.* Mar. 26, 1858, Chester Co., Pa. *P.* Pa. Acad.; and in 1878–1879 in Paris under Jean Paul Laurens. Established studio in N.Y.C., 1880. In 1882 traveled through west and northwest Canada making sketches to illus. *Picturesque Canada. Illus.* for *Harper's*, etc. N.A., 1905.

SMITH, De Cost (1864–1939) No biog. information available. *Illus.* for *Outing Magazine*, Oct., 1893, May, 1894, from personal experiences in Dakotas, Montana, etc. An accomplished artist.

SOHON, Gustavus (1825–1903) *B.* Dec. 10, 1825, Tilsit, Germany. *D.* Sept. 3, 1903, Wash., D.C. To U.S. when 17, settled in Brooklyn, N.Y. Enlisted in U.S. Army in 1852; and stationed at Fort Dalles on Columbia River, Oregon Terr. Assigned to Gov. Stevens's exploration of railroad route through Rocky Mts., 1853–1855. Made many drawings of Indians. Guide and interpreter on building wagon route, Fort Benton to Walla Walla, and led first wagon party over same, Aug. 7–

Oct. 4, 1860. *Rep.* 45 original drawings in Smithsonian. See *Gustavus Sohn's Portraits of Flathead and Pend D'Oreille Indians, 1854–*, by John C. Ewers. Smithsonian Misc. Coll. (1948).

STANLEY, John Mix (1814–1872) See Chapter 8.

SULLY, Alfred (1821–1879) *B.* May 20, 1821. *D.* 1879. Son of Thomas Sully. Entered West Point at 16 in 1837, graduated in 1841. Sent to Rio Grande in 1846 and served in Mexican War. In Nov., 1848, sailed from N.Y.C. and arrived in Monterey, Calif., in Mar. 1849. In 1851 served in Indian Campaigns in Oregon. Helped build Fort Ridgley on Minnesota River. Became major general, 1865. Painted principally in water colors; his views of Western forts are of historic as well as artistic interest.

SWINNERTON, James E. (1875–) *B.* Nov. 13, 1875, Eureka, Calif. Raised by grandfather, who had been in the gold rush. *P.* Calif. Art School. Became newspaper cartoonist. Transferred to N.Y.C. and produced comic strips. Ill health sent him back to Calif. in 1903; became landscape painter, with particular interest in desert scenes of Southwest. See *A Gallery of Western Paintings*, by Raymond Carlson, McGraw-Hill, 1951.

TAFT, Lorado (1860–1938) *B.* Apr. 29, 1860, Elmwood, Ill. *D.* Oct. 30, 1936, Chicago, Ill. *P.* Ecôle des Beaux-Arts, Paris, 1880–1883. *S.M.* sculpture. Instr., lecturer at Art Inst. of Chicago, 1886–1929; professor, lecturer, Univ. of Chicago, 1909, and Univ. of Ill., 1919–. Author, *The History of American Sculpture*, 1903. A.N.A., 1909; N.A., 1911. Dir., Federation of Amer. Artists, 1914–1917. *Rep. Blackhawk*, heroic Indian figure, Eagle's Nest, Ill.; Columbus Memorial Fountain, Wash., D.C.; *The Pioneers*, Elmwood, Ill. Recipient of numerous awards.

TAIT, Arthur Fitzwilliam (1819–1905) *B.* Aug. 5, 1819, near Liverpool, England. *D.* Apr. 28, 1905, Yonkers, N.Y. A.N.A., 1853;

N.A., 1858. *Rep.* Corcoran Gal., Wash., D.C., etc. (See Chapter 13.)

TAVERNER, Jules (1844–1889) *L.B.I. B.* 1844, Paris, France. *D.* May 18, 1889, Honolulu. *P.* in Paris under Felix Barries. Some of his Western subjects lithographed by Currier & Ives.

WANDERSFORDE, Ivan Buckingham (1817–1872) *L.B.I.* Apparently went to Calif. from England in gold rush days. Did landscapes in the Hudson River School manner. In 1872 became first president of the San Francisco Art Assoc.

WARRE, Capt. (Sir) Henry James (? – ?) No biog. information available. In 1845 journeyed from Montreal to Fort Garry and across Rocky Mts. to mouth of Columbia River. Twenty folio prints in *Sketches in North America and Oregon Territory*, by Capt. H. Warre, London (1894).

WHITTREDGE, Worthington (1820–1910) *B.* 1820, Springfield, Ohio. *D.* Feb. 25, 1910, Summit, N.J. *P.* Cincinnati Art School; in 1849 went to Europe and studied in London, Paris, Antwerp, and under Andreas Achenbach in Düsseldorf. Established studio in N.Y.C. N.A., 1862. Went West in 1866 and made other subsequent trips to Rocky Mts. Best known as painter of Hudson River School. *Rep. Crossing the Ford, Platte River, Colorado* (40 in. x 68 in.), signed and dated 1868–1870, in Century Club, N.Y.C.; *On the Plains—1866; The Emigrant Train*; etc.

WIMAR, Charles (Karl Ferdinand) (1828–1862) See Chapter 11.

ZOGBAUM, Rufus Fairchild (1849–1925) *B.* 1849, Charleston, S.C. *D.* Oct. 22, 1925, N.Y.C. *P.* A.S.L., 1878–1879; and in Paris under Leon Bonnet, 1880–1881. Did number of military subjects in Paris, 1883; in England, 1882–1883; in Germany, 1883; and first pictures of U.S. West in 1885. *Illus.* for *Harper's Weekly*, after 1885; Gen. Merritt's *U.S. Army and Indian Campaigns*; Capt. King's *West Point Sketches*; also murals for State Capitol, St. Paul, Minn.; Williams College; Naval War College; etc.

Adios.

Index

A CATALOG OF SELECTED
DOVER BOOKS
IN ALL FIELDS OF INTEREST

A CATALOG OF SELECTED DOVER
BOOKS IN ALL FIELDS OF INTEREST

DRAWINGS OF REMBRANDT, edited by Seymour Slive. Updated Lippmann, Hofstede de Groot edition, with definitive scholarly apparatus. All portraits, biblical sketches, landscapes, nudes. Oriental figures, classical studies, together with selection of work by followers. 550 illustrations. Total of 630pp. 9⅜ × 12¼.
21485-0, 21486-9 Pa., Two-vol. set $25.00

GHOST AND HORROR STORIES OF AMBROSE BIERCE, Ambrose Bierce. 24 tales vividly imagined, strangely prophetic, and decades ahead of their time in technical skill: "The Damned Thing," "An Inhabitant of Carcosa," "The Eyes of the Panther," "Moxon's Master," and 20 more. 199pp. 5⅜ × 8½. 20767-6 Pa. $3.95

ETHICAL WRITINGS OF MAIMONIDES, Maimonides. Most significant ethical works of great medieval sage, newly translated for utmost precision, readability. Laws Concerning Character Traits, Eight Chapters, more. 192pp. 5⅜ × 8½.
24522-5 Pa. $4.50

THE EXPLORATION OF THE COLORADO RIVER AND ITS CANYONS, J. W. Powell. Full text of Powell's 1,000-mile expedition down the fabled Colorado in 1869. Superb account of terrain, geology, vegetation, Indians, famine, mutiny, treacherous rapids, mighty canyons, during exploration of last unknown part of continental U.S. 400pp. 5⅜ × 8½. 20094-9 Pa. $6.95

HISTORY OF PHILOSOPHY, Julián Marías. Clearest one-volume history on the market. Every major philosopher and dozens of others, to Existentialism and later. 505pp. 5⅜ × 8½. 21739-6 Pa. $8.50

ALL ABOUT LIGHTNING, Martin A. Uman. Highly readable non-technical survey of nature and causes of lightning, thunderstorms, ball lightning, St. Elmo's Fire, much more. Illustrated. 192pp. 5⅜ × 8½. 25237-X Pa. $5.95

SAILING ALONE AROUND THE WORLD, Captain Joshua Slocum. First man to sail around the world, alone, in small boat. One of great feats of seamanship told in delightful manner. 67 illustrations. 294pp. 5⅜ × 8½. 20326-3 Pa. $4.95

LETTERS AND NOTES ON THE MANNERS, CUSTOMS AND CONDI-TIONS OF THE NORTH AMERICAN INDIANS, George Catlin. Classic account of life among Plains Indians: ceremonies, hunt, warfare, etc. 312 plates. 572pp. of text. 6⅛ × 9¼. 22118-0, 22119-9 Pa. Two-vol. set $15.90

ALASKA: The Harriman Expedition, 1899, John Burroughs, John Muir, et al. Informative, engrossing accounts of two-month, 9,000-mile expedition. Native peoples, wildlife, forests, geography, salmon industry, glaciers, more. Profusely illustrated. 240 black-and-white line drawings. 124 black-and-white photographs. 3 maps. Index. 576pp. 5⅜ × 8½. 25109-8 Pa. $11.95

THE BLUE FAIRY BOOK, Andrew Lang. The first, most famous collection, with many familiar tales: Little Red Riding Hood, Aladdin and the Wonderful Lamp, Puss in Boots, Sleeping Beauty, Hansel and Gretel, Rumpelstiltskin; 37 in all. 138 illustrations. 390pp. 5⅜ × 8½. 21437-0 Pa. $5.95

THE STORY OF THE CHAMPIONS OF THE ROUND TABLE, Howard Pyle. Sir Launcelot, Sir Tristram and Sir Percival in spirited adventures of love and triumph retold in Pyle's inimitable style. 50 drawings, 31 full-page. xviii + 329pp. 6½ × 9¼. 21883-X Pa. $6.95

AUDUBON AND HIS JOURNALS, Maria Audubon. Unmatched two-volume portrait of the great artist, naturalist and author contains his journals, an excellent biography by his granddaughter, expert annotations by the noted ornithologist, Dr. Elliott Coues, and 37 superb illustrations. Total of 1,200pp. 5⅜ × 8.
Vol. I 25143-8 Pa. $8.95
Vol. II 25144-6 Pa. $8.95

GREAT DINOSAUR HUNTERS AND THEIR DISCOVERIES, Edwin H. Colbert. Fascinating, lavishly illustrated chronicle of dinosaur research, 1820's to 1960. Achievements of Cope, Marsh, Brown, Buckland, Mantell, Huxley, many others. 384pp. 5¼ × 8¼. 24701-5 Pa. $6.95

THE TASTEMAKERS, Russell Lynes. Informal, illustrated social history of American taste 1850's–1950's. First popularized categories Highbrow, Lowbrow, Middlebrow. 129 illustrations. New (1979) afterword. 384pp. 6 × 9.
23993-4 Pa. $6.95

DOUBLE CROSS PURPOSES, Ronald A. Knox. A treasure hunt in the Scottish Highlands, an old map, unidentified corpse, surprise discoveries keep reader guessing in this cleverly intricate tale of financial skullduggery. 2 black-and-white maps. 320pp. 5⅜ × 8½. (Available in U.S. only) 25032-6 Pa. $5.95

AUTHENTIC VICTORIAN DECORATION AND ORNAMENTATION IN FULL COLOR: 46 Plates from "Studies in Design," Christopher Dresser. Superb full-color lithographs reproduced from rare original portfolio of a major Victorian designer. 48pp. 9¼ × 12¼. 25083-0 Pa. $7.95

PRIMITIVE ART, Franz Boas. Remains the best text ever prepared on subject, thoroughly discussing Indian, African, Asian, Australian, and, especially, Northern American primitive art. Over 950 illustrations show ceramics, masks, totem poles, weapons, textiles, paintings, much more. 376pp. 5⅜ × 8. 20025-6 Pa. $6.95

SIDELIGHTS ON RELATIVITY, Albert Einstein. Unabridged republication of two lectures delivered by the great physicist in 1920–21. *Ether and Relativity* and *Geometry and Experience*. Elegant ideas in non-mathematical form, accessible to intelligent layman. vi + 56pp. 5⅜ × 8½. 24511-X Pa. $2.95

THE WIT AND HUMOR OF OSCAR WILDE, edited by Alvin Redman. More than 1,000 ripostes, paradoxes, wisecracks: Work is the curse of the drinking classes, I can resist everything except temptation, etc. 258pp. 5⅜ × 8½. 20602-5 Pa. $4.50

ADVENTURES WITH A MICROSCOPE, Richard Headstrom. 59 adventures with clothing fibers, protozoa, ferns and lichens, roots and leaves, much more. 142 illustrations. 232pp. 5⅜ × 8½. 23471-1 Pa. $3.95

A CONCISE HISTORY OF PHOTOGRAPHY: Third Revised Edition, Helmut Gernsheim. Best one-volume history—camera obscura, photochemistry, daguer-reotypes, evolution of cameras, film, more. Also artistic aspects—landscape, portraits, fine art, etc. 281 black-and-white photographs. 26 in color. 176pp. 8⅜ × 11¼. 25128-4 Pa. $12.95

THE DORÉ BIBLE ILLUSTRATIONS, Gustave Doré. 241 detailed plates from the Bible: the Creation scenes, Adam and Eve, Flood, Babylon, battle sequences, life of Jesus, etc. Each plate is accompanied by the verses from the King James version of the Bible. 241pp. 9 × 12. 23004-X Pa. $8.95

HUGGER-MUGGER IN THE LOUVRE, Elliot Paul. Second Homer Evans mystery-comedy. Theft at the Louvre involves sleuth in hilarious, madcap caper. "A knockout."—Books. 336pp. 5⅜ × 8½. 25185-3 Pa. $5.95

FLATLAND, E. A. Abbott. Intriguing and enormously popular science-fiction classic explores the complexities of trying to survive as a two-dimensional being in a three-dimensional world. Amusingly illustrated by the author. 16 illustrations. 103pp. 5⅜ × 8½. 20001-9 Pa. $2.25

THE HISTORY OF THE LEWIS AND CLARK EXPEDITION, Meriwether Lewis and William Clark, edited by Elliott Coues. Classic edition of Lewis and Clark's day-by-day journals that later became the basis for U.S. claims to Oregon and the West. Accurate and invaluable geographical, botanical, biological, meteorological and anthropological material. Total of 1,508pp. 5⅜ × 8½. 21268-8, 21269-6, 21270-X Pa. Three-vol. set $25.50

LANGUAGE, TRUTH AND LOGIC, Alfred J. Ayer. Famous, clear introduction to Vienna, Cambridge schools of Logical Positivism. Role of philosophy, elimination of metaphysics, nature of analysis, etc. 160pp. 5⅜ × 8½. (Available in U.S. and Canada only) 20010-8 Pa. $2.95

MATHEMATICS FOR THE NONMATHEMATICIAN, Morris Kline. Detailed, college-level treatment of mathematics in cultural and historical context, with numerous exercises. For liberal arts students. Preface. Recommended Reading Lists. Tables. Index. Numerous black-and-white figures. xvi + 641pp. 5⅜ × 8½. 24823-2 Pa. $11.95

28 SCIENCE FICTION STORIES, H. G. Wells. Novels, *Star Begotten* and *Men Like Gods*, plus 26 short stories: "Empire of the Ants," "A Story of the Stone Age," "The Stolen Bacillus," "In the Abyss," etc. 915pp. 5⅜ × 8½. (Available in U.S. only) 20265-8 Cloth. $10.95

HANDBOOK OF PICTORIAL SYMBOLS, Rudolph Modley. 3,250 signs and symbols, many systems in full; official or heavy commercial use. Arranged by subject. Most in Pictorial Archive series. 143pp. 8⅜ × 11. 23357-X Pa. $5.95

INCIDENTS OF TRAVEL IN YUCATAN, John L. Stephens. Classic (1843) exploration of jungles of Yucatan, looking for evidences of Maya civilization. Travel adventures, Mexican and Indian culture, etc. Total of 669pp. 5⅜ × 8½. 20926-1, 20927-X Pa., Two-vol. set $9.90

AMERICAN CLIPPER SHIPS: 1833–1858, Octavius T. Howe & Frederick C. Matthews. Fully-illustrated, encyclopedic review of 352 clipper ships from the period of America's greatest maritime supremacy. Introduction. 109 halftones. 5 black-and-white line illustrations. Index. Total of 928pp. 5⅜ × 8½.
25115-2, 25116-0 Pa., Two-vol. set $17.90

TOWARDS A NEW ARCHITECTURE, Le Corbusier. Pioneering manifesto by great architect, near legendary founder of "International School." Technical and aesthetic theories, views on industry, economics, relation of form to function, "mass-production spirit," much more. Profusely illustrated. Unabridged translation of 13th French edition. Introduction by Frederick Etchells. 320pp. 6⅛ × 9¼. (Available in U.S. only)
25023-7 Pa. $8.95

THE BOOK OF KELLS, edited by Blanche Cirker. Inexpensive collection of 32 full-color, full-page plates from the greatest illuminated manuscript of the Middle Ages, painstakingly reproduced from rare facsimile edition. Publisher's Note. Captions. 32pp. 9⅜ × 12¼.
24345-1 Pa. $4.95

BEST SCIENCE FICTION STORIES OF H. G. WELLS, H. G. Wells. Full novel *The Invisible Man*, plus 17 short stories: "The Crystal Egg," "Aepyornis Island," "The Strange Orchid," etc. 303pp. 5⅜ × 8½. (Available in U.S. only)
21531-8 Pa. $4.95

AMERICAN SAILING SHIPS: Their Plans and History, Charles G. Davis. Photos, construction details of schooners, frigates, clippers, other sailcraft of 18th to early 20th centuries—plus entertaining discourse on design, rigging, nautical lore, much more. 137 black-and-white illustrations. 240pp. 6⅛ × 9¼.
24658-2 Pa. $5.95

ENTERTAINING MATHEMATICAL PUZZLES, Martin Gardner. Selection of author's favorite conundrums involving arithmetic, money, speed, etc., with lively commentary. Complete solutions. 112pp. 5⅜ × 8½. 25211-6 Pa. $2.95

THE WILL TO BELIEVE, HUMAN IMMORTALITY, William James. Two books bound together. Effect of irrational on logical, and arguments for human immortality. 402pp. 5⅜ × 8½. 20291-7 Pa. $7.50

THE HAUNTED MONASTERY and THE CHINESE MAZE MURDERS, Robert Van Gulik. 2 full novels by Van Gulik continue adventures of Judge Dee and his companions. An evil Taoist monastery, seemingly supernatural events; overgrown topiary maze that hides strange crimes. Set in 7th-century China. 27 illustrations. 328pp. 5⅜ × 8½. 23502-5 Pa. $5.95

CELEBRATED CASES OF JUDGE DEE (DEE GOONG AN), translated by Robert Van Gulik. Authentic 18th-century Chinese detective novel; Dee and associates solve three interlocked cases. Led to Van Gulik's own stories with same characters. Extensive introduction. 9 illustrations. 237pp. 5⅜ × 8½.
23337-5 Pa. $4.95

Prices subject to change without notice.
Available at your book dealer or write for free catalog to Dept. GI, Dover Publications, Inc., 31 East 2nd St., Mineola, N.Y. 11501. Dover publishes more than 175 books each year on science, elementary and advanced mathematics, biology, music, art, literary history, social sciences and other areas.